SIX FACETS OF LIGHT

Also by Ann Wroe

Lives, Lies and the Iran-Contra Affair
A Fool and his Money: Life in a Partitioned Medieval Town
Pilate: The Biography of an Invented Man
Perkin: A Story of Deception
Being Shelley: The Poet's Search for Himself
Orpheus: The Song of Life

ANN WROE

SIX FACETS OF LIGHT

JONATHAN CAPE
LONDON

3 5 7 9 10 8 6 4

Jonathan Cape, an imprint of Vintage Publishing,
20 Vauxhall Bridge Road,
London SW1V 2SA

Jonathan Cape is part of the Penguin Random House group of companies whose addresses
can be found at global.penguinrandomhouse.com.

Penguin
Random House
UK

Copyright © Ann Wroe 2016

Ann Wroe has asserted her right to be identified as the author of this Work in
accordance with the Copyright, Designs and Patents Act 1988

First published by Jonathan Cape in 2016

www.vintage-books.co.uk

A CIP catalogue record for this book is available from the British Library

ISBN 9781910702321

Printed and bound in the UK by Bell & Bain Ltd, Glasgow

Penguin Random House is committed to a sustainable future for our business, our readers and
our planet. This book is made from Forest Stewardship Council® certified paper.

CONTENTS

LIST OF ILLUSTRATIONS

CREDITS

Chalk Paths by Eric Ravilious (1903-42), Private Collection, Bridgeman Images

Night Startled by the Lark by William Blake (1757-1827) and *Light and Colour (Goethe's Theory)—The Morning after the Deluge—Moses Writing the Book of Genesis* by J.M.W. Turner (1775-1851) © Tate, London 2015

Cortona Annunciation by Fra Angelico (Guido di Pietro) (c. 1387-1455), Museo Diocesano, Cortona, Italy/De Agostini Picture Library/G. Dagli Orti/Bridgeman Images

Cloud Study, 1821 by John Constable (1776-1837), Yale Center for British Art, Paul Mellon Collection, USA/Bridgeman Images

Harvest Moon by Samuel Palmer (1805-81), Private Collection, Bridgeman Images

This book is a series of musings on light, compiled from wonderings, observations and associations made while walking the luminous Downs of southern England between Brighton and Eastbourne. It is not scientific, and only occasionally philosophical. It is really just a love song to light, sung by myself and the various poets and painters, of many eras, who have walked along with me.

<div align="right">AW</div>

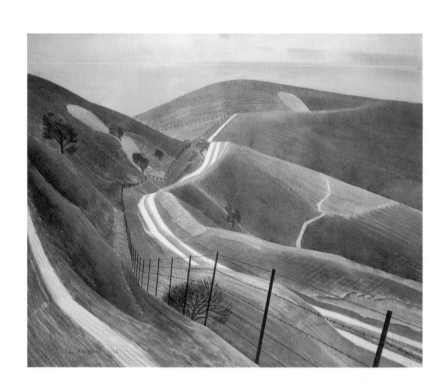

COUNTY LIBRARY
PH. 01 4620073

THE WHITE STONE

Sixty miles south of London, reached by an ambling train that divides at Haywards Heath, lies Eastbourne in East Sussex. Weathermen say it is the sunniest town in Britain, with brightness almost every day. Pensioners know this; they have long colonised the place, shuffling in white cardigans and golf shoes past the glacé-icing façade of the Grand, or sitting on the benches by the Martello tower where the marigolds make a show. Everything dazzles, or is bleached out. A man walking a dog across the lawns becomes a radiant ghost of himself. Teapot, cups and spoons blink blindingly on a table. The sea breaking on Holywell Ledge by the westernmost tea chalet sparkles in sequinned foam, and a single yacht – there is always one – cleaves the sea like a blade.

The artist Eric Ravilious was brought up here in the early 1900s, the tall, floppy-haired son of a man who, appropriately, made his living by selling and fitting blinds. On Sundays you might see him – 'the Boy', as friends called him later, in token of that unjaded child's gaze – arm-in-arm with his parents, walking briskly to the Methodist church where the minister preached hellfire. For hours he would sit there, morning and evening, in a hall darkened by infernal visions, watching

through the high windows how the light played outside. He would hear above the wheezing organ seagulls crying light, scrapping for it, keening down the great curve of it, while wood-and-canvas biplanes buzzed them and more boats, sails shining, rode jauntily on the sea. Or so he painted the scene later, adding – for good measure – vapour trails, clouds, fireworks.

For there was no getting away from it. If he escaped by bike to the Downs to the north and west of town the air was still saturated with light, like a shout. The whole region was famous for it. When Richard Jefferies, Victorian England's greatest nature writer, moved his long lean Wiltshire frame in the 1880s to Brighton, twelve miles west of Eastbourne, hoping for health, he was enchanted by the dryness and clearness of the air. The place was 'a Spanish town in England, a Seville', where light so filled the sky and cascaded off the walls, caressing the blooming, fluttering, laughing girls as it went, that even a northern aspect shone. The sheer 'champagniness' of Brighton light, he wrote, 'brings all things into clear relief, giving them an edge and outline'. Ravilious, cycling out into fold upon fold of clear-edged hills backed by glare, carried Jefferies's books in his mind or his saddlebag. Aficionados of light and chalk tend, like downland starlings, to flock together.

The combination is too strong for some eyes. Chinese tourists on the Number 12 bus, which plies the coast road, not only don sunglasses and sit on the shaded side but pull their caps over their faces to save themselves. It doesn't help. Light lords it here and, besides, the land is built from it. Rabbits kick it up from the banks, white scuts jumping in a rubble of white stones. Poppies catch scarlet fire at the

field's edge, each petal glassy with powder of light. Trees are rooted in square-cut walls of it, as if their leaves did not absorb enough from the fiercely gleaming air. Men quarry it; one of Ravilious's favourite subjects was the Asham cement works near Tarring Neville, dug deep into the Downs, where talcum-light lay in drifts over buildings, dolly engines, hedges and trees.

When the topsoil is ploughed or harrowed light shoulders through, bone beneath skin as delicate as that quarried dust. Real bones also break from it, of rabbit or sheep, or the bleached, strewn ossuaries of birds of prey. Fields that are plain smooth grass erupt with light, in pebbles of chalk or damp mushrooms overnight, with occasional perfect shells flung up by wave and gale, or even with the scattered forms of far sheep grazing – for it is a curious quality of this light that all objects, near or far, are equally intense and clear. The result can be a sense of illusion, almost trickery. W.H. Hudson, another tramper of the Downs favoured by Ravilious, thought he had stumbled once on one of those bright, prophetic fields, singled out by the cloud-fighting sun, where divine words wait to be read: an old ploughed field, it seemed from a distance, completely covered with tall white-campion flowers. But it was only a patch of downland waste strewn with shining flints, blue forget-me-nots misting among them.

In ancient times some downland fields were explicitly dedicated to light. At West Dean, hiding behind a spur of hill barely two miles from the sea, two small pieces, Lampland and Tapersland, were farmed in the fourteenth century to provide candles for the tomb of Isabella Heringod, who slumbers in the church. When Ravilious was teaching at Eastbourne School of Art he would bring his students out here,

by bike or bus, to draw. The tiny village, now sunk in woods planted by the Eastbourne Water Board, was then as open to the sky as any other neighbouring place. For centuries, under that brightness, men laboured to farm the soft white stone, leaving what Hudson called their 'chance hieroglyphics' in dips, mounds and plough-ridges. And for those who know where to look, as the low light of dawn or sunset reveals their uneven lines in the turf, the chalk hides prehistoric chambers decorated with spiral mazes in which the sun was believed to disappear and go deep, as a man's spirit lay within himself.

In chalk all the pathways are laid with light, emphasising the sense that they lead to a higher state. John Bunyan, in his *Pilgrim's Progress*, was perhaps the first to mention this. Above his own clay plains the chalk Chilterns appeared as holy hills blocking off the divine country, and the white tracks that crossed them as necessary pathways for the pilgrim soul. On these Delectable Mountains, shepherds grazed their flocks; from the high ridges they could point out to pilgrim Christian the Abyss of Error, and Mount Innocent, and Mount Marvel, where they saw 'a man at a Distance, that tumbled the Hills about with Words'. They could also show him, through their Perspective-Glass, the Gates of the Celestial City.

Chalk in any case was holy in itself, like 'the Child of God': white, warm, soft, and moreover, Bunyan wrote,

> It leaves a white Impression upon those
> Whom it doth touch, be they it's Friends or Foes.

This purity is seen most clearly at the shoreline. At Hope Gap near Cuckmere Haven chalk stands in great cubes and rectangles, as if

4

cut by a saw; between these it lies in luminescent eggs and spheres, their roundness cupped by gritty sand. Farther out it spreads itself in plateaus and ledges smoothed by the waves into regular scalloped squares, like an ancient courtyard all men have trodden, or will tread, into the milky blueness of the sea.

Some it has embraced are swept back again. In Friston church-yard, a few miles inland to the east, several are buried under a wind-bleached wooden cross engraved only with the words WASHED ASHORE. People have a habit of leaving a few wild flowers there: ox-eye daisies, or buttercups from the glowing field that runs down to East Dean. *Purge me with hyssop, and I shall be clean,* says the psalm; *wash me, and I shall be whiter than snow.*

> *Humble among the old memorials,*
> *a cross of time-grey, weathered, sea-worn wood*
> *and daffodils in grass. They brought him here*
> *for decent burial, as they thought they should.*
>
> *'Washed ashore' the epitaph he's given.*
> *Nothing more complicated to proclaim –*
> *a resting place for anyone discovered*
> *without a face, or clothing, or a name,*
>
> *rolled in the unkind breakers like the chalk*
> *fallen from cliffs, but softer, splaying limbs*
> *loose as the seaweed, pebbles in his hair*
> *and seagulls' fretful squalling for his hymns.*

Thus rubbed, reduced, wrung out, his whitened wreck
rocks unlamented on an unknown shore;
or loved, laved, lavendered, is lifted up
in the bright washing he was waiting for.

Bunyan's Christian cried *Selah*, the word that punctuates many of the Psalms, to invoke God's help on his journey, especially the final stage. When Ravilious wrote of painting the bleaching and browning of the winter hills, 'never so exciting as it is this time of year in Sussex', he added: 'I'd like to put Selah after this … if the word means what I think it means.' He thought it meant as good a light as he could hope for.

With easel and brown canvas satchel he walked the chalk paths daily in the mid-1930s, heading up Beddingham Hill to paint the wide vistas north to the Weald and south to the sea. His boots would pick up that 'white impression', light splashed thick as paint or bird-lime on leaves, and tread it home afterwards. He also cut these paths into boxwood blocks, their lines swirling across in rhythm with the line of the hills. But it was in his watercolours that they preserved their mystery. They dipped and curved, always bending out of view, towards the horizon that might never be reached and the country that might never be known. When they made for houses – thick-walled, deep-roofed, crouched against the slanting rain that forced the walker into the hedge – they flowed past, bound elsewhere. In one painting, this time of chalk hills in Jefferies's Wiltshire, two lanes intersected, either route possible, neither certain, nothing marked on signs; a red Post Office van hesitated amid the green and white. In another, of Cuckmere Haven, a white path wound beside the white meanders

of the river towards the boundless radiance of the sea. The paths ran beside telephone poles, their deep-worn silence contrasting with the high hum of the wires, and in parallel with barbed-wire fences, smooth beside sharp.

Yet Ravilious did not paint these paths, in the strict sense. He left them as white paper, brushing in the spare grass with thinnest strokes to show the bare scapulae of the hills. For what had to be caught was that underlay of light. Not just the surface play of it, when it moves up a slope as a thumb rubs through velvet or as a teasel cards wool, misting into deep drifts at the field's edge and wisps across the summit – but the kingdom of brightness just beneath the grass, and hollow as a drum beneath the feet.

Four miles north-west of Eastbourne the apparent ruler of such a kingdom, the Wilmington Giant, lay carved in the chalk, reinforced with white bricks, with a tall staff in either hand. Ravilious loved this figure, depicting it again and again, though mischievously he sometimes called it a giantess, seductively shining under sun or moon on the broad flank of the hill. There were gates of light involved here, opening in the chalk: thrust wide by Baldur, the summer god, to let the day begin, or by some far older Neolithic sun god to announce the high season of growth and harvest. The figure lies on the north slope of Wilmington Hill, underneath the main path, so that it is often in shadow and hard to see; but at its back, or through the gates, lies a southern, sea-bright, scintillating world, continually flashing with new stars.

There was to be a book of such figures. Ravilious, handed this commission, painted half a dozen or so on travels across the chalk

Downs of the south, most of them giants or swift-running horses observed from third-class carriages in trains. He worked fast, for with the coming of war in 1939 they were to be blacked out or turfed over, together with all the chalk ways, cuttings and tracks. On a train journey in 1941 he met 'a tall and rather lordly person' who owned the land around the Wilmington Giant, and learned that he had already camouflaged the figure with grass. The god was buried again, a premonition of the deadening and darkness to come.

For within white chalk lay movement and power: a quickening gleam, a declaration from beyond, as when swallows burst out of a fragment of cliff that fell to the beach at Brighton, then Brighthelmstone, during a winter storm in the 1760s. Gilbert White, the great naturalist of Selborne, told the story in his *Natural History*, a work Ravilious eagerly made engravings for. Both men agreed, as White wrote, that 'there is somewhat peculiarly sweet and amusing in the shapely figured aspect of chalk-hills'. 'There are bustards on the wide downs near Brighthelmstone,' White continued, a statement Ravilious found 'beautiful' and elegantly engraved, with the great bird standing stoutly against the smoothly sweeping scene. Still more marvellous, though, were the Brighton swallows. Many witnessed the wonder of their tumble out of the rock; others, not seeing, wished to believe it, for it might explain why and how these birds disappeared when summer ended. They crept inside the chalk and slept. The man who told White the story, an 'intelligent person', took it to be true that apparently inert stone could be inhabited by life. People still talk of cutting into the 'living' chalk or limestone in a way they do not talk of granite, sandstone or shale.

Shepherds of the Downs also shared that understanding. Their local name was 'lookers' and their trade 'lookering', as if they scrutinised everything in their realm that lived and moved in light. As they wandered with their sheep they set up flocks of small birds, pretty white-rumped wheatears, which nested in cliffs and rabbit holes and could be taken from the stones, if horsehair springes were set for them. (On a ploughed field of brown-and-white flints the birds are disguised so perfectly that the stones themselves seem to start and fly.) The peeping, fluttering prey were caught, strung on a grass stem and stowed away in a greatcoat pocket, carefully, for they were worth eighteen pence a dozen when sold as dainty mouthfuls for fashionable Brighton supper tables. An old shepherd told Hudson that one couple, laying traps on Beachy Head, snared 1,200 wheatears and, unable to thread them on crow quills as usual, bagged them up in the husband's smock and the wife's billowing white petticoats.

The little birds that sprang from the chalk could also prompt higher pursuits. One shepherd boy and champion wheatear-catcher, John Dudeney of Newmarket Hill near Lewes, hid within the white hillside in the 1790s his home-made pasteboard telescope – a Perspective-Glass through which he had seen not the Celestial City, indeed, but still the transit of Mercury – his *History of Rome* procured at Lewes fair, his Latin primer, his precious store of blank white copybooks and Turner's *Introduction to Geometry*. He called this his 'under-stone library'. All had been bought with money from wheatears and from the lamb and white wool of the single sheep he owned. Had he caught a bustard – for his grandfather had seen one, up on the Downs where four parishes met – he might have gained a whole encyclopedia.

He did not neglect his flock. He would pace to and fro, reading, as the sheep cropped quietly beside him. One winter, when the whole scene glared white, he could not study, for 'the snow turned into ice on my eyelashes, and [my father] breathed on my face to thaw it off'. When the turf was dry again, laying out his white paper on the barely grassed white stone, he drew out perfect circles and triangles with an old pair of iron compasses which he had filed down to hold a pen. A valley lies beyond the hill, Cold Coombes, bare and unwatered, scattered with sparse thorns; but the chalk slopes beneath it hold chanted declensions, and elevations of the stars.

Chalk thrown up from the earth is scoured so clean that it seems to have had nothing to do with soil or the spoil-heaps of working the land. Instead it dots the hills as the uncut ore of light. *To him that overcometh*, says the Spirit in Revelation, *will I give to eat of the hidden manna, and will give him a white stone, and in the stone a new name written, which no man knoweth saving he that receiveth it.* On the clifftops above Beachy Head hand-sized white stones, perfect for new names, lie everywhere. Passing ramblers string them out on the turf to make the names they already know, with declarations of heart-love that can be read from any small, buzzing aeroplane. Walking there one summer I found, lying among the pearl-pebbles on the short dry turf, a 'real' pearl ear stud with a thin gold shaft. Its faint opalescence was mirrored in the sea. If one lay there, how many others did? Or under what trick of the sky or the light would all turn into jewels?

This fascination was encouraged young, when my great-aunt would lead me on walks with the spaniels just below the chalk North Downs at Bearsted, in Kent. Our longest ramble would take us to a muddy track called Button Lane, once the site – she told me – of a button factory, before the war. Not a trace of it remained, except for the small, flat pearl buttons scattered along the path and in the pasture round it. Most were four-holed, some two-holed, and all slightly mottled on the back with black, green and brown, like a bird's egg. Thirty years after those walks it was still common to find them, trodden only a little deeper, muddied but rainbowed repositories of light. In my dreams they became silver threepences and sixpences, endlessly turning up out of the grass.

Thomas Traherne, ministering to his flock at Credenhill near Hereford in the mid-seventeenth century, would have said that all grains of dirt were destined for transformation. Indeed, he believed stones were jewels already; as was every tiny 'sand'. ('O what a Treasure is evry Sand when truly understood!') As a child he had seen the streets of Hereford strewn with powder-gold, which his shouting playmates took for common dust. He knew better, he told a friend, for from infancy he could see 'on both sides the Vail or Skreen': what seemed earthly, even dirty, was painted, for him, in heaven-colours.

> And Nothing's truly seen that's Mean;
> Be it a Sand, an Acorn, or a Bean,
> It must be clothd with Endless Glory,
> Before its perfect Story
> (Be the Spirit ne'er so Clear)
> Can in its Causes and its Ends appear.

Jefferies, too, pondered the 'perfect Story' of these inconsequential things. Lying on the clifftop above Beachy Head, stretching his limbs beside the new-found chalk ways that captivated him in the early 1880s, he would sometimes carelessly rub out little pebbles from the dry, crumbling earth. (Casual observers thought he did nothing but wander and dream, though he also wrote just enough books and articles to live on.) He considered the pebbles with his large, blue-bright eyes, marvelling at the sand that glistened on them. 'Particles adhered to my skin – thousands of years between finger and thumb, these atoms of quartz, and sunlight, shining all that time.' He found, too, those natural concomitants of chalk, legions of tiny, grey, empty shells that crunched under his boots like hoar frost or fragile beads. These were 'receptacles of ancient sunlight'. A glow could still be seen in them, like that in curved amphorae stacked against a wall slowly moving with gleams of the blue, trireme-rearing sea.

Thousands of similar shells lie in the grass of the surrounding hills. Some curl on themselves like ammonites, some are pointed spirals; none is bigger than a centimetre. All are grey-white; some are edged in black. Whether they are new or ancient is often hard to tell. Perhaps they live and move, earth creatures perilously fastened with a dot of slime to the tall, bending grass stems; perhaps they have worn free long ago from the deep seabed. On a bank they make a show of dozens of points of light, lifted to lie among scabious and pink restharrow and the tiny mauve-flowered thyme – Ravilious's 'wonderful smell of the hill country' – in which Jefferies ecstatically buried his face and his hands. 'There may be an outcome for us that we know nothing of,' he wrote afterwards. 'An outcome for all that has

lived: the Eastbourne hill shells for example – the (blue) swallow ...'
His own outcome, so devoutly wished for among the natural litter
of the chalk hills, was that his soul might come to expand with the
whole life and power of the sun: that he might know 'unutterable
existence infinitely higher than deity'. The Downs encourage that
sort of thing.

The poet John Clare was a shell-man, but of narrower horizons.
He especially sought the cases of Northamptonshire field and garden
snails. As a ploughboy and ditch-filler in his young years, he turned
them up; and well into adulthood he would go 'pooty-hunting', follow-
ing the 'silver slimy trails' on his hands and knees. He treasured espe-
cially 'a scarce sort of which I only saw 2 in my life picked up under a
hedge at Peakirk town-end & another in Bainton meadow its colour
is a fine sunny yellow larger than the common sort & round the rim of
the base is a black edging'. It was not, he added – surprisingly, since he
was so seldom in London – 'in the collection at the British Museum'.
Evidently he had visited, and checked. As he held the rare specimen
in his big coarse hands it had the light of summer in it, again perhaps
an ancient summer, for he had found other shells, 'most of them of the
large garden kind', on the Roman bank beside the Roman road, small
curved horns that had long outlasted the tramp of the centurions. His
shells were often buried in banks, in places screened by bramble-bines
and hazel leaves, tremblingly parted as if he spied on the mossy, deep,
untidy nest of the dull brown nightingale, from which it sometimes
sang. He would edge with a finger the same rounded interior smooth-
ness, the same intricacy of weave and line, but the snail's small house
he could carry away.

On a page of his journal around 1825 he drew ten such 'pootys' with his pen. To the untrained eye they all seem rather similar, though not to him. He intended to paint them with some 'cakes of colors' he had just bought. They had the look of Neolithic spirals. And indeed the most striking aspect of the larger, wind-lifted snail shells that also litter the Downs is how they radiate outwards from that raised apex, passing through a gamut of colours – patterned bands of white, blue and purple, tabby-cat markings, skylark featherings that Clare called 'mozzld' – and also spiral inwards, in a line that seems to imitate the curl of the wave, the dip of the hill and the flow of the stars. Each seems profound and beautiful in a different way, as they swirl from light to dark and dark to light: air, earth and sky all enclosed in a coil of calcium carbonate that lodges in a pocket, buffered with leaves and grass.

One morning in spring, 'poking about the hedges' as usual, Clare found objects startlingly different. The dewdrops, he wrote,

> on every blade of grass are so much like silver drops that I
> am obliged to stoop down as I walk to see if they are pearls
> and those sprinkled on the ivy-woven beds of primroses …
> are so like gold beads that I stooped down to feel if they
> were hard but they melted from my finger. And where the
> dew lies on the primrose the violet & whitethorn leaves they
> are emerald and beryl yet nothing more than the dews of the
> morning on the budding leaves

Clare was by then mad, or taken to be. When his notes on the morning dew were transcribed, by another hand that added proper

punctuation, he had been committed to a private asylum at High Beeches in Essex. From there in 1841 he escaped, wandering home to his village of Helpston by going from heartless public house to public house, sleeping in sheds on trusses of clover. Gravel hobbled his feet in his shoes, and his food over several days was nothing but quids of chewed tobacco and half a pint of beer, bought with a penny thrown to him by someone who took him for a broken-down haymaker. It was perhaps with an eye already skewed by madness that he saw the grass full of pearls and gold beads that fell to water in his hands.

Yet he saw too as a peasant-poet, much as he disliked the phrase: one who would 'drop down behind a hedge bush or dyke', like a bird, to write down his 'things' on paper scraps pressed on the hard crown of his hat, and who learned to observe the fields at a sauntering pace as he weeded or ploughed, or minded cows. His publisher hoped, in vain as it happened, that he might write a natural history of Helpston, like White's of Selborne. Clare's own word for his way of walking was 'saunered', suggesting even more a lackadaisical, whimsical wandering in Nature. He needed to walk slowly to appreciate the golden furze, the thyme-scented hummocks in the sheepfields, the 'sun-tannd green' of the ripening hay, the dragonflies 'in spangled coats' and, in the May woods, lilies of the valley under hooded leaves 'like maids with their umbrellas'.

A slow pace, too, like his, reveals the beauty of stones – the purple and blue interiors of white-robed flints, Ravilious's favourites, the fools'-gold flecks of pyrites, or the strange round flattened stone, marked with a perfect six-pointed star, that lay beside a puddle on a walk of mine. The immense shingle beach at Brighton reveals almost

no stone that is not interesting for a hole in it, flecks on it, or some oddity of shape, marbling or coloration. There are said to be semi-precious stones on some southern shores, cornelian and jasper, lying within reach of the red-skinned visitors who quickly hobble over them, or lounge on their beach mats playing ducks and drakes with the waves. Yet the commonest pebble too, Jefferies insisted, 'dusty and marked with the stain of the ground, seems to me so wonderful; my mind works round it till it becomes the sun and centre of a system of thought and feeling'. It would be just such a common stone, wrote Jakob Böhme in the 1620s, unprofitable and trodden underfoot, that would prove to be the pearl of divine understanding.

The humblest part of Nature, in the eyes of writers like these, might hide unexpected reserves of light. This was true even of the grass, silently robing the earth from generation to generation. Evidently it fed on sunlight and grew towards the source, in the way of all green things. But poets, who tended to fling themselves down unhappily in grass, found closer parallels with themselves. They imagined they heard it growing, singing; they compared it to men, and its brief season to their own lives. *As for man, his days are as grass,* ran the words of Psalm 103: *For the wind passeth over it, and it is gone; and the place thereof shall know it no more.* Jefferies liked to sit on it, buzzed by scarlet-dotted flies, as if he too were a blade of grass, unselfconsciously living and filled with the sun. This seemed the most perfect existence possible for 'an indolent, dreamy particle like myself'. One blade pressed to his cheek, he claimed, could tell him what all Nature was saying.

16

Close up, grass is also lovely; and as much so when dead, feathery and dry as when alive. (Ravilious disliked the 'continually vivid green' of Essex fields when he lived there, and longed for the subtler colours farther south.) Grass dances and ripples under wind-light on the hills; it may be gilded with low sun, silvered with ice, quaking with the glitter of its own seed. The short bristle-leaved bent grass of the Downs makes a surface sprung like a dance floor, lifting the walker's heart as well as his feet, so that even a shepherd boy like Dudeney feels the wide sky is his province, as much as the curving earth.

The name of downland grass was unknown to me until I found, in a London charity shop, a green *Observer's Pocket Book of Grasses, Sedges and Rushes*. It was as humble as its subject, damp-stained and battered, costing fifty pence and without its jacket. Yet half its illustrations, surprisingly, were in colour, showing clusters and panicles touched with pink and purple, blue and grey; and the grasses were praised for their beauty, elegance and decorative effect as if they were garden flowers. Relatively few, in the author's quaint phrase, were 'of use to the agriculturalist'. Their use was to the artist and the dreamer.

Grasses have a hundred names, as my little book informed me – even without Clare's 'feather-headed', 'tottering' and 'spindling', which were unofficial. Sweet vernal grass, whose oil perfumes hayfields; green panick grass, neatly spiked and with no sign, despite its name, of agitation; meadow soft grass, its faint pink flowers spreading mist across the fields; slender fox-tail grass, silky bent grass, false oat whose spikelets glitter like metal; and unlovely couch grass, sprawling and tenacious, whose country names, 'Quickens', 'Quitch' and

'Squitch', all mean 'living', and green life. Both Clare and Traherne referred to 'spires' of grass: the old word, but one that also suggested blades and panicles reaching to heaven, each one 'wholly illuminated' by the sun, wrote Traherne, 'as if it did entirely shine upon that alone'. Jefferies saw grass, untouched by anything but daylight, lit like a torch; William Blake in his *Songs of Innocence* painted its leaping spirals intertwined with flames.

A child brought him grass, Walt Whitman wrote (loafing at his ease, world-including, accepting the gift with his enormous, sky-parting hands). The small voice asked what it was. Whitman had one confident answer, in the roaring compendium of poetry he called 'Leaves of Grass':

I believe a leaf of grass is no less than the journeywork of the stars,
And the pismire is equally perfect, and a grain of sand, and the egg
 of the wren...

His poem had begun with summer grass, its blades blazing at sunset with 'individual splendour'; and out of those leaves his 'Song of Myself' was woven, making him, too, 'the journeywork of the stars'. Yet his subsequent thoughts were sadder and more tentative. The grass that composed him sprang also from the graves of Civil War casualties he had nursed and mourned in the army hospitals of Washington, those brave, wrecked bodies going open-eyed into the ground with 'the beautiful uncut hair' of those struck down too soon. Blood and bandages, heartbeats and putrefaction, stars and sweat, were all mysteriously meshed in the grass-universe of himself.

How could I answer the child? I do not know what [grass] is any
 more than he.
I guess it must be the flag of my disposition, out of hopeful green
 stuff woven.
Or I guess it is the handkerchief of the Lord,
A scented gift and remembrancer designedly dropt,
Bearing the owner's name someway in the corners, that we may see
 and remark, and say *Whose?*

Jefferies adored *Leaves of Grass*. Others were decidedly cautious. One
was Gerard Manley Hopkins, who found his own early poems lumped
in with Whitman's by the critics, though in his opinion Whitman's did
not 'rhyme or scan or construe' and their author was, besides, immoral.
Hopkins was thirty or so when he first read him, a committed Jesuit,
witty but dogged by exhaustion and bowel trouble, studying theology
at St Beuno's in wild Wales; he could hardly have been more different
from the brawling, louche newspaperman of Brooklyn and New Jersey.
His song was of the glory of God in Christ; Whitman's was the song
of Whitman, 'an American, one of the roughs, a kosmos,/Disorderly,
fleshly and sensual'. For all that, they strayed close to each other, as
Hopkins was painfully aware. Both of them were dazzled by the whole
span of creation. In 1882 Hopkins admitted to his friend Robert Bridges
that he had always known 'in my heart Walt Whitman's mind to be
more like my own than any other man's living'. He added:

As he is a very great scoundrel this is not a pleasant confes-
sion. And this also makes me the more desirous to read him
and the more determined that I will not.

Nonetheless, he had noted Whitman's lines about the grass. He remembered God's handkerchief 'designedly dropt'. The American had messed about with the dactylic rhythm, he complained, just the sort of 'savage' thing Whitman would do – but for all that the talk of messages, hints and remembrancers was after his own heart. For God left such suggestions in anything which, like the grass, played between light and shade; light being, for Hopkins, the Word.

> ... rose-moles all in stipple upon trout that swim;
> Fresh-firecoal chestnut-falls; finches' wings;...
> All things counter, original, spare, strange;
> Whatever is fickle, freckled (who knows how?)
> With swift, slow; sweet, sour; adazzle, dim;
> He fathers-forth whose beauty is past change:
> Praise him.

Jefferies was less convinced that God was involved. But he too was fascinated by the messages he found, for example, in the depths of a pinewood: the 'spots, dots and dustings' in a foxglove and on a butter-fly's wing, on meadow orchids and the rind of oaks. There was noth-ing, he wrote, that was not 'stamped ... [with] the sacred handwriting, not one word of which shall fall to the ground'. Some 'inner meaning' informed the sun, the wood-wasps, the trees, the grass: all that 'shin-ing, quivering, gleaming ... changing, fluttering, shifting ... mixing, weaving'. Light-script flashed even in wisps of straw, caught up by oak boughs from high-piled wagons that swayed along the country lanes. It shone too in the clover-and-timothy hay tumbled after a journey in

Whitman's hair and clothes, prompting his cry: 'I must get what the writing means.'

Eager eyes found potential messages everywhere in Nature, for to observe something at all might imply a private summons to read and understand. Everything demanded notice, as clearly as if it rayed out light; everything spoke, if you could only hear it, and the act of seeing could become a sort of transcendental conversation. It might be natural then, as Clare bashfully recorded of a rural poet rather like himself, to talk back:

> And as he rambled in each peaceful round
> Hed fancy friends in every thing he found
> Muttering to cattle – aye and even flowers
> As one in visions claimd his talk for hours
> And hed oft wonder were we nought could see
> On blades of grass and leaves upon the tree
> And pointed often in a wild surpprise
> To trifling hues of gadding butterflys ...

As a child I believed fervently in these hidden codes; so much so that at the age of ten I devised with my friends a coded mystery involving a Chinaman. I knew no Chinamen, but had heard they had pigtails and never cut their nails, which they used as pens. The shadow of such a man – no more than that – had been seen on the wall of the infants' cloakroom at school, just at the bottom of the stairs. Then he began to leave messages. The first were odd words and numbers written on scraps of exercise-book paper, folded very small and pressed into window frames. I found several, once under

the aged watery eye of Mother Winifred, who paid no attention and was therefore involved. Then the Chinaman dropped on the playing field three coloured cords knotted round a drumstick – a form of communication used, I claimed, by the Aztecs or the Incas. Yet he was a subtler worker, too, and soon his signs were everywhere. I saw his Morse code, or perhaps Braille, on the grey silky bark of every beech tree that lined the playground. It was too high to read, but meant for us, nonetheless. Directions were scratched on stones, and important numbers reckoned by nodes on twigs. Any exquisitely finished thing in Nature – acorn cups, triangular beechmast, streaked tulip petals, the polished-smooth oak apple I kept in my blazer pocket – seemed to have his hand in it. When his calculating shadow started crawling in the spotted laurel leaves and the dandelion clocks, we all decided in terror that the mystery should end. I no longer believe that there are code words written through the landscape by a yellow, long-nailed finger. I still feel, however, that my eye is drawn to things for a reason.

So did Henry David Thoreau, one of Whitman's first admirers, who after decades of official surveying of the fields, hills and bogs about Concord, Massachusetts in the mid-nineteenth century could still be shocked by some discovery in Nature, and always read it as a message for himself. Often an acquaintance would bring it casually to his fierce blue eye, like the rare purple *Azalea nudiflora* which his neighbour Melvin had sprigs of in a pail behind his house, pulled from some secret swamp. ('Well, I told him he had better tell me where it was; I was a botanist and ought to know … for I should surely find it if he didn't.') Sometimes he found the thing himself, like the tiny barred bream, *Pomotis obesus*, trapped one November under the ice of Walden

Pond, which he had never spotted in all his months of solitary living in his hand-built cabin there. In August 1858, with equal suddenness, he became aware of the tufts of purple wood-grass in Concord Great Meadows. He had never noticed those either. But at that moment, he felt, the grass rose up and blessed him: 'Wherever I walk this afternoon [it] stands like a guideboard and points my thoughts to more poetic paths.' The same thing occurred two years later, outside Lowell, when for the first time he observed (from a railway carriage!) the *Sporobolus serotinus*, or dew-grass, holding beads of dew so thickly along its stems that they looked like the work of frost. The humble plant 'had its day', and shone out to him. If he could have things all his own way, he often thought, he would do no surveying at all, but would just pick evergreens and herbs to sell to the Concord townsfolk, trading thus in 'messages from heaven'. Even wisps of straw that caught the sun meant to him, as to Whitman, 'some small word dropped'.

Indeed all plants, Böhme wrote, were expressions of the earth's hidden brightness breaking through: of that perpetual leaping up from lower realms to higher he called, alchemically, 'the growing of the Lily'. Thus rushes and reeds, those lowliest grass relations, could also harbour light – and even more effectively when dead than when alive. In answer to shepherds' reed pipes in Milton's *Lycidas* the evening stars appeared, gradually steadying into brilliance. Blake, too, began his heaven-sent *Songs of Innocence* by piping songs among his sheep; then, taking another hollow reed, he dipped it in 'stain'd' water to write them down. That simple pen wrote clearly all through his book, in translucent brown ink with the tinge and waver of rivers in it. Blake drew himself in the frontispiece with his tapering pipe in his hands,

pausing in mid-breath as a child in a cloud gave him instructions; his
flock, like Dudeney's, grazed gently behind him. Yet he was also a sing-
ing reed himself, slim and hard-jointed, with his shock of red-tasselled
hair tied in a loose, wild pigtail. He could trill words, as Milton's shep-
herds drew out stars.

Reeds, as much as grass, were a type of the poet, making music
plaintively and continually in the water and the wild. Clare's 'oaten reed' –
a straw, in fact – was sometimes so rawly warbling that he would
throw it in a corner in disgust; yet, also like him, it could produce a
'sweet, wild-winding rhapsody', filled with light, on other days. George
Herbert in his rectory around 1630, thin and straight as a stem, hoped
that he might make a 'poor reed' in the consort of heaven, being musi-
cal. His consumptive lungs would not disqualify him: God had prom-
ised in the Book of Isaiah, after all, that he would not crush the broken
reed. In December, reedbeds in the southern marshes capsize into glit-
tering wickerwork along the ditches; and reeds also made the 'roof of
rusted gold' on Blake's cottage at Felpham in West Sussex, where the
angels' ladder ended and they lay, wings folded, along the thatch.

Rushes and bedstraws showed their virtue in a different way, by
softening stone floors and hard beds for the Holy Family as well as
common folk. The bedstraws, with their tall menorahs of tiny white or
yellow flowers, were thought to have acquired them as sparks of pass-
ing grace: a sleepy shift of the Virgin's hip, a drop of her milk, the Holy
Child's tears. The flowering rushes, their small wire parasols tipped
with white, had possibly guided holy feet over wet, treacherous places.
But rushes also burned, their whole body fuel to a flame. Stripped of
their rind, bleached, dried and steeped in tallow, they made a light for

the poor – and for poets. They burned in Dove Cottage in Grasmere, in that low dark kitchen half-buried in the bank, guiding Dorothy Wordsworth to a drawer or the servant girl to a shelf of bowls into which, winter and summer, she would spoon their morning porridge. They flickered, too, in Clare's dim cottage, shrill with tumbling children, where their father bent over the table to clip 'Odditys' from the newspaper, or to read the literary magazines.

Rushes were dearer to Clare even than grass, for they made up most of the 'moorey ground' in his corner of Northamptonshire that still lay open for sauntering and stock-grazing, and had not yet fallen victim to the Enclosure Acts. He walked out there with no set purpose, just seeing how the elms and the brook and the old ivy-hung stile were getting on, hoping to find and greet them before the 'No Trespass' boards appeared. In answer to 'each little tyrant with his little sign', nailed on the very trees as if the birds should obey, Clare cried out in pain for 'the eternal green':

> Unbounded freedom ruled the wandering scene
> Nor fence of ownership crept in between
> To hide the prospect of the following eye
> Its only bondage was the circling sky …

Thus infinity was found among the rushes in Northamptonshire, in Clare's Elysian Fields.

For Traherne, too, Paradise was green; this time with young wheat, filling the valleys beyond Hereford's gates in its 'first springing verdure',

'great and verdant', 'fair and delightful'. He prayed for faith as vibrant and enduring, for he felt those fields would never change: 'The Corn was Orient and Immortal Wheat, which never should be reaped, nor was ever sown. I thought it had stood from Everlasting to Everlasting.' Past the bordering woods a 'glitt'ring Way' ran on towards hills which must, he thought, be those of the eternal country. Each year, for the rest of his life, the sight of green wheat springing gave him that same shock of delight.

To many eyes barley is lovelier, undulating in a soft sea, its brassy tints brushed with red and rose-madder as it carelessly flows across the dip and rise of the fields. By contrast wheat is regimental, orderly; it stands stock-straight, letting the sunlight flash through its blue-green spears (translucent as chrysoprase, Hopkins wrote, 'Nearest to emerald of any green I know'). By June those blades have a casing of gold and a gold, sharpened tip; by August the heads are dry, glittering and ready. No wonder Milton described his angels forming a phalanx with their spears in heaven,

> as thick as when a field
> Of Ceres ripe for harvest, waving bends
> Her bearded Grove of ears, which way the wind
> Swayes them …

Clare remarked on the brittle 'sun-threads' that pricked, intensely bright, in wheat stubble and when hay was cut. Hopkins saw 'delicate and very true crisping' (a word he used also for wave foam and lark song) along the tops of the crowded ears. This was the only plant

sharp enough for stardom: Spica virginis, the wheat-ear in Virgo, keeping company with heroes and gods.

Like grass, wheat has a song: murmurous, quiet, intent, though under the wind – Jefferies said – it could produce 'a sharp ringing resonance', like a tuning fork. It could talk, too, when Jefferies in one short story sent a small boy to explore it, his nimbus of gold curls not yet overtopping the rustling, rippling ears. The wheat, calling him 'darling', and 'my love' with a Wiltshire burr, whispered of past colours and ancient sunshine, the growing of oaks and the nesting of swallows, and wondered aloud why men could not share the world's wheat fairly. ('Naughty Socialistic Wheat', the poet Edward Thomas called it.) 'Til you have a spirit like us, and feel like us,' the wheat told the child, 'you will never be happy.'

Enchanted, Jefferies's little boy would gladly have lost himself among it. So would Jefferies himself, who longed to absorb beauty inwardly as wheat ears took in the sun. And so would Samuel Palmer; for to him wheat was holy. At nineteen, pale-faced, scruffy-haired and short-sighted, he too observed it from ground level. The year was 1824, and he had just met Blake; his head was filling with wonders. Earlier he had examined the play of light among the grass he lay in, peering through the blades at the sun, 'inimitably green and yet inimitably warm so warm that we can only liken it to yellow'. On the other hand (shifting his position slightly), 'light transmitted through objects is warmest & reflected from them coolest so among these splendid masses some dewy points of grass reflect very cool, white and grey …' Now wheat pushed glossier spikes before his eyes, and these entranced him. He thought a picture would be 'very pretty' with

nothing but a cottage and a clump of elms emerging from that great golden sea. A few years later he found himself in such a place, in the valley of the Darent at Shoreham in Kent, where he and a group who called themselves 'the Ancients' gathered in self-conscious penury, in a farmhouse soon known as 'Rat Abbey', to paint as Blake had done.

In Palmer's steep, sacred Shoreham fields the wheat stood tall, like the thick rippling pelt of a creature sleeping under the woods. In an ink-and-sepia drawing of 1825 a man in Jacobean dress, perhaps Bunyan's Christian, lay in such a field, cheek on hand, reading the Psalms; wheat clustered round him to give grave illumination, as if the stalks were heavy-headed acolytes with candles in their hands. In Palmer's drawings and watercolours wheat waited in stalk or sheaf alongside human activity, each stalk the height of a man, a silent and burnished congregation of souls; in one watercolour a rustic church was walled with fiery wheat, with a wattle door standing open. At dawn wheat was erect, alert, cheering on a smocked and vigorous young man heaving harness on an ox; at dusk the sheaves, like men and women, leaned on one another for weariness. Wheatfields under sunlight or moonlight lay hallowed, with the Host-orb hovering over them; and their reapers or gleaners became angels, but that is another story.

Palmer drew wheat and barley in exquisite detail, in pencil and watercolour on tinted paper. Elaborate notes on how light transformed them were written down alongside. He drew out in the field, his battered sun-hat (big as a parasol) the colour of dried straw, the pockets of his spreading brown drawing-coat stuffed with chalks, palettes, sketchbooks, knives, his 'little Milton' brass-bound at the

corners, torn envelopes, his snuffbox and, at one dangerous stage, bottles of egg yolk to make tempera. Through his round, scratched glasses – the sort, he lamented, that did not attract the *ladies*, disguising as they did 'the darting artillery of my eyes' – he once saw a thin golden halo round an ear of wheat, where the transparent husk stood against the sunset. He noted the reds and ambers in it, struck out of it with prismatic intensity by the sun. And this, too, he tried to paint. Individual ears of wheat, mere diamond-pricks of paint, were often the brightest element in his landscapes.

When Ravilious attended the first proper exhibition of Palmer's Shoreham paintings, in 1926 just before he left the Royal College of Art, he was deeply impressed. Nothing like these visionary watercolours had been seen in England, except for Blake. Immediately afterwards he walked with his two best friends the twenty or so mostly suburban miles to Shoreham, all three dressed up as Ancients (the usual costume being broad hats and trailing coats). Other imitation was more serious. Ravilious came to see light, especially twilight, as Palmer did, wandering out of 'the worst sort of American film' in June 1935 to find, as he told his lover Helen Binyon,

> such a marvellous quiet pink evening and a late cuckoo.
> There were a few stars out and half a moon and trees
> silhouetted in spots very dark and rich like Sam Palmer's.
> I was glad to be missing the film really.

His flint-and-brick Sussex churches acquired Palmer settings, buried deep in fields and trees; and in those fields his wheat, like Palmer's, became numinous and tall. Though Ravilious's sacred talismans were

usually a cup of tea and a packet of Player's cigarettes (the Downs in winter, he mused once, were 'a wonderful tea colour'), he painted the corner of a wheatfield below Wilmington Hill tufted with crimson fire, and engraved wheat stems erupting from a sheaf like fireworks exploding in the sky. He longed to go to Sussex, he told friends, when the corn was at its best – for then the light was.

The wheat in Palmer's paintings glowed against 'umbrageous' trees (his own rather ponderous word), high-heaped and broad-leaved. Under them shadowy flocks lay down in the heat of day or the repose of dusk. The blotchy darkness of the trees, as Ravilious noticed, was often laid on thick. Yet they could also play a different role. Sometimes their canopies held light longer, catching the last of the declining sun when the sun itself had disappeared. In the course of a year I noted down many such Palmer effects: a line of oaks under Ditchling Beacon, for example, glowing gold and green beneath sun-set clouds whipped up like candyfloss, while the nearer fields already lay in shadow; or the last flicker-and-flame of November plane trees in St James's Park against grey-misted Westminster; or the birch at Pulborough just tipped – coiffed – with sparse yellow leaves, a torch above the hedge. Each of these seemed picked out as a light-bearer, like the single birch at Rydal Dorothy Wordsworth called 'our favour-ite': a 'flying sunshiny shower' in the wind's glance, or a 'Spirit of Water' in a tree's shape.

It was natural that Dante's fourteenth-century Paradise should be structured like a tree, its leaves never falling, for these bore messages of light as clearly as the white leaves of books. Indeed, perhaps words could be exchanged that way. Thoreau thought of his journal as 'a leaf

which hangs over my head in the path – I bend the twig and write my prayers on it then letting it go the bough springs up and shows the scrawl to heaven …' When in 1845 he took up his solitary life in the woods by Walden Pond, wishing to 'learn what it had to teach' and to 'live deliberately', passing friends who found him absent would pencil their names, for calling cards, on yellow walnut leaves; though some he could guess at by their peeled willow wands on his table, or the grass they had plucked and thrown away.

Clare, who in his poverty often had nothing to write on, thought silver-birch rind would make a fine substitute for paper. ('It is easily parted in thin lairs & one shred of bark round the tree would split into 10 or a dozen sheets & I have tryd it & find it recieves the ink very readily.') This would make a safer repository for his poems, no doubt, than the scraps of coloured shop-paper he had resorted to as a boy, hiding them in the kitchen wall away from his mother, who otherwise used them as firelighters and kettle-holders. With his poems on birch bark, whole woods could blow with his gleaming words. And he could hide among them.

> I felt it happiness to be
> Unknown, obscure and like a tree
> In woodland peace and privacy

Yet those unknown and unconsidered trees also glowed with industry and beauty. Traherne never forgot his childhood astonishment when he first saw trees ranged against the sky outside Hereford: 'their Sweetnes and unusual Beauty made my Heart to leap, and almost mad with Extasie, they were such strange and Wonderfull Things'.

He wished green, living branches might spring from his own soul, with fruits following at any time of year. Herbert too longed for this. Sighing over his book of devotion, he longed to be a tree, his sinewy arms and fingers embracing the air,

> for sure then I should grow
> To fruit or shade: at least some bird would trust
> Her houshold to me, and I should be just.

Specifically he wished he was an orange tree – 'That busie plant!' – putting forth unwithering leaves and bright, heavy lamps of fruit which, when dried, would scent the many-drawered cupboards and dove-jointed boxes where he stowed his gloves, his neatly folded handkerchiefs and his prayers, whether grateful, joyous or despairing:

> Then should I ever laden be,
> And never want
> Some fruit for him that dressed me.

Trees did not groan to God, did not prostrate themselves and beat their breasts on the cold tiles of Bemerton chancel as he did, when it seemed he was unworthy to be called as a minister. Instead they laid down wood and held out beauty, silently. *My root was spread out by the waters*, ran the Book of Job, *and the dew lay all night upon my branch. My glory was fresh in me, and my bow was renewed in my hand.* Even wood that was sawn and dead, planks, rafters, beams – like Herbert's deadened heart, as he saw it – could open out in light. At Godshill on the Isle of Wight, in the church that towers on its mound above the village, a fourteenth-century wall painting shows Christ on a cross that

has flowered into lilies round him. (Hopkins knew this painting from family holidays in Shanklin, and recalled it when he found another living-tree cross at St Albans.) The crucified figure hangs among green sprays, so weightless that it seems he has merely fainted, and in this bower must wake again. Incarnate light springs out of beams of wood as naturally and silently as the leafing of the April trees; and from the finials of the branches flowers like stars detach and drift away.

At March in Cambridgeshire, as well as in several other churches crouched under the huge East Anglian sky, the double hammer-beams of the nave roof break out in flights of angels. They seem to have burst from the dense oak like starlings from the living tree; or perhaps they have struggled out slowly, like damselflies from their cases, tentative fingers here, a heaving wing tip there, their gleaming fibres drying into golden curls. For a little while they have hung from the beams among carved leaves and flowers, their robed bodies too soft yet, too damp, their wings wet quills that lie dark across their backs. Then, flickering carefully into gilded life, they stretch to fly.

Even the hawthorn can break out in light. This is the archetypal tree of the Downs, the lone straggler, apparently good for nothing. It is so spare that in Ravilious's paintings it makes another abstraction in the landscape, alongside barbed wire. You cannot build with it, or make cupboards, barrels or bats. You cannot eat the fruit (though Clare saw a shepherd on a 'rawky' November morning pluck 'a handful of awes from the half naked hedges' to munch as he went on). You cannot climb it, for it is all scratches and thorns. In country lore the hawthorn is sometimes a magic tree, deflecting lightning; but often

an evil one, its strong-scented blossoms bad luck if they are brought into the house. The hawthorn bows, bends, writhes, knots, and every inch of its struggle stays visible in the tree. But it endures. It ages, and is stripped bare to windward until it is nothing but sharp, grey, knitted bones. Yet on those bones lichen grows, bold splashes of gold leaf, drawing small birds to visit with care among the spines; against the sun, bare winter thorns may be garlanded with raindrops on every twig; and between the boughs the deep sky of late summer is set as sapphire glass.

The most crabbed and lonely of hawthorns still leafs on any twig it can, their deep-notched green the most vivid of early spring. (In medieval art these leaves sometimes crowned the Queen of Heaven.) It still flowers, pink, red and white, the flecked foam of May that Hopkins loved, each one stamen-speckled like the eggs of hedgerow birds. It still fruits, its hard berries engine-red – or, to prolong the suffering metaphor, withering to the colour of half-dried blood. Unlike rosehips and rowan they do not turn you with a start, as if fire broke from the hedge. They are modest and unshowy. In winter, curiously, the topmost twigs may sport a spiky white fungus that looks, from a distance, like improbable blossom; in May, a lovelier play of lacework, tall meadowsweet may grow through each tangled, stunted branch. The tree clings on, though its roots (sometimes exposed by rubbing livestock for two feet below the surface) are anchored only to crumbled chalk, a foothold in light.

Sheep find shelter here, the hollowed-out ground strewn with their dung and wool, and wool hangs white in the branches in confusion with old man's beard. The walker may find shelter too, often the

only chance for miles, for the hawthorn is a companionable tree, a fellow man who trudges before you or stops and salutes you, his hat long since blown into the next county and his arms mere sticks, pointing the way it went. There is seldom good grass under a hawthorn; it is clumpish and thin. But there is shade at least, like an old coat cast off. Downland shepherds like Dudeney used to pile branches of it against banks for shelter in winter, and would throw themselves into it backwards, as into a bed, to avoid the spikes. They called it 'hawth', a good name for a friend.

Jefferies thought these trees were shaped like candles in a draught, and some, indeed, are consecrated. Beside the chalk-and-flint track across Blackcap above Lewes, a lonely thorn has been turned into a memorial to John William Arnold, beloved Dad and Grandad, who died aged eighty-two in 2010; a small wooden plaque commemorates him, and the twigs have been hung with delicate silver bracelets and plastic flowers. Hawthorns, it is said by those who distrust them, may be propitiated with 'something bright'. At Stanmer by a gatepost stands another thorn whose lower trunk, from long salutation, is worn smooth and copper-brown as an old walking cane: Joseph of Arimathea's cane, perhaps, thrust into the ground to flower, clasped by the hand that smoothed perfumed oils on the body taken from the Cross. And it is the ravaged hawthorn of Glastonbury, not the lily or the rose, which in dead of winter puts out a second burst of flowers to greet the coming of light, Christ, the first-appearing.

Hence perhaps my affection for one old thorn on the scarp face of Firle Beacon, on the last bend of the principal track that climbs up from Firle itself, which as it comes into view among the battering

winds lifts a gaunt hand to bless the walker, a salutation from a skeleton woven out of wire. On a closer approach it is not quite naked, but cinctured with fresh leaves; and not quite abandoned, but strewn about with purple orchids or, in April, cowslips in the grass.

The scrawniest trees thus have their visitations of light. On the banks of the Cuckmere south-east of Firle it is small willows, tossing and wrestling silver at the least indication of rain. Clare especially treasured the grey willow, 'shining chilly in the sun as if the morning mist still lingered on its cool green'. No tree is better at picking up water-light from root to tip, every gleam mirrored and multiplied, each leaf a long, hollowed, silver nib to scribble words between water and air. 'Swallow' and 'willow' both express that flickering, zigzag sweep. Yet Hopkins noticed the same movement in chestnut trees, which 'when the wind tossed them ... plunged and crossed one another without losing their inscape'. And his greatest emotion was reserved for poplars or aspens, perhaps the showiest dancers in light, batting and reflecting it until they flashed all-over white, and the storm broke. A group stood at Binsey, near Oxford, on a still largely unspoiled stretch of river meadows now famous for a thatched pub, the Perch, and an unassuming row of cottages. (In my time at Oxford I only once went out to Binsey – it was a place of dream, and remains so still, a faded Victorian photograph incongruously visited by cars.) Walking there in his black soutane, coat and biretta, already mourning dress, in 1879, Hopkins suddenly saw that the aspens had been cut down. And since leaves condensed the light, as he had noticed of the whitebeam, this meant that their light, as well as their shade, had gone.

My aspens dear, whose airy cages quelled,
Quelled or quenched in leaves the leaping sun,
All felled, felled, are all felled;
　Of a fresh and following folded rank
　　Not spared, not one …

This stripping or shedding of leaf-light – whether brutal or natural, by man's hands or by the season – meant, for Hopkins, the tree's loss of itself. The fellers' mere 'ten or twelve/Strokes of havoc', he wrote, had 'unselved' the landscape – but, before the landscape, the trees. He had met this among the elms at Roehampton one October, as he walked out from Manresa House after making his half-yearly renewal of vows, on a day of quickly melting frost: 'in a few minutes a whole tree was flung of [leaves]; they lay masking and papering the ground at the foot. Then the tree seems to be looking down on its cast self, as blue sky on snow after a long fall, its losing, its doing …'

In leaf or not, some trees seem vested with unusual power. Beneath them, Jefferies said, 'the heart feels nearer to that depth of life the far sky means'. There are two old oaks on Hampstead Heath, and one massy copper beech, which must always be saluted when I pass them: the copper beech for the pale stained-glass loveliness of its new leaves, and the oaks for the words, phrases, solutions and resolutions that have sprung from their crabbed branches over the years, thick as acorns. 'Why', Whitman asked,

are there trees I never walk under but large and melodious thoughts descend upon me?
(I think they hang there winter and summer on those trees and always drop fruit as I pass;)

At his Timber Creek retreat near Camden, New Jersey he knew a tulip tree he called 'the Apollo of the woods', dreaming once that it strode out golden as the god when he was not around and sometimes, a divine favour, when he was. Thoreau made regular pilgrimages to some special black birch, hemlock or yellow birch with its sparkling silver grain, his 'shrines' as he called them; and might tramp ten miles, even in deep snow, to 'keep an appointment' with a favourite beech, as if with a human philosopher. It was under a chosen clump of elms, gazing up through their branches at the sun as it rose, hoping that no curious passer-by would notice him, that Jefferies when young began the deep-breath meditations that led in 1883 to *The Story of My Heart*.

Since evergreens remained the same, however, shedding needles but not losing them entirely, perhaps they preserved a greater integrity: a truer self, as Hopkins would have said. Their pyramidal shape pointed skywards, making a spire as grass did, or imitating the reach of flame. They appeared layered with light, powdered and crystallised with it or, in season, snow. (That was the season, too, when Clare welcomed the evergreen garlands draped in Helpston church as 'emblems of Eternity'.) Pines held their seed cones upright, taper-fashion; the blue boughs of spruce, in winter, were bristled and razored with ice. This was an effect that could outlast the thaw. Thoreau, just keeping his footing above Holden Wood in a March gale in 1858, watched 'clear ethereal light' coursing up and down within the pines and their swirling needles delicately frosted, though there was no frost that day. At the sight his spirit too was 'a lit tree', and he wished he might stay that way, preferably 'planted on some eastern hill to glisten in the first rays of the dawn'. With pines he would frequently commune, rough

woodsman with rough, rugged, prickling trees, finding them 'sacred' and 'a revelation'. In his nearest woods he claimed that every light-honed needle was known to him; though not, after forty years, the mysterious essence of the trees that bore them.

The deep hush under conifers is not only the slippered rug of fallen needles but a resinous, amber-dropping presence that both embraces and intimidates. It was so beneath the great old cedar that shadowed the convent lawn at school. We never dared scratch our initials on that bark, as on the smooth grey trunks of the playground beeches; even to touch this tree was somehow to violate it, like opening the cedar-scented cupboard at my great-aunt's house to finger, in silent covetousness, the little porcelain cups and silver-mounted pencils. We never played under the cedar tree, but sometimes processed and prayed. It may not be true, but is hardly strange, that when Martin Luther found a small frost-stiffened fir in the forest he decked it with candle-stars as a symbol of the coming of Christ; and it is not surprising that Rilke portrayed a fir tree waiting and listening beside the snow-pure forest path for that chance of becoming *lichterheilig*, sanctified by lights.

All the worse, then, that after that transforming moment in the life of Christmas trees they are stripped bare and thrown into the street, where they wait to be reduced by the council to dust again.

> *Celebration over, they are cast out,*
> *each one by the wall –*
> *dried pale by central heating, tall*
> *beauty lopped at the root,*

and the hurt bound
with holly-paper tight wrapped round.
Where now the pride
of high-hung orbs and candle-shine,
Thick tinsel-trails of the divine
when first they came inside?
Only a tease of left-on silver threads
and, from the pavement, yet-uplifted heads.

The configuration of trees with stars might go deeper. It was Hopkins who discovered it, as he strove to describe the 'inscape' of living, growing things: the fundamental structure or essence that made each thing what it was, that gave it a *thisness* (Thoreau's word) or a *haecittas* (his own, from Duns Scotus, his favourite philosopher). For Hopkins, since there was God in this, there had to be light too. 'It will flame out, like shining from shook foil,' he wrote – and explained to the ever-querulous Bridges that this meant not only 'broad glares like sheet lightning', but also 'owing to its zigzag dints and creasings and network of small many cornered facets, a sort of fork lightning too'. The patterns in nature – feathering of frost on windows, fretting of leaves, 'damasking' of dead half-bitten grass strewn in a sheepfold – were expressions of light and, at the same time, expressions of the thing – the individuality, the *self* of it. He tried to pin down this idea in pencil drawings, too – exquisitely detailed renderings of how undergrowth tangled or waves broke, his long, solemn face rapt in concentration – but in his own hard opinion he failed.

40

For years he tried to discover the ordering principle in trees, their layering and gradations and the exact form of the clustering of their leaves. (He wrestled manfully with this sensual longing to look at Nature, a longing that must in the end be sinful, though he indulged the vanity of sending some of his drawings away to be photographed, in order to preserve them.) In 1863, aged nineteen and on holiday in Shanklin, he explained to his friend Baillie that he had done many sketches of things that astonished him: 'The present fury is the ash, and perhaps barley and two shapes of growth in leaves and one in tree boughs …' It was then that he also recorded his visit to the flowering and leafing Godshill Cross, and drew in his sketchbook the buds of the white lily. 'He has made us bear his leaf,' he was to write; '…we are so grafted on his wood.'

By the mid-1860s Hopkins had discovered that both the twigs and bursting buds of the ash made 'quains' or crystals, the three-dimensional shapes of stars. (Star-gazing in 1868, he had noted 'Cassiopeia on end with her bright quains pointing to the right'.) With this in mind he investigated oaks, finding that the normal growth of the boughs was radiating, that the 'scanty leaf-stars' were organised 'spoke-wise', and that 'the star knot is the chief thing: it is whorled, worked round, a little, and this is what keeps up the illusion of the tree.' The narrower leaves, especially, gave 'crisped and starry and catharine-wheel forms'. In September 1868 he drew an oak as empty space except for its outermost leaves, a nimbus of writhing stars.

He called this 'the law of the oak leaves'. It was equally the mystery of the elm or 'fretty' hornbeam, the 'starrily tasselled' flowering limes or the moorland rocks he clambered over; quaining, once he

had detected it, was everywhere in Nature. His mind did not impose it, he was sure, but simply picked up something already there: 'and I thought how sadly beauty of inscape was unknown and buried away from simple people [like those poor, drunken slum-dwellers to whom he was to preach of the Holy Ghost] and yet how near at hand it was if they had eyes to see it and it could be called out everywhere again'. It might almost be heard as well as seen, as the wood-grass had seemed to cry out to Thoreau; the starry inscape was also the instress, and the stress the life, the declaration, of the thing. 'As kingfishers catch fire, dragonflies dráw fláme', he began at St Beuno's in 1877,

> As tumbled over rim in roundy wells
> Stones ring ...
> Each mortal thing does one thing and the same:
> Deals out that being indoors each one dwells;
> Selves – goes itself; *myself* it speaks and spells,
> Crying *Whát I dó is me: for that I came.*

'All things', he continued in a notebook, 'are charged with love, are charged with God, and if we know how to touch them give off sparks and take fire ... and tell of him.'

If Hopkins was walking with a companion, talking punningly and philosophically as he often was, he might miss this message, with the ear as well as the eye. He endeavoured not to. Quaining gave structure, in the spring of 1871, to 'broken blots of snow in the dead bents of the hedge-banks' and to the wilting wild daffodils in his hand, '[helping] the eye over another hitherto disordered field of things'. It was also, he thought, the 'forepitch' or 'origin' of big woolpack clouds, of 'flying

pieces' and of tufts of cloud blown before the wind. A mere pond in the wood, too, thickly overhung with leaf-quains, became 'fairyland':

> Rafts and rafts of flake-leaves light, dealt so, painted on
> the air,
> Hang as still as hawk or hawkmoth, as the stars or as the
> angels there,
> Like the thing that never knew the earth, never off roots
> Rose.

And the 'silver slips of young brake' on the hills above St Beuno's, as he wandered there with Mr Strappini, a fellow seminarian, rose against the light 'trim and symmetrical and gloried from within'.

The fruit of such trees and briars might well contain light, too. Whitman, after all, imagined some he knew dropping inspiration. Ravilious, in his wood engravings, often gave his trees variety by freighting some with stars. They seemed worthier of bearing something higher, at any rate, than simple apples or blue sloes. Yet Hopkins had found in a 'lush-kept plush-capped sloe' the sudden rush of bittersweet grace; and apples had the distinction of being, in popular understanding, the fruit of the Tree of the Knowledge of Good and Evil of the Garden of Eden. They could therefore never quite be the ordinary produce of an ordinary tree. Just as Milton's Tree of Life might have come from any orchard, 'Loaden with fruit of fairest colors mixt,/ Ruddie and gold', and with a mossy trunk up which Satan sinuously climbed, so any apple might still offer revelation. Some Eden-light might be left in them.

Traherne, amid the orchard-heavy Herefordshire hills, instinctively thought apples heavenly. God's wonders were 'like dangling Apples or like Golden Fruits', the two equivalent; he classed cider with those other 'diffusive Joys', honey and wine. Palmer (who maintained he could happily live on 'bread and butter and apples' and, at Shoreham, mostly did) mistakenly thought Milton's Paradise landscape was sown with apples everywhere. In consequence, he could not help gilding them with grace.

Standing close beneath the tree, he drew apples as carefully as he had pictured wheat, noting how they shone in the full sun as if they stored and increased it. 'Apples universal bright,' he noted; 'Gen. effect in bright sun the whole tree apples & leaves very golden … boughs next in size to smallest twigs are I think of a crusty texture and a pale dead gold …' The 'last few sun-glows', he wrote, 'give the fruits their sweetness'. When he painted them, however, they seemed to grow heavy with light until they were branch-bending spheres of gold or brass or, in his *Magic Apple Tree* of around 1830, blazing scarlet lamps. (Even the blossom on his apple trees hung in whorls of white and pink paint so thick that blobs of it would break away from the paper.) These were not trees, but firework displays. They recalled the thought that in medieval times it was apples, rather than candles, that were used to make festive trees of lights.

An unkempt wild apple tree shouted to me once on the York-to-Selby footpath one afternoon in November when all else was grey, brown, flooded, dead; high umbelliferous stalks withered to black, and the only sound the shooters bringing down pheasants, or black crows, across the broad wet fields. I passed the tree first against the

44

sun, and never noticed it; on my return, the sun behind me, it lit up with copper-red apples the inaccessible bank on which it grew. With a pipe-playing shepherd and his flock beneath it, and a sweep of thick wheat beyond, that tree would have belonged in Palmer's Paradise.

A single gold apple sang, too, from a tree left behind when the end of our garden was severed by a high wire fence for the North London line – an apple or perhaps a quince, for we could never get near enough to tell, and the boughs were half wrecked round it. No birds tried to eat it, but we speculated that an angel might, if with a blaze of tangling wings one chanced to pass that way. The fruit hung there in case of need.

One variety in particular, the Golden Russet, seemed the very food of poets. (It is rarely seen or sold now, small and hard, its skin the dulled colour of unpolished brass.) This apple grew on Jefferies's childhood farm at Coate in Wiltshire; one of his favourite spots for meditation was a plank seat set thickly in buttercups (his 'flowers of the sun') under the russet tree, through which light dappled and fragmented. From an upper window, closer to, he could discern 'delicate streaks of scarlet' on the fruit, 'like those that lie parallel to the eastern horizon before sunrise'. Another Golden Russet grew beside Clare's childhood cottage at Helpston, and helpfully contributed its crop to pay the rent of forty shillings a year. When the cottage was divided into tenements and the garden parcelled out, his father chose to keep the old tree, for it was his favourite, and 'Tho the ground was good for nothing yet the tree still befriended us & made shift to make up the greater part of our rent …'

45

It was not so far away, in the garden of the family farmhouse at Woolsthorpe in Lincolnshire – a house built of the 'white stone rock' that lay beneath it – that Isaac Newton sat one night under an apple tree and thought about gravity, the earth and the moon. (The tree still stands, and gives fruit; its variety is Flower of Kent.) Like Clare, Newton was accustomed to thinking in the open air. In boyhood, set to mind the cattle, he would hide under a hedge with a book, or inspect in his sober, silent, short-sighted way snail-shells, stones, grasses, the purple pasque flower and the starry bog bean, asphodel and moonwort, and bring these simples home with him. Not long before his death in 1727 he remarked that to his mind he had always been such a boy, playing as it were on the seashore, and 'now and then finding a smoother pebble or a prettier shell than ordinary, whilst the great ocean of truth lay all undiscovered before me'. Palmer often quoted those words, perhaps liking the idea that 'Newton's Particles of light', as Blake called them, might first have been noticed, casually and serendipitously, among the sands of the sea.

The story of the apple seemed to come from various conversations, including one with young William Stukeley as, sitting under other apple trees years later on a summer evening, he and Newton drank tea together. The tale grew in the telling. In Stukeley's version of 1752, as Newton had sat musing, he simply saw an apple fall perpendicularly to the ground, and wondered why it did not go upwards or sideways. 'Assuredly,' he concluded, 'the reason is, that the earth draws it.' In another version, the apple did not fall. It merely hung there, silvered by moonlight on the tree into a sphere of purest metal, about twenty feet away from him. This was how medieval minds had

46

imagined the luminous bodies to be, and almost as close. Newton, observing his apple-sphere, saw that it subtended in the sky the same half-degree of arc as the moon; and that the moon, like the apple, was not flung about wildly as it flew through space. The gravitational pull of the earth, therefore, extended much farther than men thought. In the words of another acquaintance who heard the tale, 'Why not as high as the Moon, said he to himself.'

Man fell with apples, Byron commented in *Don Juan*, and with apples rose.

Eve, though, did not expect to fall. She did not understand the meaning of the word. Satan, erect before her, coiling and scintillating, had told her that if she ate the apple her eyes would be 'perfectly Opend and clear'd', and she would 'be as Gods'. So she bit in, eagerly: afterwards bowing low to the tree, 'as to the Power/That dwelt within'.

The taste may have gone from nectar to ashes in a moment. Random wild apples can be unreliable: misshapen and wasp-creeping things, the rind tough, the flesh chewy and unflavoursome, fuzzing the tongue and coating the teeth – and so the eating of them, straight from the white-dusted path, is seldom sensible. Yet it is also irresistible, because they are on offer, however small; and their burnish seems to rekindle the original temptation of Eve in the golden grove. I remember one, hanging beside the sunken lane that runs down to Ovingdean from Brighton, which still kept in late December the gold patina of September, though shrivelled to the size of a cherry and almost hollowed by two pecks near the stem. Such eaten-away apples,

Jefferies wrote, were sometimes more 'glowingly beautiful' than the rest. And there is a tree I know of, more gilt-lace lichen than tree, above Sheepcote Valley at the edge of East Brighton golf course, where the apples' flesh is the softly graded pink-to-red of an Albertine rose, and their taste is of perfume and dew. In ancient documents such lichen-painted trees are called 'hoar', as if transfigured into frost and light. A few bites of fruit from these might well open what Blake called 'the doors of perception', and the Gates of Paradise.

By these he meant, in the first instance, human eyes. But those doors, or gates, could sometimes be as literal as the apple was. They were so for Blake himself, whose visions at Felpham began one morning when he heard a ploughboy say, as he passed the cottage, 'Father The Gate is Open.' From then on, heaven-light flooded in on every side. It was through the city gates of Hereford that the child Traherne gazed at 'the Valley of Vision' leading to 'the End of the World'; and through plain wickets, opening on to wheatfield or sheepfold, that Palmer traced the white paths that wound towards Elysian hills. In boyhood (an apple for sustenance) he would walk out with his father beyond Greenwich to a certain gate in Dulwich he later called 'the gate into the world of vision'. A 'better country' lay beyond, which at nineteen he intended to show by painting, behind the hills, 'a mystic glimmer like that which lights our dreams'. The seven years at Shoreham took him to his own Valley of Vision – his term, as well as Traherne's, though very little of Traherne was published in his day. In old age his curtailed but favourite walk ended at a gatepost, the gate gone and the prospect free; the very 'Prospect' perhaps, of blue river,

glowing hills, castle and massed white clouds that he was reimagining, painting slowly in his bed, in the months before he died.

Gates can be tricky, though. A stile is an invitation and continuation, quickly climbed or even jumped. ('Always get over a stile,' Jefferies advised.) But a gate holds something back, dictating a pause and the question of whether it should be passed through at all. Ravilious, when painting houses, gardens or landscapes, routinely left the gates and doors ajar to field or path or street, or simply to the air. He sometimes took a paling or two from a fence, for a man with a boy's whims to wriggle through. This also let in light. People might see anything if they stepped – or ran, as his were often running – to the other side. But first, the gate must be open.

He had evidently been trained on the gates of East Sussex and the scores of fastenings devised for them; fastenings so complex that it may be easier, after all, to leave them ajar. There are kissing gates in places, and at Friston, Jevington and East Dean rare five-bar tapsells that swing round at a touch; but those are too easy. So local gates are fortified with wooden latches, spring-loaded metal bolts, iron catches modelled on bicycle bells, stick-and-knob levers, chains, string, wire, baler twine; and weights made from oil cans, rusty pendulums, pierced bricks, salt-lick and large beach stones already worn through by the sea. One baffling gate used to block the path leading out to the west side of Cuckmere Haven, to that shout of light and white cliffs, where two Z-shaped brackets had to be disengaged from a rusty metal plate. It has been improved now, with the brackets made redundant, but still demands thought. A small pond, its water dead, opaque and brown, lies to one side, a high hedge of elder to the other. The ground is

swampy, like Bunyan's Quaggs; the fields low and riverine, with cattle grazing. The gate guards the way south, as does the grey heron standing sentinel at middle distance, beside an overgrown ditch. In an almost identical landscape of ditches and cows, wondering how he might record the look of light on it, Ravilious mused that a heron might solve his problem, 'if it were large enough'.

Bunyan's Christian, similarly baffled as he set out for the Celestial City, asked Evangelist the way to go.

> Then said Evangelist, pointing with his Finger over a very wide Field, Do you see yonder Wicket-Gate? The Man said, No; then said the other, Do you see yonder shining Light? He said, I think I do. Then said Evangelist, Keep that Light in your Eye, and go up directly thereto, so shalt thou see the Gate; at which when thou knockest, it shall be told thee what thou shalt do.

He said, I think I do –

<div align="center">

The Gate *Chyngton Farm/June*

</div>

At the wide field's end stands the wicket gate:
and then? Ah, then, the deliberate pause,
arms on warm wood, and the silent wait
for the direction marked as yours.

Behind, the way trodden to the white bone,
the map followed, and the task complete;
vetch greeted, and speedwell, and the thin dust blown
in bluish glitter from the ramrod wheat –

Ahead, a vast country never seen before,
no matter how often you have passed this way:
flowers unpicked, fields rearranged, mysterious lore
chipped by the chaffinch from the elder spray –

Behind, the known world's bustle and its glare
fade into nothingness. The rusty catch
holds back the breathing of enchanted air –
Step forward, then, and lift the latch –

And immediate at the sound the heron-guard, his wings crooked like a collapsed umbrella, leaps up and flaps away from this realm to that –

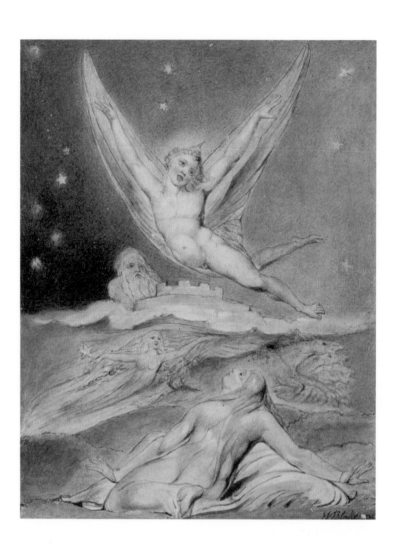

AMONG THE BIRDS

Our heron may not be visible for long. Birds, as they fly, carry brightness with them in the sheen of a breast or the turn of a wing. They reflect the unseen sun at dawn or evening or focus it like cloud, sometimes resolving completely into light. Blink at a squadron of starlings speeding over the sea, and it disappears. On Telscombe Tye – that great apron of downland that sweeps to the sea between the brown-roofed semis of Saltdean and Peacehaven – the grass and sky in summer are alive with larks, but invisibly. It is all song, or at most a glittering agitation of the intervening air. Ravilious loved this effect, and in his wood engravings often reversed his flying birds into silhouettes of light against the hills and in the trees. They were there, and not there, both at once.

Birds were always 'borderers' on the earth, Thoreau wrote. They were creatures of a subtler element, 'which seem to flit between us and the unexplored'. Blake, more excitably, had had this thought before him:

> 'How do you know but ev'ry Bird that cuts the airy way
> Is an immense world of delight, clos'd by your senses five?'

Jefferies, too, observing birds – specifically the gull, the chaffinch and the eave-swallow – surmised that all things had 'a Third Existence' in the beyond. 'They [come] to their object there, the end and purpose of their lives. Not immortality in the same shape; their object.' The note-book thought petered out, as he fell to wondering what sort of birds those would be. They might be transmuted into light, like the yellow-hammer he saw on a branch of ash, so bright in the singing sunshine that its feathers seemed wet with it. Or perhaps they were light already, as he had conjectured before. 'Everything matter ... the prismatic feathers of the starlings ... Blackbird entirely formed of matter – eye, mind, heart, love, song ... Now analyse matter and it resolves to force ... clearly it is like electricity ...'

The word 'prismatic' was perhaps more exact than he knew, for Newton had observed that colours were struck and light reflected from 'the thinness of the transparent Parts of the Feathers; that is, from the slenderness of the very fine Hairs, or *Capillamenta*, which grow out of the sides of the grosser lateral Branches or Fibres of those Feathers.' The same was true of 'the Webs of some Spiders, by being spun very fine'. Both could be analysed almost entirely in terms of light refracting and reflecting. Newton had looked at the sun through a feather; three rainbows grew round every filament, as they did round his prisms.

For Jefferies no bird was closer to light than the skylark. Whenever he heard 'that sweet little loving kiss', spring seemed to appear, and the sun shone. 'The lark and the light are one,' he wrote. The lark's ascent was a universal wonder; Clare would pull his hat over his eyes to watch as it leapt from the stubble, 'winnowing' the air until it became a 'dust-spot' above him, its breast flashing with the first rays as the sun's rim

edged above the hills. This was not without effort: the vibration of the short wings can seem almost frantic, the chest bursting with song. But as the bird gains height and disappears it becomes all music – or all heavenly effect, like the wide wing-swoop of cirrus clouds, crowned with a lark's crest, that was sketched one morning over Cattle Hill in Ovingdean as I made my way down the chalk lane where the wild apples grow. Pope Benedict XVI recalled that at his ordination as a priest a lark rose singing from the altar. He was not sure it was a lark – perhaps a swallow, since larks are not generally seen in churches or in towns. Yet that leap into grace could doubtless be done as well from an altar of marble as the altar of the grass.

And exuberance, or praise, was not all it meant. With its sharp, small, silver spurs, the lark pricked the sun and made him rise. In its etymology, 'lark' means the revealer – almost the betrayer – of the rising sun. (And it is curious that the other dawn singers, no matter how raucous, fall silent at that dayspring, that first scratch of light.) Even later in the day, in seasons of fog, a trill of larksong announces light. One afternoon on the north side of Mount Caburn, outside Lewes, the February scene gave me the sensation of being trapped inside a watercolour: everything blurring, blotting and misting, bare woods smudging into fields, fields into sky, the fog itself a vast soft brush driz-zling and damping. The bank I was tentatively following suddenly blundered up as sheep, mud-matted, fleece-soaked, thumping away and vanishing … and when the lark as suddenly sang it was as if the saturated paper had been turned down at one corner, and fastened with a silver pin.

To the sound of larksong, too, on Wilmington Hill, an extra-ordinary cloud formation like a scallop shell appeared all across the

summer sky, scattering baptismal grace in a few drops of unexpected rain. Rain and sun, glinting together, fell down with the song. In their constant travels between earth and heaven the numberless larks of the Downs seem responsible for muddling the two, so that fragments of sky – scabious, gentians, harebells, blue butterflies giddy above the grass – appear wherever they fly. But Hopkins, typically, recorded far more complex machinations:

> Left hand, off land, I hear the lark ascend,
> His rash-fresh re-winded new-skeinèd score
> In crisps of curl off wild winch whirl, and pour
> And pelt music, till none's to spill nor spend.

What this meant, he explained patiently to Bridges in 1882, was that the song fell to earth 'not vertically but trickingly or wavingly, something as a skein of silk ribbed … or fishing tackle unwinding from a *reel* or *winch* * (*or as pearls are strung on a horsehair)'. This pealing lark-light resembled nothing so much as his April clouds, 'stepping one behind the other, their edges tossed with bright ravelling, as if white napkins were thrown up in the sun but not quite at the same moment so that they were all in a scale down the air falling one after the other to the ground.'

Blake's larks had a more determined career, entirely devoted to carrying light back and forth between earth and heaven. They were young angels to him, no more, no less:

> A Skylark wounded in the wing,
> A Cherubim does cease to sing.

He drew and painted them from life, for they had sprung singing round him on morning walks south through London's fields, before

56

the light of childhood was closed from him 'as by a door and by window-shutters'. His larks were part-boy, part-bird, with a pointed topknot crest and with wings extending from their arms. Throats trembling with 'the effluence Divine', they led the Choir of Day,

> Mounting upon the wings of light into the great Expanse,
> Reecchoing against the lovely blue & shining heavenly Shell …

Their hidden nests, most often made where the wild thyme crept, marked the Crystal Gate of the First Heaven of Los, the spiritual sun. Larks were his messengers. When they soared from the grass in Felpham's Vale it marked a moment of supernatural visitation and inspiration, knocking Blake prostrate on the path to his cottage door, his broad-brimmed black hat rolling away. He rose up, though, in power.

Palmer was more sceptical. Though in almost all things he revered Blake, he could never quite grasp those spirit-larks. ('I say … none of that!' he thought the bird might have replied, with his own Victorian properness.) Yet he painted and etched with love the rising of the lark at dawn, keeping in mind one of his treasured images from Milton's 'L'Allegro':

> To hear the Lark begin his flight,
> And singing startle the dull night,
> From his watch-towre in the skies,
> Till the dappled dawn doth rise.

In Palmer's etching, a shepherd at his cottage gate stood watching the bird; his dog, too, watched. The trees were heavy with night, the clouds just beginning to part with the coming day. That dappling effect, which both Palmer and Hopkins read as heavenly messaging,

spread across the sky. The lark's song of light outlined the crowded sheepfold and the crisped, bowed heads of a field of wheat which, as always, Palmer could not forget. Larks traditionally sprang from wheat, especially Hopkins's young wheat of emerald and chrysoprase, and fell again, straight as a stone, to the deep concealing meadow. They were silent as they fell, Dante wrote, because they were satiated with sweetness. Palmer's son Alfred observed that at his father's burial in 1881 a lark sang joyously above them the whole time, 'till, as the last words of the service died away, it dropped silently into the long grass.'

Blake also saw larks sold in the London streets: not as sophisticated mouthfuls like wheatears, but to be hung up in cages indoors or outside city windows. They were caught in nets on the open Downs and transferred to wooden boxes, where most failed to sing. For Blake the caging of birds was unremitting cruelty, the coffering of light itself. Others found beauty and enjoyment in it, as though greenwood-and-meadow freshness came indoors with them. Ravilious, who kept a log of his bird sightings in the wild, painted the parlour of his house in Great Bardfield in Essex as a wicker cage alive with birds, vying with the swallows that built above the door. He bought a toy bird in a cage for his baby son John, but liked it so much he decided to keep it for himself. His alphabet 'B' for the Wedgwood china company was a bird in a cage; and in silhouette again, but this time dark. Almost certainly it would reverse into light, when it flew.

For poets the imprisoned bird was their own imagination curbed. Samuel Taylor Coleridge, working as a journalist in London in 1808, heard from his bedroom at the *Courier* office (looking out on the dirty brick walls of the Lyceum) the continual song of a sweet bird 'encaged

somewhere out of Sight' and found in it hope, love and growing fields. In fact, he told his little son Hartley, all birds sang of love, the lark especially: and love and light often seemed, to him, intrinsically connected. His own songs, though, struggled to emerge. His marriage was unhappy, his amours hopeless, his literary and philosophical productions too prolix for their own good. Too often he was 'bird-limed' or 'a Starling self-incaged, & always in the Moult, & my whole note is, Tomorrow & tomorrow & tomorrow'. Tomorrow, he meant, he would accomplish something. Or, as a different agent of light, he might sweep over southern oceans; but there he flew in danger of his Ancient Mariner's crossbow on flagging albatross wings.

> 'In mist or cloud, on mast or shroud,
> It perched for vespers nine;
> Whiles all the night, through fog-smoke white,
> Glimmered the white Moon-shine.'

The great bird, which Coleridge had never seen, seemed obscured (like him, unkind contemporaries said) by the metaphysical fog around it. In certain weather smaller seabirds, too, became confused with air or ocean, as if they were merely part of the play of atmospheric light. This Coleridge did observe, in a brisk gale, when seagulls rose up from 'the ever perishing white wave head' as if 'the foam-spots had taken Life and Wing'. On Iona, St Columba (whom Coleridge eagerly declared 'shall be my Saint') was said to have meditated on small birds which, as they flew, vanished into the storm, and as they dived disappeared into the tumbling waves. With these flew the storm petrel, famed for tireless flight even in the worst weather, its snow-white

rump flashing through the turbulent air, seeming never to take food either from the sea, or from the air above it. Such birds of passage fascinated Coleridge; he even dreamed he might be one, flying beside Sara Hutchinson whom he loved but who did not love him, 'reciprocally resting on each other in order to support the long flight, the awful Journey' and never, perhaps, finding land again.

Onshore, swifts play this role. They live in the air, launching into it from their brief nesting places, feeding there, coupling there, holding screaming 'parties' and, presumably, drowsing and sleeping there. Light is their element; they perform in it and, in flight, can seem to generate, gather and disperse it. In May 1873 Hopkins watched them 'round and scurl' under the clouds, flinging bright streamers away 'row by row behind them like spokes of a lighthung wheel'.

In the last spring of the nineteenth century W.H. Hudson, walking near Midhurst in Sussex, met 'a singular looking boy', very thin, with a sharp face and earth-coloured clothes. The boy said he was looking for primroses; but he preferred to relate how, 'morning after morning' just after sunrise, swifts would plummet out of the sky to one chosen spot, near a field from which he had to scare the crows away. Yards from the hard ground, they saved themselves. Evidently they had roosted higher than any tree, and higher than eyes could follow them. Hudson claimed that if they tumbled to earth they could usually rise again, but Clare doubted it. The church clerk brought him a fallen swift once, all stubby feathered legs 'like a bantum' and curved, narrow, pointed wings, its eyes protected by tufts from the 'sharp' wind; inspecting it, he thought it unsuited to anything but continual life in the air.

Hawks, too, soared to the zenith and back again, plunging like a shooting star: as Milton said Mulciber and Uriel fell, angels out of heaven. To Thoreau, the nighthawks at Walden came 'with a swoop and a sound as if the heavens were rent'. At their highest they were invisible unless the sun flashed from breast and wings, as from Hopkins's windhover in Wales, 'daylight's dauphin, dapple-dawn-drawn Falcon':

> AND the fire that breaks from thee then, a billion
> Times told lovelier, more dangerous, O my chevalier!
> No wonder of it: shéer plód makes plough down sillion
> Shine, and blue-bleak embers, ah my dear,
> Fall, gall themselves, and gash gold-vermilion.

On both its rise and its dive to earth the bird selved in light, like his aspens and chestnuts in the wind; like the coming of Christ. Indeed hawks bring down with them a whole litter of light, heaven crashing into the hedge in a swirl of pigeon's feathers, as young Dudeney saw them smash down among his trapped, terrified wheatears. Yet the killer itself is often unseen then or later, when it leaves a random graveyard of tiny bones and small, beaked skulls.

Peregrine *Southease*

> *Sky-scything hawk that crashes to the earth*
> *Blades in the warm breast, the sharp-clawed hedge*
> *Shaking with fright and death – this must be yours,*
> *Yours too, the ossuary of torn-off wings*
> *And thin-beaked skulls – oh, and one perfect shell*
> *Picked, quiet and clean.*

Clare tamed a pair of hawks, 'of what species I cannot tell'. He loved the way each bird hung motionless above him, 'as if it was as light as a shadow & could find like the clouds a resting place upon the blue air'. The larger bird would come to his whistle and once, when he was out in the fields, settled on his shoulder, startling him with its wild familiarity. It would not, however, let itself be caught; it followed him where it would, when it would, until he 'took no more heed of losing them' and became free, as they were. For Jefferies, the 'unchecked' life of every wild hawk already belonged to him, expanding his own life. A hawk would pass him, as he dreamed, 'like thought'. For Coleridge even a hawk's dropping was beautiful as it fell against the sun: 'a falling star, gem, the fixation, & chrystal, of substantial Light … how altogether lovely this to the Eye, and to the mind too …'

Olivier Messiaen, composing in the mid-twentieth century, thought all birds represented light 'and our desire for light'. They were *éclairs sur l'au-delà*, flashes of the beyond. Some did better than others in this role. The corncrake in the meadow grass was faint as could be, 'slow, distant, lunar sounds, as if it's from another planet and the bird has long gone'. But all birdsong was divine, since this was the music inherent in the act of creation: music that reflected the patternings of light. Messiaen did his considerable best to notate it, wandering in the woods in raincoat and beret with his manuscript book, sleeping in haystacks so he would not miss the greeting chorus of the dawn. In particular he listened for the song of the wood thrush, 'the loveliest singer in France', with its incantation that was 'full of sunlight, almost sacramental'. Hopkins, though less quick to use that word so freely, also loved the thrush's loud strikes and 'lightnings' of melody,

like 'rinsing drops' on pear-tree leaves, tools on metal, or a snail-shell knocked on a stone. As for Thoreau, striding over the hills on a late summer afternoon, this song was a 'medicative draught' to his soul, '[which] changes all hours to an eternal morning'.

Sometimes that song was almost human, as when Whitman in 1865 heard the grey-brown hermit thrush piping in the swamps, 'Limitless out of the dusk, out of the cedars and pines', and knew it mourned for Lincoln's death as he did:

> Sing on dearest brother – warble your reedy song;
> Loud human song, with voice of uttermost woe.
>
> O liquid and free and tender!
> O wild and loose to my soul –

Conversely, too, men and women might emulate the bird. Hudson, out on the Sussex Downs again in midsummer after rain, heard alternating snatches of thrush song and human song, the human performer a boy in the gorse among his cows. The voices of both, bell-like and pure, ringing out at intervals and seeming to answer each other, were 'indescribably beautiful'. But the singers were invisible, thrush and boy both hiding: the boy's grey cap glimpsed sometimes, but his habit otherwise 'like a shy little lizard, or a furze wren'. Clare, too, a grown man who never lost his love of concealment, would creep into bushy coverts where no one could see him, to sing a little with the robins: their 'melancholy sweetness ...very touching to my feelings' and, perhaps, what he himself felt.

Bird and man could thus share a language, though it might not be understood on either side. Thoreau, who played his flute at

Walden like a solitary bird, searched for years in the New England wilderness for one he had never identified, a singer by day and night, which he called 'the night warbler'. When half-seen it was always diving, into bush or tree, and vanishing; on his evening walks near Fair Haven lake, its song broke out sometimes 'as in his dreams'. It haunted him alongside other animals he had lost 'long ago', 'a hound, a bay horse, and a turtle dove', whose footfalls and wingbeats were occasionally reported to him. His friend Ralph Waldo Emerson – incidentally a friend of Whitman's, too – warned him that if he found and 'booked' the bird, 'life should have nothing more to show him'. Thoreau responded, not quite heeding the warning: 'You seek it like a dream, and as soon as you find it you become its prey.'

Another hidden, unknown bird whistled for Edward Thomas, 'three lovely notes', very soft, weaving within the summer wood some sentence meant only, it seemed, for him. It sang all that May and June of 1915 when he turned from writing prose and hackwork to poetry. No one saw the bird, and no one else heard it; he wondered, as Thoreau had, whether he and it were in a dream together. The song was 'bodiless sweet' and, inevitably for Thomas, sad; though he felt comforted by it. Perhaps it sang of the path he was to take, climbing at first over steep white chalk, whistling like that bird, towards the battlefields of France on which he would die two years later. For death would mean relief to him; and he would dance then, he wrote, like an aspen tree, no heaviness remaining.

One evening in summer an unseen blackbird sang the sinking of light, somewhere near the golden-apple tree at the back of my London garden. Folding the sheets from the line, I half listened; this was a

bird I took for granted. But now the intensity of the song, carrying through the hush and the last pale glow in the silhouetted trees, made me wonder, as I went indoors. And at dawn the next day the melody came again, insistent. This was a song that demanded to be translated, even if it was saying only: 'This is how it is.'

> *Some messages we cannot hear,*
> *others we misunderstand;*
> *so when the blackbird sang, clear,*
> *rippling, open-throated, over land*
> *hummocked and hushed to night, there seemed*
> *no requisition in it, no command.*
> *I closed the door. But then, long hours away,*
> *he sang once more, abandoning the tree*
> *for city ledge and wall, at milk-chink day*
> *rousing me, urgent. So his song must be*
> *what poets hear, knowing their summons, then*
> *bending to write. He has not sung again.*

Only one bird-summons has been persistent in my case. That has been silent, and from swans. The first came some time in the late 1970s, a date I can fix only from the red bohemian dress and brown beads I was wearing: the wrong clothes, as usual. I had been invited to lunch, as a raw young journalist, with members of *The Economist* board in the top-floor dining room at St James's Street. Conversation was sticky, and I had trouble eating my peas politely. At one point, almost frozen by social ineptitude, I glanced up; and three white swans flew past the window.

All three were there at once, almost beside each other, their wings rising and falling in alternate beats. All were silent, and seemed to draw silence after them. They were just outside the glass, flying very close, as if through a canyon of tall office buildings, although they had plenty of space and air. And in an instant they were gone.

Presuming no one else had noticed, I said nothing, and hid the sighting away for years. The swans have persisted, though. They have appeared in dreams, their feathers painted in impasto so thick that it seethes with mystical, all-smothering light: Apollo's light, perhaps, since these are his birds. I have seen them on the Thames, on the Hampstead ponds, on a reed-filled backwater of the Ouse in York, and very often on the shallow, muddy Cuckmere as it winds through waterlogged meadows under the Downs near Alfriston, by the wooden bridge. There are always three of them. If two are there, the third will soon appear, rounding the river bend or preening on a bank, its blackish beak thrust into a cumulus of feathers. One bird I can ignore; like the tiny plastic swan of my childhood, carefully glued to a pocket mirror, it seems to live only an introverted, decorative life. The exception was the single swan in Cornwall, on a creek near Fowey on a May morning of torrential rain, when steeply down through the stitchwort-starred and dripping woods I glimpsed a nook of river on which the white bird floated. Green water backed it like a cameo. That swan said: *Remember!* But three seem to repeat the words at the entrance to Apollo's temple, *Know thyself.*

Perhaps the simplest message comes from the white dove that flutters through Christian art, appearing from heaven directly. It is linked to one word – as in the beginning was one Word – that might be given as *Ecce,* 'Look.' The word of light. Thus a dove pecked at the

Virgin's casement, pushing gently to come in among her cushions and prayer books, with its pink determined eye; so another hovered at the Jordan river, a single bright cloud above the wet and naked Christ. This is she; this is he; God pronounces, and *it is*.

Anyone who has dealings with doves – their plump prissiness, their gluttonous hustling after crusts, the restless thunder of their feet on the roof tiles at dawn – knows that they make unlikely agents of celestial light. Italian Renaissance doves are as solid as pieces of domestic chinaware; and those that hover over the heads of saints, fatly foreshortened and stuck fast with their own rays, seem even heavier than those that have escaped divinity for the warm, seed-strewn ground. Yet it is that very stillness that recommends them. Doves are tame creatures. They nestle in the hand, press against the cheek, as Picasso painted one held almost too hard by a child in a pale sashed dress. They subside, and curl their heads under; they consent sometimes to be captured, where earth-light never will. Hopkins's incarnate light was the wildly beautiful buckling windhover; but his Peace was the wild wood-dove, 'shy wings shut', which 'comes to brood and sit'.

The souls of the outer regions of Paradise – almost wholly light, as Dante reported, having been swept up by light to join them – had not yet found that dovelike calm. Their habits were those of starlings. They moved in flocks in the wide, brilliant skies of the sixth heaven, rising and whirling in the air to form circles, hexagons and the letters 'D', 'I' and 'L', until they had spelled out the words *Diligite Iustitiam*, 'Love Justice'. On the final 'M' they wove a white lily, for Maria. Then, 'like sparks from a log', *innumerabili faville*, in glittering trails against the golden air, they flew back up in their thousands.

67

In November 1799 a similar 'vast flight' of starlings astonished Coleridge, as he rattled south to London in the overnight coach. His mood was sleepless and hectic, not only because he had just met Sara Hutchinson, but because his collaboration with Wordsworth on their revolutionary book of poems, *Lyrical Ballads,* had become an exercise in frustration. His 'Rime of the Ancient Mariner' was now his only substantial contribution. But for a moment, just after sunrise, he was distracted by the shapes the birds were making:

> like smoke, mist, or any thing misty without volition – now
> a circular area inclined in an Arc – now a globe – now from
> complete orb into an ellipse & oblong – now a balloon
> with the car suspended, now a concaved semicircle & still
> it expands & condenses, some moments glimmering &
> shivering, dim & shadowy, now thickening, deepening,
> blackening! –

Inevitably, the starlings had come to symbolise himself. They did not form words but seemed, all the same, to be his thoughts flocking and swarming, some catching light but most failing to, and the whole spectacle a portrait of his own troubled soul.

The starlings in their winter murmurations over Brighton Pier form exactly the shapes he saw, as well as double helices that build and flow into each other with endless invention and grace. Small posses of latecomers, desperately speeding against the sunset, are effortlessly swallowed into the ever-evolving cloud. From time to time, as the angle changes, whole curves and ellipses disappear. Tourists and locals alike, rapt in that heady evening smell of ozone and chip-frying,

pause to watch and photograph the whirling, silent display. It may be mass exhibitionism, and nothing else; but the birds discuss it afterwards, roosting and shuffling under the seaweedy girders of the pier, as though their performance held meaning not only for themselves but also for the lumbering, unwitting world of men.

Indecipherable messages might lurk even on the eggs of birds, with their dashes of light and shade. Jefferies thought those markings, especially the 'brown, black, greenish, reddish' blotches on finches' eggs, contained a whole library of knowledge without an alphabet, as wonderful and puzzling as 'the strange inscriptions of Assyria'. Ravilious, another avid nester, more than once drew untidy boys, dangerously high in trees, reaching in for the mysterious treasure, and would break off his open-air sketching in sand pits to plunge his hand into sand martins' holes in the cliffs. In his Wedgwood alphabet 'N' was a nest, with shining eggs in it. Hopkins, evidently seeking and finding along the hedgerows, called thrushes' eggs 'little low heavens'. They were sparely marked with black dots, but did not need those to be eloquent. The light-filled song of the thrush had formed within eggs as blue and fragile as the April sky.

Clare, the most expert birder among poets, was equally interested in the secret construction of nests: how the golden-crested wren glued its eggs to the base with resin; how the blackbird lined its nest with hair, but the mistle thrush used wool; how the song thrush made a lining of smoothed dried dung, and the nightingale (most retiring of birds, whose nest he had never procured) wove an outer shell of old oak leaves. The nest once admired, though, and the bird away, he slipped in his hand to count, and feel, and take one of, the smooth still-warm eggs, sometimes – in the case of the titmouse and the wren – little

larger than pearls. He loved to watch, motionless, the bird sitting, hiding as he was; and then as quietly, as if investigating his own pounding heart, to take stock and steal.

A similar communion was reported by the priest-poet R.S. Thomas, who did not expect it. One October day, walking or cycling about his country parish as his habit was, he blundered into a spinney full of splintered sunlight and goldcrests, at Lleyn on the western coast of Wales. He found himself 'netted … in their shadows' while the birds themselves behaved as though he were another sunlit tree, nothing more. He tried to fathom why the moment was so important to him, and how it seemed that 'When it was happening, I was not'. The words that came to him at last were those of Coleridge, from his *Biographia Literaria* of 1817: what was occurring within him and around him, as he stood there invisible, was 'a repetition in the finite mind of the eternal act of creation in the infinite I AM'. He and the birds were both involved in building the world from light.

Coleridge himself, on a January evening in 1804, had stumbled across a flock of brown linnets in a thicket, flying in a roughly circular formation: the 'twinkling of wings' and their 'sweet straight onward motion' across the diameter of their own circle, 'all at once in one beautiful Whole, like a Machine'. He did not know what they made, or why; again, they did not seem to notice him. But by his very presence he was implicated in the forms they were creating.

Both these encounters were apparently silent. Like the falling hawk and the flocking starlings, birds did not need to vocalise in order to express light. But they could do that, too. The song of birds, Messiaen wrote, seemed 'an absolutely impenetrable chaos, a prodigious

entanglement' of free rhythms, strange pitches, added semiquavers and untempered intervals smaller than a semitone. Yet out of it came rhythmic symmetry and 'non-reversible rhythms', of the kind he also saw, traced by light, in the wings of butterflies and the veins of leaves. Out of it came forms. Again he noticed this most clearly in the song of the wood thrush: 'stanzas repeated two or three times, incisively and with authority'.

At Dartington in Devon, in the early 1940s, the painter Cecil Collins saw one April afternoon a thrush singing. A shower had fallen, and the sun shone through the raindrops on the leaves to turn them into diamonds. Collins had already painted a thrush singing dreams for a young man asleep on a hillside. Now it seemed to him that this bird's song made the intricate, swirling shape of the jewel-bright bush on which it sat. By evoking light, it could also construct the waking world.

Tradition and folklore already connected the songs and sights of spring. Clare noted that the catkins appeared on the hazel when the mistle thrush began to sing, and that the sallow-catkins turned from white to yellow when the blackcap started. The trees were defined both by those songs and by slanting, flickering light, as if birds flew there. Some city blackbird, perhaps, sang the silver birch I saw once from the bus in Camden, scribbled over with long cat-kins like sunlit shafts of rain; and, even earlier in the year, the same tree decked in dreams of catkins, its thread-like smallest twigs blown to brilliance by the wind. On the Downs the first larksong sprinkling the sky, and the earliest violets in the rough, pale winter grass, make their entrance together. Thoreau on a March morning in 1858 thought the spring deep-blue of the valley of the Concord

river, and the new look of the mountains suddenly clear of snow, had come at the very same moment as the chorusing, returning birds. Whole landscapes may be embroidered, or woven, or incised, by birdsong and the beat of wings.

Ravilious sometimes did his wood engravings with his parents' canary, Charlie, freed from his cage to perch on his left hand or his shoulder. He would sit 'very quietly … as long as he is allowed, but [he] makes rather a mess of my coat, so I can't encourage him too much. His whistle in my ear is so startling if he begins to sing.' With Charlie or without him, he whistled like a bird himself ('better than a nightingale,' his friends said): Tudor ballads or 'vocal gems from *Show Boat*' or airs from *The Beggar's Opera*, his long delicate forefinger held along the graver as it cut into the boxwood block. He seemed to whistle in thirds, rapidly and trillingly, on the inbreath rather than the outbreath, his line of incised light following the song. At moments, man and bird worked together. The same synchronism struck the hermit-author of a ninth-century Irish poem, who found that when he sat with his white ruled book beneath the leafing trees where blackbird and cuckoo were singing, his words flowed as never before.

On evidence like this, birds did not merely hint and prophesy. They might steer the human mind directly towards light. This could be true of birds as small as goldcrests or as silent as swans. It seemed particularly true, though – as R.S. Thomas wrote, remembering that moment in the spinney – of migrating birds, drawing lines of travel and as restless on the earth as he was.

'A repetition in time of the eternal
I AM.' Say it. Don't be shy.
Escape from your mortal cage
in thought. Your migrations will never
be over. Between two truths
there is only the mind to fly with.
Navigate by such stars as are not
leaves falling from life's
deciduous tree, but spray from the fountain
of the imagination, endlessly
replenishing itself out of its own waters.

Swallows, those mysterious navigators, warbled and cried rather than sang. They gave their message mainly by darting to and fro, pointing the way with their sharp wings to hidden, holy places. They swooped past Catherine Blake's window in Lambeth, 'the angels of our journey', directing her and Mr Blake to Felpham, and visions. Ravilious was delighted when, one Christmas, his wife Tirzah devised a Nativity scene featuring flights of swallow-tailed angels.

It was easy to miss their going, as Clare did in October 1824, being dull and unhappy, so that 'when they went I know not' – and where they went 'is a mystery ... & remains a mystery'. For him, as for Gilbert White, it seemed vital to know it; and he longed to uncover it, whether from chalk cliffs falling or some other strange occurrence. He was well aware, though, that the birds played tricks with him, one moment gathering as if to go, the next dipping and dispersing, flaunting their white and blue livery, as usual. On a village green at evening – as at Alfriston once, near the church – it is hard to tell what may be

swallows, and what some effect of the fading summer light. Jefferies observed them in the height of the sky become colourless, like the air.

In Crete once a swallow flew pell-mell from a whitewashed village church, inviting me to enter with sweeping, silent urgency. It was nesting not in the eaves, as I supposed, but on top of an old brass incense-burner that hung above the font. Globules and stalactites of dried clay dripped down towards the basin, so thickly layered with dust and bird-lime that it must have been many years since any child was baptised there. Grace came not from the water, slowly trickled from a brass jug, nor from the prayers of the bearded, black-robed priest, nor from the dim, gilded icons sooty with candle smoke, but from the light and dash of the swallows, inside and out of doors.

Many common birds were associated, in poets' minds, with the heavenly lights. It was not necessary to spot, as Traherne did, the 'strange' Bird of Paradise itself, which timidly shed or hid its gorgeous feathers when flying among men. The blue-green sheen on the magpie, and the shimmering dots on starlings, showed where they belonged. Even crows, those hunched marauders, show it. In Gloucestershire once I came across a field dedicated to the death of crows, with their corpses splayed in the sharp, sun-threaded stubble and gibbeted on the wire fence. Farmers no longer employ thin, strange boys to bang on tin trays to scare the birds away; they bring in friends to shoot them. This farmer had left the carnage as a warning to others of their kind. I sympathised with him until I saw that individual crows' feathers shone with iridescence on the black, and were beautiful. Had I picked one up to use as a quill it might well have written, not dark thoughts, but words

as heaven-haunted as the feather of a swan. I have read somewhere that they make fine pens, for those whose hand is neat and small.

Henry Vaughan, a close contemporary and admirer of Herbert's, interpreted all birds' markings and specklings – specifically those of starlings – as proof of their 'native stars', distancing them from the muddy, beer-stained, clamorous earth:

> I would I were some *Bird* or Star,
> Flutt'ring in woods, or lifted far
> Above this *inne*
> And Rode of sin!
> Then either Star, or *Bird*, should be
> Shining, or singing still to thee.

'A star in the sky or a bird on the wing' were the precious things the Child Jesus might cry for in the old Appalachian carol; and 'he surely coulda had it/ For he was the king.' In the medieval stories of his infancy he made sparrows out of clay, as his father had made man, and blessed them: flexing their thick, stubby wings, shedding mud and heaviness as they went, they flew away, as far in the firmament as they were flung to.

The connection of swifts with stars seemed especially close. Jefferies's acolyte Henry Williamson, lying in the Devon dimmit-light on a grassy garden wall, thought their gradually vanishing cries belonged 'to the spectral light of the stars and the mystery of infinite space'. He imagined them wheeling, like the constellations, 'where Aldebaran and Vega shine without quiver in the unearthly air'. (He had also traced swallows vanishing at night, 'speeding down the silver stain of the Milky Way towards the big lantern star Formalhaut'.)

With sunrise the swifts reappeared, falling like arrows – as Hudson's young crow-scarer had noticed – from some high, unknown place.

Modern experiments with indigo buntings have shown that at least some migrating birds make use of the stars to steer themselves: instinctively using Polaris, for example, to navigate from the northern hemisphere away to the south, and refining their direction by using the rotational map of the night sky. The light of the stars, therefore, prompts and governs their sudden disappearance in one season; and, in another season, their equally sudden appearance somewhere else.

One February, back in Ravilious country, I scribbled down some notes on links between birds and stars, standing by the stirrup gate that leads into a hidden wood and valley on the dip-slope of Ditchling Beacon. The day was just mild enough for such a pause, if I did not take my gloves off.

Birds mark out the landscape for shore-dwellers, as for sailors the vast undifferentiated canvas of the sea is defined and explained by stars –

Here, at the gate between dip-slope and hanging wood (the gate's decided clang accentuating the quiet), birdsong gradually scoops out a small dry valley, sketching in the reddish tips of the February trees; and the slow blink of a crow's flight northward illuminates the scale and gives the bearing, as would a star –

The great tit's song, that high repeated sawing, is so sharp as to seem visible; it hones the grass blades and outlines the gold-grey lichen on the old thorns, as would a star –

The peregrine, her yellow eye and talons raying out danger, patrols and knows the field below her; seagulls, with their long quartering sweeps, chart the

emptiness of the sea, and their cries curve elliptically across it towards unknown promontories, marking the landfall, as would a star –

It is cockerels, above all, that sing the landscape gradually mapped by light: the edge of the wood, the shape of the hill, the white house crowning it. This must be why they preside on weather vanes to point north, south, east and west. They sing substance into the scene, carving through the mist of barely contrasted forms. Before even this, their first cry cracks the dark, finely, as an old glaze will craze on a teacup, or as new light first flickered through unbroken night and undifferentiated space. Coleridge, typically insomniac, recorded it in Keswick near the River Greta on November 2nd 1803, 'Wednesday Morning, 20 minutes past 2 o'clock':

> The Voice of the Greta, and the Cock-crowing … the Cock crowing is nowhere particular, it is at any place I imagine & do not distinctly see …

There may be only one bird, distantly coming awake 'past the edge of the world', as Edward Thomas wrote. Or perhaps there are two, one confirming the other, as he splendidly imagined them:

> Out of the wood of thoughts that grows by night
> To be cut down by the sharp axe of light –
> Out of the night, two cocks together crow,
> Cleaving the darkness with a silver blow:
> And bright before my eyes twin trumpeters stand,
> Heralds of splendour, one at either hand,
> Each facing each, as in a coat of arms:
> The milkers lace their boots up at the farms.

Between four and five in the morning on his long voyage to Malta, in a dead calm, Coleridge heard two cocks answering each other from his own ship and one that lay nearby on the flat, rippling sea. He thought it might be how Calm itself sounded: the call and its reply, with the quivering delay between.

The first crow is tentative, teetering out of the dark, like a pencil that dare not make its mark. But then each one comes stronger, more defined and settled, as hills, trees and gables creep into focus after them. Each cry rings out more confidently, brisker, painting with louder strokes. Thoreau said that cockcrow, like sunshine, filled him with 'illimitable holiness'. Ravilious, engraving a prospectus for the Golden Cockerel Press in 1933, surrounded his lean shouting bird with rays of clover leaves, flower buds and printed pages springing from the dark, as though it had created them all.

The thought of cockcrow still summons up for me the eastern attic window of my great-aunt's house, by the dressing table with its three tall mirrors folded in to sleep. It comes with a taste, of astringent early-morning tea, and a smell, the mustiness of an old sideboard creaking open on a bowl of dark brown sugar. (No one ate the sugar; it seemed there only to fascinate me, as it slid damply from the silver spoon.) The smoke of a first cigarette would drift upstairs, with my great-aunt's voice, hoarse as cockcrow, upbraiding the dogs. So day began. From the western attic window – as small as the eastern, its thin gingham curtain still drawn – came a contrary sound, the cooing of wood pigeons deep in the dark pines, muffled as the drop of cones on the thickly needled lawn. The east had been sharpened and scoured by cockcrow, but in the west there was muddle in

the messy branches and a confusion of soft sounds, no message yet made out.

For the cock is the great declarer: the bird that continually cries *Christus natus est!* on Christmas morning, shouting out light, while other birds and animals mutter *Ubi? Cur? Quando?*, 'Where?', 'Why?', 'When?' (In Dante's universe these questions, especially *Ubi?* and *Quando?* reverberated through heaven, philosophers' confusions, to be answered curtly and definitively by the sheer blaze of *luce etterna*, the *Ecce!* of God.) There must be, wrote Vaughan, some 'seed' or 'glance' or 'magnetisme' that turned the cock so steadfastly to light: that made it, too, like a star, 'tinn'd and lighted at the sunne'. He thought it must dream all night of Paradise.

Such orientation, or light-seeking, was instinctive in Nature. Flowers and herald-cock turned to the dawn; salmon and swallow followed the magnetic pull of seas known or skies flown; the frost on the cedar, as Hopkins observed it in November 1869, left each needle 'edged with a blade of ice made of fine horizontal bars of spars all pointing one way, N. and S.' Nothing seemed to draw men to focus on one direction rather than another, accounting perhaps for their inveterate restlessness. Coleridge remarked that he never knew which quarter he, or the wind, was in – and, for him, none was home. When, as a child of four or five, Albert Einstein was shown a compass by his father, he was shocked that the needle behaved in such a determined way. 'It did not fit at all into the nature of events,' he wrote later. 'It made a deep and lasting impression on me. Something deeply hidden had to be behind things.'

Even Clare, with his bird-like sensibilities, did not infallibly know where his bearings should be. On his long journey north and homewards from the Essex madhouse he was careful to sleep with his head

in that direction, to steer him in the morning. Nevertheless at one crossroads he missed his way, began to sense that he had, and limped at last to a tollgate where he asked the man whether he was going northward; '& the man said "when you get through the gate you are",' so he thanked him and went through on the other side, humming and singing.

In order to avoid such uncertainties, Thoreau kept his surveyor's compass ready, delicately sighted with a horse-hair; and his friend Emerson, too, never failed to carry his pocket compass with him. He told a fellow passenger, as he returned by steamship from Liverpool to New York in 1873, that he liked to 'hold the god in my hands'. While in England, he had learned that the first compass had been given to Hercules directly by the sun god, in the form of a golden cup in which a magnet floated. His own small brass instrument was divine for a different reason. In an early poem called 'Self-Reliance' he had equated the little needle that 'always knows the North' with a bird that always remembered its note, as well as with God's constant voice at the bottom of his heart. As he flicked open the case the needle would be set quivering, by invisible force, like the singing throat of a bird; but then it would settle along a straight line, star to star. Any man or woman could steer that way, aligning as the frost did 'N and S' by unwavering Polaris. It happened to Dante among the intersecting compass lines of Paradise, drawn to the beauty of a voice at the heart of a light – that light being a bird-like blessed soul – 'as the needle to the north star',

Che l'ago a la stella
Parer mi fece in volgermi al suo dove.

80

For some years, at primary school, I too carried a compass. It was very small, no bigger than my thumbnail; I had found it outside my teacher's house where I waited to be walked to school, lying beside the wicket gate that led into her garden. I never thought to ask Mrs Whitlock, with her red face and brassy curls and prominent blue eyes, whether it was hers. It seemed impossible. Where it had come from I never knew, and did not really wonder. It lay there for me to find: not visibly part of any other object, simply itself. It was backed with a mirror, equally small; but behind the glass face the blue needle had become detached from the pivot and could never be reattached, for all my shaking.

Nonetheless I had the world in there, north, south, east, west, and a blue Polaris to point me through it in a crooked fashion, and a mirror to see how I got on. And the mirror itself, being so tiny, reflected back only my fingertip of ridges and valleys or my cheek looming like a hill, a giant's curious face bending over a miniature pool of light.

This magic thing I kept in the pocket of my blazer or my school dress, with handkerchiefs and holy pictures and sticky sweets removed from my mouth before lessons, preserving it so carefully that I have it still. It was not God as far as I was concerned, for He was in heaven, bearded, severe and cushioned in clouds. But when the blue-star-needle caught for a second or two on the pivot and, in a lopsided way, see-sawed as I held it, its trembling energy seemed to tend both infinitely high, and infinitely far –

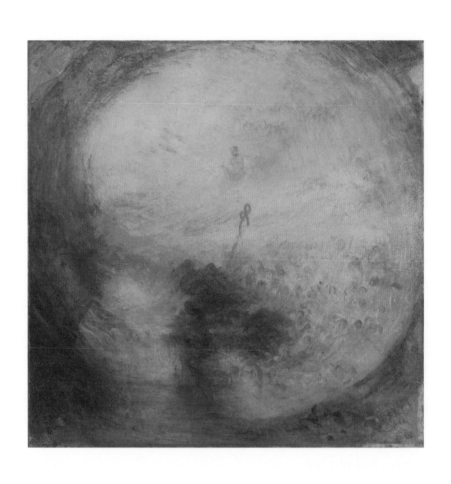

IN THE BEGINNING

And God said, Let there be light: and there was light –

My writing-perch was on the grass beside the track that winds from Firle up to the Beacon. A Sussex friend described Firle Beacon to me as 'our Mont St Victoire' – the mountain in Provence that Cézanne repeatedly painted, never tiring of the way the light changed on it. Firle, at 800 feet or so, is not quite a mountain, but as Gilbert White implied, the Downs have that feel about them. This is the hill that every artist paints, which nonetheless stabs the heart with each encounter because it is so silently grand, and so much loved. Local clergy go up there to celebrate Pentecost, the feast of light.

My notebook was new, open to the first page: plump, tight, slightly convex, with the white paper winking minutely in the sun as though thoughts were already held there. 'I shall now begin a new sketch-book,' wrote Palmer in 1824 on a similar fresh page, 'and I hope, try to work with a child's simple feeling.' The same thought struck Traherne, as he opened the notebook which his 'Excellent' friend Susannah Hopton had put into his hands – the book in which he was to write, for her, his *Centuries of Meditations*. 'An Empty Book is like an Infants Soul ... It is Capable of all Things, but containeth Nothing. I have a

Mind to fill this with Profitable Wonders.' There is always a sense, with an unwritten book, of returning to the beginning of everything.

The best route from Firle village had taken me a while to find. The more easterly path is a struggle in its last section, breath-catchingly steep to the stirrup gate that barely, stiffly pushes open. The more westerly track up Beddingham Hill, on the other hand, running past the lane to the farmhouse at Furlongs where Ravilious stayed with his lover Helen Binyon, is too long. It winds round the bowl of the valley, every field evoking his brushwork on white paper, and each twist of the view echoing his remark that he could draw a local geography, starred with asterisks, of all the spots where he had kissed her.

The old blessing thorn stood behind me, precipitous chalk combes before me, the wide, wide sea beyond the ridge. Purple orchids were flowering everywhere, small beacons in the grass. A couple in summer clothes and sun hats, plausibly from the 1930s, plausibly Helen and Eric, paused on the path to admire them. For if all the light by which we see is ancient, having journeyed from the first crack of time, it surely carries with it all manner of memories, disturbances and ghosts.

The words from Genesis, as I wrote them down, were meant to provoke me into writing more on that clean, expectant page. Instead I just thought how good they were, simple and unstinting as the sun above me. *God said, Let there be light.* And there was light. The first act of creation was a word: *the* Word, as St John explained. Light and word emerged together, the same thing, the first thing. The primeval light, wrote Robert Grosseteste with his candlelit medieval clarity, 'was begotten at God the Father's speaking'. And light, being uttered by God the Father – not *once* uttered but *being* uttered, never stopping since – made

all forms: as the cock maps the morning world, or as certain tribes we call primitive believe their ancestors sang into being their own geography, from basking lizard to gum tree to broken, red-rock hill.

God's speaking, Grosseteste cautioned, was inaudible, for it was made of light and no ears heard it. Yet many presumed that sound came too: not necessarily just one almighty delayed thunderclap, as after lightning, but the tonic note of the chord from which all music sprang, and goes on springing.

Hermes Trismegistus, the Greek-Egyptian demigod of writing and magic, claimed to have heard about the first moments of light. It was sent 'inarticulately' out of the darkness, together with smoke 'as if from fire' and the strange, ineffable, mournful sound of darkness itself. By this account the birth of light seemed difficult, confusing, as if something was unwillingly pushed into view. Yet it was hard to believe that light had not been there for ever: and easier to imagine that God, rather than brooding in His own dark, was in Meister Eckhart's phrase 'a light shining in itself in silent stillness ... self-poised in absolute stillness', before He spoke.

That word – that light – was *in the beginning with God*, said St John. Not separate from Him, as if He struck a match, or drew with a sparkler on the yet-to-be-created air; nor as if, like Ravilious once, He sat enthroned in 'a magnificent Chinese chair' in the old Belle Tout lighthouse above Beachy Head, up in the lantern, imagining how the great beam of the lower light would suddenly stab and sweep through the night-time land and sea. Light was 'Bright effluence of bright essence increate' in Milton's formula, rippling out like a solar flare. The uncreated from the unbegotten. As Hopkins saw it, light – or word – was 'the first

outstress of God's power'. As Böhme believed it, the word at the centre of God's heart simply opened, and 'the love-light world' began –

[*the couple in sun hats have sat down just below me, among the orchids; she lies back and laughs, he tickles her with grass*]

– that love-light world which Ravilious, walking here, called 'the extreme brightness of everything'.

Genesis placed God in charge. But God's shoulders seem too broad here, His shadow too heavy with human history. Instead perhaps the First Cause, like a night spider – potentially light-like already, frisky, nimble, ubiquitous – spun light out of itself. The image seems modern. But Traherne came up with it earlier, describing the 'Quick and Tender' love-light of God as 'able to feel like the longlegged Spider, at the utmost End of its Divaricated feet: and to be wholy present in every place where any Beam of it self extends'.

Just so, between the flowering heads of timothy grass more than a yard apart on either side of me, a small brown spider races to and fro at eye level, improbably tilting on his humped back, front legs feverishly working to build new barely visible worlds. He hangs before the scene – the chalk punchbowl, the blue woods, the lovers half-hidden, Firle's bulwark massed behind – throws out a filament and scrambles along it, much as I throw out thoughts and scribble after. I will break them when I move, both web and thoughts – he will start again –

'A noiseless patient spider,' wrote Whitman, saluting him,

I mark'd where on a little promontory it stood isolated,
Mark'd how to explore the vacant vast surrounding,

86

It launch'd forth filament, filament, filament, out of itself,
Ever unreeling them, ever tirelessly speeding them.

One morning in September 1741 Gilbert White woke to a world
made of gossamer. It began with meshes of dewy cobweb in the
stubbles and clover grounds (they wrapped the eyes and muzzles of
his foraging dogs, driving them wild), and continued with showers of
rags of web from the sky, 'falling into sight, and twinkling like stars as
they turned their sides towards the sun'. Over an area of some twenty
square miles of Hampshire chalk country from Bradley, to Alresford,
to Selborne, the gossamers fell all day, hanging in the trees and hedges
'so thick, that a diligent person sent out might have gathered baskets
full'. Each filament of this web-landscape was made by a minute
spider shooting out a thread – once from White's finger, once from a
page of his book, as he watched in astonishment.

Coleridge in 1804, earthed and bowel-bound, had evidently seen
the same: 'Like the Gossamer Spider, we may float upon air and seem
to fly in mid heaven, but we have spun the slender Thread out of our
own fancies, & it is always fastened to something below. – '

Perhaps to nothing more, though, than sky-feathering leaves of grass.

Thinly then, perhaps barely visible, that first line of light leapt out
across its own unbounded space, chaos and the dark. (In wind and
low sun it is the rays or spokes of a spider's web that shake out light,
rather than the lateral connecting threads; so that the impression is
of sparkling energy ever renewing itself, from the centre outwards.)
But at once light branched and multiplied, instantly everywhere, like

Hopkins's many-faceted creasings and forked-lightning, or Messiaen's birdsong and leaf veins, as well as spider silk. 'It has what I might call a self-generativity of its own substance,' wrote Grosseteste, 'filling the place around it all at once.'

Though light's rays were assumed to travel through emptiness in straight lines, the most efficient way, they were easily deflected. Roger Bacon in the thirteenth century held that light left its straight path, as soon as beasts and men were created, to twist through the tunnels of the optic nerves 'consistent with the soul's operations'. Newton's light moved to and fro, back and forth, reflected and transmitted from any matter in its way, like a tailor stitching a wavering seam of sparks. Einstein affirmed that light bent as it travelled to follow the curvature of space.

Straight, curved or haphazard, the effect was the same: creation by illumination. In Dante's *Paradiso* the images of curve and line came together in a wheel of light, the centre spreading out in spokes, spandrels and traceries that suggested cathedral rose windows or the workings of clocks, revolving eternally in that harmonic hum of praise that persists from the organ even when the stops are muted. (In Rodez in south-west France, where I was deputy organist in my mid-twenties, the bats in the cathedral loft would fly out and clutter round me as I played, like fragments of night astonished.) All things were now eternally sounding and eternally becoming, each new creation mirrored from the last. Dante, from his Paradise-perch, learned the secret of that beginning: form and matter, he wrote, came into being as a ray shone in a glass, or in amber or crystal, with 'no interval between its coming and its pervading everything, all at once'. As St Paul put it, 'All that was made manifest was light.'

And the light shineth in darkness, and the darkness comprehended it not.
Chaos, or night, which existed before light visible, did not understand
it and could not contain it. Yet nor could the two be separated. Still
they clung together. Astronomers now think they can find evidence of
that moment: a 'surface of last scattering' in which photons reveal the
long-ago conversions of the forming universe: density fluctuations,
inflation and waves of gravity in which light's pulses or particles wob-
bled, rocked and finally aligned themselves, like boats on a rough
sea. And it was perhaps at this point that Genesis described light as
brooding on the dark, mantling its wings over it, as when birds that
have bathed briskly in dust stretch out their feathers to cool them;
or when a swimmer on bottomless water, rising a little and falling,
embraces the infinite curve of it with tired white arms.

That sea, though, did not remain the same. The child-light now
contained the mother-dark, pressing it into an infinitude of forms,
much as Coleridge watched the waves change on his voyage to Malta:

> every form so transitory, so for the instant, & yet for that
> instant so substantial in all its sharp lines, steep surfaces, &
> hair-deep indentures, just as if it were cut glass, glass cut into
> ten thousand varieties ...
>
> O what an Ocean of lovely forms! ... the mind within
> me was struggling to express the marvellous distinctness and
> unconfounded personality of each of the million millions of
> forms, and yet the undivided Unity in which they subsisted.

Light had a power, the ancients believed, to make random par-
ticles coalesce into shapes already idealised by the First Cause; and

subsequently, in Böhme's words, to move the forms themselves 'always to make that very thing with which the spirit is impregnated'.

Above all, light imposed order. So said Genesis, for that strictly organised first week of divine work all sprang from the original spark. So said the Greeks, for Apollonian light was metre, measure and music, as perfectly spaced and set as the arrows of the god. As Traherne explained the process to Susannah with his usual hectic enthusiasm, light drew design from confusion. And this generated more light; as forms took shape, light was 'Expresst', and grew 'Activ around them'. Brightness increased as creation was arranged. Traherne had noted that in the midst of smoky, roiling human occupations, order was 'a Bright Star in an obscure Night … a summers day in the Depth of Winter … a Sun shining among the clouds'. What was true on earth must have held true from the beginning, as the universe unfolded.

> Order the Beauty even of Beauty is,
> It is the Rule of Bliss …

Hopkins understood this instinctively. His was a world in which everything was regulated by repeated patterns of light, even in the apparent chaos of falling water or bramble-tangled ground. 'All the world is full of inscape,' he concluded in 1873, 'and chance left free to act falls into an order as well as purpose.' It was not, then, chance at all. From his teenage years he recorded in pencil, chalk and words the curling regular strands of waterfalls, the webbing and 'chain-work' of sea waves, snow-dust gliding in rows 'like so many silvery worms', clouds showing 'beautiful and rare curves like curds … arranged of course in

parallels'. On the fells near Stonyhurst in gritty snow he saw 'green-white tufts of long bleached grass … each a whorl of slender curves, one tuft taking up another', like nebulae. In a mown hayfield at Pendle in September he found 'an inscape as flowing and well marked almost as the frosting on glass and slabs'; and in 'random clods and broken heaps of snow' swept by a broom, ripples perfectly spaced.

These patterns into which the world fell did not go unnoticed by others. Ravilious's clouds almost always moved in series and in parallel. He also found a curious regularity in the footprints of customers in the sawdust of a butcher's shop; in the dark parallel swerves of sledges and pram wheels in snow; in the rough but even spacing of clumps of grass in a field; and on the sea, like Coleridge and Hopkins, the perfect geometrical latticework that covered the surface of the waves.

His influence persists here on Firle, too. Overhead near-identical clouds drift in quiet procession, formed and blown from the same source; the fields below run in even, parallel terracing, like contour lines on a map; and the finches that flock past are in bands arrayed as neatly as, in their far grey vapour trails, the faint displays of fighter jets at the Eastbourne air show. Either I am arranging this or, if that seems dubious, light is –

Traherne insisted that immaculate order applied at the tiniest and humblest level. A drop of water, he wrote, 'an Apple or a Sand, an Ear of Corn, or an Herb' (to mention only his immediate favourites, those within sight of his church porch at Credenhill), were all established as they were 'by the best of Means to the Best of Ends'. When things were in their proper places they shone, 'Admirable Deep and Glorious'; a mere spire of grass, 'in useful Virtu, native Green/ An Em'rald doth

surpass'. By contrast, out of their place they were 'like a Wandering Bird ... Desolat and Good for Nothing'.

Clare, wandering down a lane, recorded with delight old farm implements in their places: 'a pair of harrows painted red standing on end against the thorn hedge ... an old plough ... on its beam ends against a dotterel tree ... & an old gate off the hooks waiting to be repaired', all blending with Nature and 'pleasing in the fields'. Jefferies echoed this thought with his vivid appreciation of a cart outside the wright's, 'wet with colour and delicately pencilled at the edges'; Ravilious did so with his rollers and harrows, his serenely mismatched chairs, his serviceable tools and coils of rope, and cups set on the table for the ritual of tea. To reduce confusion to order, in the words of Alfred Rich in *Water Colour Painting* – a manual he particularly followed – was to place round the most commonplace object 'a halo of beauty'. Even at eleven, doing his art homework, Ravilious could portray perfect order and clarity in a pencilled egg nestled in a pencilled cup. Inevitably, perhaps, he also drew a perfect teapot, its knobbed lid finished with exacting care. These objects shone where they had been useful, and would be again, with their own bounding line and stillness, in their place.

Many others had noticed that halo of light – bounding both in the sense of defining, and in the sense of being active and alive. Hopkins glimpsed it round the 'sillions' of a field and the blade of a plough 'with-a-fountain's shining-shot furls'; Dorothy Wordsworth observed it on thick-curled backs of sheep and lattices of ash; Jefferies noted its 'edge and outline' round boats, shop signs, pebbles and everything else he saw in Brighton. 'The more distinct, sharp and wiery the bounding

line, the more perfect the work of art,' Blake wrote; for every line was the Line of Beauty.'Leave out this line and you leave out life itself; all is chaos again, and the line of the almighty must be drawn out upon it before man or beast can exist.' Grosseteste elaborated:'For every shape is a kind of light, and a manifestation of the matter that it forms.'

That line shows above Firle round grass blades, sessile-oak leaves, a terrier racing past, the lovers lying close (he smoking, she with a book, bare arms crooked, hip bone tight beneath her summer dress), the wings of a chalk blue half-closed on a clover flower, and the long shoulder of the Beacon against the summer sky. Ravilious said it was the design of the Downs, 'so beautifully obvious', he painted them for. His thought seems to match the quotation from Psalm 65, Palmer's favourite, on the wall beside Firle church, 'The hills are girded with joy'.

Yet there was almost no weight in Ravilious's hills, nor in anything he painted, no matter how substantial they seemed in life. A battleship moored by hawsers to a quay was as delicate as a dinghy, and a ship's mine buoyant as a balloon; trees fluttered like flags, and planets spun as if they were tennis balls. Almost defiantly, he called every aircraft an 'airoplane'. His machines, too, were weightless on the earth, as if all was form and function without mass; as if, instead of matter, there was merely light and line. Everything, like one of his beloved Tiger Moths, might take off, somersaulting through the clouds until all that was left was the original thought, a vapour trail snaking and shining in space. *For every shape is a kind of light.*

Or a brushstroke, perhaps. Traherne thought God's word, or light, was His 'Pencill', and His own beauty and power the colours with which He painted the 'table' of the world, bringing it to be.

The principle could be seen on a single beech leaf, the clear 'raiment' fading away from the sharp green edge. (Every leaf in the spring woods displays this, outlined by the sun and then filled in by it; Dante used the colour of young beech leaves for angels' wings in heaven.) Blake drew the simple conclusion: 'Form is the Divine Vision, And the Light is his Garment.' Goethe put it sharpest, a shock to those hoping to be invisible in the jungle of the summer grass: 'If light did not see you, you would not exist.'

All this happened instantly, or so it seemed. Light was announced, and *was*, with creation tumbling after. But some thought there was a slower, more tentative unfolding. In Genesis light was kept back from earth until the fourth day, held in abeyance while dry land was heaved out of water and covered with grass and trees. Provisional daylight was made for these green things, and a dim, pale day at that, said St Bede and St Jerome: more or less what appeared before sunrise, barely contesting the night. Later sun, moon and stars were fashioned like lamps to hold a working measure of light, while light itself (Milton thought), having travelled almost languorously from the east, 'sojourn'd the while' in a tabernacle of the first clouds.

Already, then, two guises of light appeared: lower and higher, functional and holy. Latin expressed this discrepancy in two words, *lumen* and *lux*. They passed into Tuscan, to Dante's pen: *lume, luce*. Both could mean the light of day or the eye, the aura of fame or glory, and life. In many ways their virtues were overlapping. But *lumen* essentially touched on the motive power and usefulness of light:

a torch, a lamp, a ray, sun or moon; something shaken through the dark, or a window, crack or chink, letting light in. Dante in Paradise saw 'all substances, accidents and relations' neatly bound together in *un semplice lume*, gathered up in light, like loose leaves in a book. It could as easily break out in accidents again.

Lux, by contrast, was tabernacle light, unchanging as the gold relief behind *retablos* of saints. Fra Angelico portrayed it with gold leaf, his figures almost one with the gilded air around them; Palmer used shell gold and gold paper, luxurious extras in the vagrant Shoreham days, to impart divinity to portraits of his friends. This light did not fizz, inveigle, flash, sidle in; it existed in pure stillness, a state of spiritual illumination. *Fiat lux*, said God in His first great declaration, establishing the principle and, wrote Grosseteste, the inward essence of His creation. *Lux* illuminated Eden and the angel-eyes of Eve and Adam, as they innocently wandered and embraced there. It also filled heaven. *Luce etterna* bathed Dante in Paradise as an infant's mouth was bathed sweetly, wonderfully with milk. *Lux perpetua* gently clothed the blessed souls.

On earth this light was understood – in so far as it was understood – as intellectual, not physical. Aquinas taught that it made up lucidity or *claritas*, 'the intelligible radiance of form that pervades a being'. It was also, as Joyce's Stephen Dedalus explained with Jesuit-trained verve, 'the scholastic *quidditas*, the whatness of a thing'. Both Aquinas and Duns Scotus built up the idea, absorbed by Hopkins as well as Dedalus, that the essence of a thing, its *self*, was fundamentally linked to light. Each particle of created matter partook of *lux*, though it was also thoroughly shaped and shaken by restless *lumen* as it passed.

The fourteenth-century author of *Pearl* saw no need for that lower, subsidiary light, at least in the beginning; no need for the 'spotty' 'grym' moon and the 'dym' sun, if newborn light was still dazzling down from heaven. It surely flowed out as generously as divine love itself. Both pagan and Christian writers believed that light never rested, never shrank to one shrouded, sacred flame; but came down unceasingly, so that sun, moon and stars had only to be held as glass jars under a waterfall, brimming and flooding over. 'The sun,' wrote Galileo, 'is just a repository of what he receives from elsewhere ... and the Scriptures make that obvious.' Yet simply by virtue of descending and taking on materiality, the 'fertilising spirit' that was light was bound to change. Its original divinity had to give way, at least for a while, to temporal illumination of the world of ordinary things.

Once again Hermes Trismegistus brought forward his strangely melancholy, brooding characterisation of light. In the Hermetic tradition he founded, passing into the medieval, light gradually grew heavy with desire for its reflection seen in the waters of chaos, with desire to become material itself, and sank down into it. As its heaviness increased, it sacrificed brightness: so that Herbert saw Christ, light incarnate, as he descended, extravagantly hanging his shining robe and rings on the stars:

> The God of power, as he did ride
> In his majestick robes of glorie,
> Resolv'd to light; and so one day
> He did descend, undressing all the way.

The starres his tire of light and rings obtain'd,
 The cloud his bow, the fire his spear,
 The sky his azure mantle gain'd.
 And when they ask'd, what he would wear;
 He smil'd and said as he did go,
He had new clothes a making here below.

There was no way but *through* that water-dark, as Bunyan's Christian found, sinking deeper in the River of Death with each step, crying *Selah* in hope of light, as the billows swelled above his head and all God's waves went over him. But on the other side he found buoyancy, speed, agility; and so too did light, recovering itself, as it fell out of heaven into the world of becoming. *Lumen de lumine* is the incarnation phrase from the Nicene Creed; the words dance. Heavy as light now was compared with what it had been, it was still swifter, fierier, subtler and more beautiful than anything else around it. And its name, among the Saxon and Anglian tribes, still connoted weightlessness as well as brightness.

Thus Langland described light, which was love, which was Christ incarnate, as it entered with blazing delicacy his fourteenth-century atmosphere of wool and soot, tallow and sin:

For hevene holde it ne myght . so hevy it semede,
Til hit hadde on erth . yoten hym-selve.
Was nevere lef up on lynde . lyghter ther-after ...
Tho was it portatif and pershaunt . as the poynt of a nedle,
May non armure hit lette . nother hye walles ...

97

Yoten meant poured out: that sense of endless flooding abundance. *Portatif and pershaunt* meant swift and piercing, needle-sharp. Strange words, combined with that linden-leaf lightness, for love or for Christ; but not for light. 'It was light and sharp and drastic also,' wrote Hermes Trismegistus of the first ray and the first word: as efficient as the engraver's burin, or the hawk's claw.

Yet there was tenderness, too, in this. Christ, or light, in a carol as old as Langland, dropped down like dew, which scattered the meadows with those silent jewels that men woke up to, out of ignorance or sleep; so quiet on spray and flower that he simply 'came' to his mother, where she was. So swift that he was instantaneously there, and here.

> As dew in Aprille,
> That falleth on the grass.

The Christ-light was also imagined drifting down more slowly, like snow, at the darkest point of the year. The feel of light was possibly similar, if out of a yellow-grey and lowering sky, suddenly, softly, with touch and spring, it were to fall. Ravilious adored snow, abandoning shaving so as not to miss it, showering it in huge flakes across his winter landscapes, snowballing until 'I was wetter than anyone about the neck and had to change my clothes' and bombing the street below, wild as a boy, when he cleared the drifts from a neighbour's roof. Like light, and as dazzling, snow defined, shaped and covered, all at once. Rather than obscuring objects, it showed what they were. Thoreau said it was 'like the beginning of the world'. He noted, too, that it fell on no two bare trees alike, but 'the forms it assumes … are as it were predetermined by the genius of the tree'.

Hopkins observed how after a heavy fall in March snow restored to his local elms, even as it shrouded them, the inscape underneath. From below he could see 'every wave in every twig ... beautifully brought out against the sky'.

If light fell like dew, or rain, or snow, perhaps it shared in some way the nature of liquid things. That would account for the way it could shimmer in heat like a screen of falling water, stream visibly before a sleet-bearing wind, or make reflections on roads; and it explained why Hopkins saw the sun above the Roehampton cedar as 'a shaking white fire or waterball'. Just tremors in the air, Newton said, accounting also for the way stars seemed to twinkle in the night sky. Others continued to disagree. 'You that wrap me and all things in delicate equable showers!' cried Whitman to light. The 'golden ambient vapour' which Turner admired in Cuyp's pictures, and which glowed in many of his own, also sounded very like light. He wished he might be wrapped in his own *Sun Rising through Vapour* when he died, particularly since no one would buy it from him.

Near Erwood, in mid-Wales, I once befriended a small stream in the depths of the woods. It was the only source of light in a cleft close-shaded by aspen and alder, sycamore and birch. Beside the plank bridge it tumbled constantly over rocks with almost the same ripple here and cascade there, the same lick of foam at the rock base and brown-gold webbing over stones. This was chaos, ordered. Horizontally the water flowed as smoothly as silk on a shoulder, but in falling it would thin and crystallise into long twists of cut glass. Everything it did seemed a model of how light might behave. Even on a level surface, Thoreau noted, water naturally braided into spirals: strands of rope, Hopkins thought, holding

him steady in a deep sun-dappled well. Perhaps light, as it grew heavier, would tend to do the same.

Strange crossovers certainly occur between water and light. Walks round about my Welsh stream were set sparkling by the tinkle, trickle and drip of tiny rivulets and run-offs of rain: a glint across a bramble leaf, a glitter in the lace of herb-robert in the hedge, a green dash of slime on a stone. Where rocks are dark and mountains overhanging, the fields deep and the clouds low, water in its ubiquity substitutes for light. Conversely, in the dry chalk south where surface water is rare – a puddle here, a dewpond there, empty ditches choked with bullrushes and wild roses – light often substitutes for water. Mudflats shine deceptively, when they will cake your boots with dust; egrets stalk, ankle-deep, in shimmering tufted grass; a small valley holds at its heart not a stream but a path, littered with white stones worn to smoothness only by feet and time. And everywhere, in lieu of moisture on leaf, grass or spray, lies a powdering of light.

Such parallels fascinated Coleridge, and had done ever since his childhood dabbling on the River Otter in Devon: a plump boy, with large grey eyes and ever-open mouth, watching from the bank that 'bright transparence' flowing over sand. Later, he laboured to describe the 'water-threads' of the falling Greta at Keswick, especially 'the white Eddy-rose that blossom'd up against the stream in the scallop, by fits and starts, obstinate in resurrection – like *life*' – or like light. In the falls of Lodore he saw the bad angels falling from heaven, 'Flight & Confusion, & Distraction, but all harmonized into one majestic Thing' – a metaphor for the endless creative struggle of light against the dark.

*

Long before scientists racked their brains over whether light was waves or particles, matter or motion, medieval minds wondered whether its texture might reveal what it was. For it certainly seemed to have texture, of a sort. Light was in fact the first form of corporeity, Grosseteste wrote in *De Luce*, from which all matter condensed and coalesced.

Many after him thought they saw it in this tiny, atomic form. 'Swarming in the brightness & the Breeze,' wrote Coleridge in Grasmere, cleverly making light both verb and noun. Thoreau described it as dashes and flakes, and could tell by sunbeam shiftings when a breeze rose. Gilbert White's gleams ('Grey, gleams, snow gone') seemed similar. Palmer in Italy, stepping from cool ecclesiastical dark into the 'dazzling weather', found all the air trembling with little motes: 'Newton's particles', as Blake would have said, adding sadly that Newton, with his musings on the corpuscular form of light, had made the world 'heavier to me'. Yet Palmer thought those tiny grains allowed him to see 'real' sunsets, and real twilights. Jefferies called them 'the dust of the sunshine', blown from hawthorn leaves, ash sprays, brambles, wheat and grass – as on a high summer day white cotton floats from the poplars, and pollen from the flowering limes. Threshers and winnowers worked in a chaff-dance of light, scratches, streaks and strokes of it, explosive as the fire-flash of furnace or forge. Hopkins filled the bowl of heaven with grain-dust; Clare, who had scrawled his first childhood words in golden dust in barns, remarked more than once on the mealiness of everyday light.

I wandered once into the Flint Owl Bakery in Glynde, a mile from Firle, in the middle of the day. The bakery, a cluster of low white

buildings, stood opposite a Georgian church whose pale stone was mottled with grey lichen and gold moss. I went there first. A wire-mesh door kept out the birds: the sort of mazing grid through which Palmer, at nineteen, adored the 'brilliant varied tints of the sky' in the tracery of a far plain-glass window. A wooden rack was provided for coats, a scraper for boots. Inside the church – one large room, rather than nave and chancel – a powder-blue ceiling, picked out in carved white wood and faintly stained with damp, glowed like a spring sky, or like the paper-thin eggs of the blackbirds or thrushes that had been saved by the mesh screen from blundering inside.

A similar light filled the bakery, where the tall grey windows had not been opened in a while. Visibly and edibly, to my famished eye, it poured through the glass. It rimed the cobwebs on their upper panes and outlined, with white rust, each hinge and catch. It settled in the trays, along the shelves and on the painted planking of the floor. The rough dark loaves were dusted with it, the sacks full. I began to understand the delight of Ravilious when, in 1935, he visited a Hovis mill, '[as] pretty as possible white and almost new looking'; and the joy of Thoreau at the 'cobweb drapery' of the Concord mill, where meal-dust revealed the *thisness* of the wooden workings just as snow, in winter, revealed the trees.

No one was about; the bakers had gone to lunch, perhaps. But they had left the door ajar on thick triangular slices of light, the tables smudged and fingered with it, lumps of it ready to be kneaded and, here and there, leftover chunks of it for wayfarers, surely, to take and eat (as I did).

light descends edibly,
forming into bread
morsel by crumb, and my noiseless tread
steals under window-white
ladders of dust
from table or altar, one radiant crust –

White loaves were left for St Cuthbert on the storeroom table at Lindisfarne by a young angel rescued from the snow: white bread being the food of aristocrats, melting and soft, rather than the chewy oaten bran of the poor. Their aroma was of lilies and roses, but whiter and sweeter than those: bread of heaven indeed. They were still warm, fresh-cooked, despite the long miles they had presumably fallen and the bitter cold outside.

The manna that fed the Israelites in the desert might have been much the same. So Dante thought, marvelling at the 'rain of manna' that was, in fact, far-off angels scintillating to make the light of heaven. God had sent light in the form of food, crumbled on the ground like hoarfrost in the low dawn sun, fading away flake by flake as that sun rose, tasting – so tiny on the fingertip! so insubstantial on the tongue! – of wafers cooked with honey. Light should taste of nothing else: infinitesimal sweetness, whiteness. Manna was white as coriander seed, said the Book of Exodus: the same tiny seeds Lucretius used to describe the minuteness of his atoms, which made up the world. Whatever else later scholars surmised manna to be – the dropping resin of the tamarisk tree, the sticky excrement of aphids, honeydew setting in white crystals on every leaf of the turkey oak – it could not

have been more nourishing or more essential. Divinely, the Israelites fed on light, as plants do, there being nothing else man so hungers for.

Each morning they gathered it in baskets. Somewhat less than four litres was allotted to each family; they ascribed some weight to it, therefore, that was more than air, though less than sand. Some stooped and grubbed for it; others merely held out their hands as it fell. Ungathered manna simply melted where it lay. Carefully the Israelites compressed it with pestles in mortars, since the flyaway, flashing particles would not otherwise cohere. Then they baked it in the fire, slowly, until it rose high and white, honeycombed with the emptiness of unbounded space; until it collapsed in the teeth and fragmented in the beard, and they crunched on light.

Nothing was left for later. Manna that was stored (except one day's worth, for the Sabbath) began immediately to rot, becoming stinking, maggoty and thick, like stagnant water. Light, once seen, never lasted, or kept the look it had had before. It had to be tasted and enjoyed in motion, as it passed – almost as if it lived and, being alive, could die.

The question at hand, though, was what its nature was. Even the same witness might give varying accounts. Dante in Paradise, surrounded by radiance both physical and intellectual – and under the guidance of his beloved, Beatrice, herself an avatar of light – described it not only as manna but also as rays, razor-sharp, and as the petals of a flower. Mostly, however, he moved among threads and filaments. He met souls (being all light) whose rays hid them 'like a creature swathed in its own silk'. Other effects reminded him of the terrestrial

night air 'threaded thick' with moonlight, and the moon herself gird-led with rainbow webs.

The thickness of these threads did not vary, Beatrice told him. Light was altered, and then superficially and briefly, only by the sub-stances it mixed with and the bodies it shone through on its journey away from God. God, meanwhile, took on the image of a fabricant, not merely thinking and singing light but working and weaving it con-tinually. Herbert, longing to reach Him, doubted he could struggle so far by the straight-slanting sunbeam that fell on the counterpane of his bed; but he hoped he might climb 'by thy Silk twist let down from Heav'n to me', the shining multicoloured threads that made creation patiently wound in, as if by his mother's fingers. (Hopkins described larksong this way, 'new-skeinèd', as well as summer lightning, 'the shivering of a bright riband string which had … danced back into its pleating'.) Newton noticed that the coloured fibres of some silks were prismatic, shot through with light, depending on how he viewed them. Poets could reverse the process, veining light with silk.

Whether or not creation was a web spun out by the First Cause, the whole world might be sewn through with light like a tapestry. *Alles sich zum Ganzen webt*, 'All weaves itself into a whole', as Goethe wrote of the light-swarming Night scene in *Faust*. Light became, to Julian of Norwich, 'our clothing, wrapping and enfolding us'; Hopkins felt luminosity pass over him like blowing linen. Palmer recorded golden light lapping a hillside, 'velvety and real in texture', and was enchanted by 'the fine meshes, the aeriel tissues, that dapple the skies of spring'. Ravilious, engraving his sun as geometrical lattices and webs, extended those webs to form trees, grass and birds flying. The nets with which

Apollo hunted, fine as his shimmering never-scissored hair, were those Blake saw, of golden twine, hung by Three Virgins from the branches of the trees of the world at dawn. They were the 'webbes' and *fyldor fin*, rows and strands of gold wire, which the jeweller-author of *Pearl* recalled, raying out from the rocks of Paradise; or the 'most exquisite net' Coleridge described in a stream in Glen Nevish,

> all whose loops are wires of sunshine, gold finer than silk,
> beside yon Stone the Breeze seems to have blown them into
> a Heap, a rich mass of light, light spreading from the loop
> holes into the interstices…

In several of the experiments that followed Newton's, investigating how rays changed shape as they passed through apertures, the now-presumed-material light was represented by a thread.

The sweeping hillsides of East Sussex often seem to hide not hard bones of chalk, but a loom of light. Ploughed fields are fine-combed; fresh-planted ones are savagely raked with white. Every time Ravilious painted or engraved the Downs he showed a warp and weft elaborately cross-hatched with brightness, under orderly cross-woven clouds. (There was indeed a warp in clouds, Hopkins wrote, as there was in lime or sycamore leaves; spotting a rack of them, 'I made out the make of it … cross-hatching in fact.') It is the same pattern you find in wool snagged on a fence, teased by the wind or carded with a teasel, pulled out of tight curls or spirals into delicate netting and then to single strands.

These strands, so fine they are almost vanishing, might be taken for an intimation of the feel of light. Sometimes it forms a soft screen

over the sea, warp threads to the wave-weft of lavender, pale green and ultramarine. Near the spot where I first noticed this, on the Downs above east Brighton, there is another memorial, arranged by a pad-locked stirrup gate overlooking the sea. Cards of the Sacred Heart are pinned up there, with small bouquets of withered flowers left on the grass; but no name anywhere. Beside the wire fence stands a faded planking sign declaring 'All you need is love'; and on the gate in chalk, the inevitable medium of this country, the unending mantra 'Love Love Love ...' Love and light weave easily together. On warm days, when the air seems layered with light-threads, squeaking swifts dart through as if to stitch the scene and hour. They vanish into Ravilious's oak-framed Sussex barns, where doors stand open to the light and the ridge tiles are outlined with lichen like gold paint.

Such weaving was not necessarily one way, from the central sun-source outwards. For centuries scholars believed that each created thing sent forth an 'effluence' of its own. Empedocles taught that tiny particles flowed out from objects continually, each 'effluence of fire' making contact with the fire in the eye; al-Kindi, the most influen-tial Islamic philosopher of the ninth century, held that everything in the world 'produces rays in its own manner, like stars'. Well into the industrial age this idea lingered, not least with Hopkins, who noted of streamer-clouds over Kemble End in Lancashire that 'what you look hard at seems to look hard at you'. Perhaps, then, an infinite confluence of these rays filled the world and wove everything together. Though they were usually invisible, al-Kindi wrote, and varied in power from weakest leaf to strongest star, they streamed out in all directions and influenced the whole of life. Through their movement, as through

light in the beginning, forms were created and changed into other forms. 'All things,' he concluded, 'came to be and exist through rays.'

The human spirit and imagination, too, were thought to send out rays, and these had the power of moving external things if they were close and strong enough. So the rays from each subject and object, meeting and intermingling, made the phenomena both of sight and, in human cases, love. Duns Scotus, Hopkins's favourite, taught that in each such encounter the beholder, too, was changed. Dante certainly believed it. He referred to his eyes as *le luce*, light themselves, for as they mirrored the smiling gaze of Beatrice, 'so full of the sparkle of love and so divine', they became what she was. Hopkins in his solitude experienced it too, describing 'those fine radiating lines of light which dart out *from* and back *to* the candle as the eyes of the beholder are slightly lowered or raised'. He called them 'trambeams', after the finest sort of twisted silk. 'What the Eye is to the Light, & the Light to the Eye, that interchangeably is the Lover to the Beloved,' Coleridge wrote, and heartily wished it were true in the lost cause of Sara Hutchinson and himself. After all, even flowers did it:

> 'Tis said, in Summer's evening hour
> Flashes the golden-colour'd flower
> A fair electric flame.
> And so shall flash my love-charg'd eye
> When all the heart's big ecstacy
> Shoots rapid thro' the frame!

In a long footnote he explained the 'very curious phenomenon' of light flashing from flowers. This had been observed in marigolds in

Sweden, and also in descending order of vividness in the monkshood, the orange lily and the Indian pink. It happened at sunset when the atmosphere was clear. But the flowers, unlike him, did not anticipate an answering flame.

That was just as well, for the light-exchange was dangerous. Once 'eye-beames twisted', in John Donne's graphic phrase, there might be no escape. Dante described how those reciprocal beams of love contained thoughts and emotions as tiny *spiritelli*, minute spirits that pierced the heart, igniting it as the rays from stars called forth the virtue of precious stones. Everything that was said, seen, felt or thought therefore added to the texture of light and the way it moved. If the sentiment was strong enough, it kindled fire. He wrote of sparks and flames flickering from Beatrice – not only when she stood in Paradise resplendent, but also when she had first appeared to him, nine years old, in church in Florence in her 'goodly crimson' dress. Her radiance then was nothing to the sparks that came from him, much as he tried to conceal them. He could no more hide them than his trembling hands, or the pallor of his long, hawk-nosed, melancholy face.

Scientists now say that the eye and objects send out no rays to encounter light, and that there is no entangling. Photons sent to the retina simply reflect from the surface, and go no further: the act of seeing is all they achieve. Yet the effect on those who see may be incalculably powerful; so within the eyes of nature-gazing poets, and certainly within the eyes of lovers, that tender twisting still goes on. Take the pair who, here on the slope of Firle, lie in a mosaic of glancing hawthorn leaves and sky; and who, between plucking grass and pretending to read, steal lightning looks at each other's luminous

skin and light-teased hair and, perhaps irrecoverably, the eyes themselves. Heaven knows, but there are webs here.

These ubiquitous threads, sometimes pulsing in rhythm, suggested to some thinkers that light sounded. If it eternally echoed the first word, or first note, some music or even speech must ripple out of it. Dante spoke of hell's darkness as *d'ogne luce muto*, mute of all light; for in Paradise light, composed of souls, had continually sung hymns and talked to him, the sound 'like pipes filled only with the breath of holy thoughts'. Al-Kindi's rays were agents and expressions of the heavenly harmony that directed all things. Newton too, in some of his demonstrations of colour breaking out of light, fell back on the mathematics of the sequence of notes in a scale.

Coleridge perhaps presumed this affinity when, coming out of London once into buttercup fields and the glint of a winding river, he seemed to hear music playing. He presumed it again when he hung an Aeolian harp in a window of his cottage in Clevedon, in Somerset, anticipating (as he wrote long afterwards) 'a light in sound, a sound-like power in light'. The jasmine on the wall and the bean flowers in the far fields perfumed the night, small stars; his favourite evening star hung 'serenely brilliant' before him; and the harp with its 'long sequacious notes' made a 'soft floating witchery of sound', not unlike theirs:

> And what if all of animated nature
> Be but organic Harps diversely framed,
> That tremble into thought …

Yet if light moved like intricate fingers or the wind through strings, who heard it? Several writers reported whispers in lamps, but some

other agency – soot, wax, small beetles – usually explained them. 'Light hath no tongue, but is all eye,' wrote Donne, as neatly confident as modern scientists are. The author of *Pearl* came closest to ascribing a sound to it, as he stumbled unexpectedly, half-blinded, into the woods and rocks of a landscape somewhere near heaven:

> As burnished silver sheer leaves slide
> That trill so thick on every side,
> When gleam of glades against them glides,
> With shimmering sheen full shrill they shine …

Light here was sharp again, with the chink of silver or glass. It purled along leaf and branch, but the word was *trylle*, like the song of the lark or the reed pipes of Palmer's shepherd boys. Precious stones on a stream-bed, emeralds and sapphires, *glente thurz glas yat glowed and glyzt*: percussive again, like Sanctus bells. The words remain in use, glint, gleam, glitter, glance; a xylophone might play them. As for shimmering, shining, sheer, those belonged to harps, as Coleridge deduced and as Blake heard – all the while painting, as Palmer declared, 'in the highest key of light'. *Schrylle* became birdsong, in full chorus through Chaucer's casement as the sun rose, or at evening, as Clare walked in the woods, when 'twittering spangles glow the leaves between'. At dawn Faust heard trumpets and trombones, Blake the hosanna chorus of the heavenly host; in an English seaside town like Eastbourne, the strengthening glare of morning sun and sea often goes hand in hand with the brittle and blown-away sound of a military band.

Though there may be no physical connection, at times light and sound can uncannily complement each other. On the Downs, beside

skylark song, there is often a strange soft piping and keening that seems to emerge from nowhere, or only from the radiance around. It might almost be an echo of that 'ineffable', 'mournful' sound which Hermes Trismegistus connected with the birth of light. It comes, in fact, from tubular steel gates, from apertures in fence posts and from looping barbed wire. India has an instrument made simply of holes in a bamboo staff that is planted where the air moves. The Sussex equivalent, at a gate just east of Seaford Head, is a post of pierced steel that focuses both the light and the notes it seems to make. Those notes can whisper too – at very close quarters, when all else is silent – from random snail-shells by the path, blowing across the illuminated rim that is also lit from within, as if light and wind have joined their tones together.

Another strange affinity is between light and human whistling. I noticed this one autumn day, sitting on the hillside above Hope Gap, as a walker went whistling down the track below me towards the undulating white cliffs of the Seven Sisters. Something in the sound – the whistler's very confidence, perhaps, that he was the centre of the world – seemed to fix the scene around him in that moment, from the curtain-fall of light on the cliffs, to the reverso sweep of a gull landing, to the grey lean of a gate, to the wind-gusting grass. Those high trill-ing notes, again like the song of the lark, pinned down and sharpened everything, as a burst of sun would have done.

The only physical link is that sound and light both vibrate; and since this was so, perhaps light was not made of particles after all. Perhaps it was a wave. Robert Hooke, a sharp contemporary critic of Newton's theories, thought light was a pulse of the aether, that invented apogee

of all elements which was presumed to act as a medium for the others. In the nineteenth century André-Marie Ampère supposed it to be waves in some kind of electrical aether; Michael Faraday thought it a vibration of magnetic lines of force. James Clerk Maxwell identified it as an electromagnetic wave-form in aether more subtle and immaterial than had been adduced before. All agreed that far from being the very swiftest, finest sort of matter, light was not matter at all, but energy in motion. It made its presence felt not materially, but by action: by the curl of the wave and the flow of the stars and even, perhaps, by dancing.

> I danced in the morning when the world was begun,
> And I danced in the moon and the stars and the sun,
> I came down from heaven and I danced on the earth …

… as Sydney Carter's hymn goes, to the old Shaker tune.

Chambers Dictionary calls light an 'agency', neatly straddling the notions of matter and force. For science now makes light both waves and particles, the particles being the subatomic quanta suggested by Max Planck and discovered, or presumed, by Einstein. He described these 'photons' in 1905 as 'a collection of independent particles of energy' – and, like everything else in his universe, equally in motion everywhere. Einstein's 'bundlings' or 'packages' of light were not objects in themselves; they had no mass, and were really mere hypotheses for the oddities that occurred when light was considered only as a wave. Yet, as a theory, this has proved as precise and predictive as could be hoped for. (Coleridge lightly grazed this thought, in his notebook: 'Sir Isaac Newton's [Hypothesis] of Light/ each Particle every where in the course of Eternity.')

But Newton, the great dissecter of light – the man who had first demonstrated that a prism split it into differently refrangible rays making different colours – never defined what it was. He was inclined to think it was tiny globular bodies, or 'corpuscles', not least because God seemed to have made everything out of 'solid, massy, hard, impenetrable, moveable Particles', no matter how small. The fact that rays of light entered and left his prisms in 'right Lines' and 'successive Parts', and that they had opposing sides, confirmed that theory in his mind. So did his observation that different rays appeared to have different sizes, strengths, flexibilities and dispositions imposed on them from the beginning, some being drawn as strongly to the virtue inherent in a crystal 'as the Poles of two Magnets answer to one another'. Light, therefore, could not merely be 'Motion or Force propagated'. On the other hand, there was a periodicity to light – a to-and-fro – and those sound-like vibrations, which were thought-provoking. He had also seen light, by continual refraction, bending into a curve.

Thus instead of making firm declarations at the end of his *Opticks* of 1704, Newton left his readers with questions. 'Are not the rays of light very small Bodies emitted from shining Substances?' he asked. He expected a positive answer, but knew he might not get one; he hoped to clear it up one day, but could not do so yet. He would leave his 'Hints' 'to be examin'd and improv'd by … such as are inquisitive'. Hooke attacked him for apparently believing that light was a material substance, but Newton had not plainly said so. Those who thought he had removed the mystery from light, reducing it to passive matter falling on the eyeball, were wrong. He had carried out

his demonstrations 'without determining what Light is, or by what kind of Force it is refracted'. The aether itself, he thought, might be light, though it was probably even swifter and more elastic; possibly the minutest rays, those 'least Parts of Light', never disengaged from aether, but were Nature's 'secret fire'. Or, in the final analysis, light might be God. There were still thinkers in the world for whom the multiplicity and velocity of light could be traced to only one source. Newton himself, his Bible thumbed to blackness and almost worn out with reading, was one.

Vincent van Gogh was another. In his thirties his missionary ardour convinced him that all the light he saw, and all the lights he saw, added up to God. The clear glow of a house or church at the end of a night walk; the slow ignition of street lamps as they were lit at 'blessed twilight', putting out yellow feelers through the mist and rain; or the 'simple and grand' arrival of the sun at dawn, always attended, in his experience, by larks singing. He went to the coal pits of the Borinage in 1879 because he wished to preach the way to light through darkness, symbolised for him by the pale, trusting glimmer of the lamps on the miners' hats. In the evenings he pondered the 'kindly' lamplight in his own room, where the silent girl bent to grind coffee or peel potatoes and then, disappearing, left him to his Bible and the whispering gas globe that burned all night beside his bed. It reminded him that God was everywhere as light, and that all he should do was seek Him.

For Galileo, tortured by light's relationship to God and creation, such an answer would have been too easy. The great astronomer admitted in old age that he had never plumbed the essence of light. He would be happy, he said, to have spent all his life in prison, fed on

COUNTY LIBRARY
PH. 01 4620073

nothing but bread and water, 'if only I was assured that I would eventually understand it'. A lifetime of solitude and darkness, therefore – rather than a career of peering through ground-glass lenses – might give him just as good a chance of knowing what light was. A similar thought occurred to Milton, who never wrote so movingly and vividly about light as after he had lost it, and entered blindness.

> ... thee I revisit safe,
> And feel thy Sovran vital Lamp; but thou
> Revisit'st not these eyes, that roul in vain
> To find thy piercing ray, and find no dawn;
> So thick a drop serene hath quenched their Orbs,
> Or dim suffusion veild.

At Arcetri above Florence in 1638, when Galileo was under house arrest for his 'heresy' of insisting on a sun-centred universe, the two men met. Milton was still young and clear-eyed; Galileo now declared his right eye 'lost for ever' and his left 'rendered null by continual weeping'. Nonetheless they talked of what he had seen through his 'optick Glass', Milton marvelling at the power of the old man's vision in times past; and also, perhaps, at how much, and how little, they had grasped about light.

Only Johann Wolfgang von Goethe, Germany's formidable poet-scientist, claimed to have 'known' light. He did so with the same cheerful confidence with which he wore, in old age, a black coat relieved only by his chosen badge of nobility, a silver morning star. He did not consider light as something physical, despite his unstinting observations of its effects through glass, on paper and in candle flames.

He recorded with reverence that it was utterly pure and untainted by colours, for all Newton seemed to say; and that it was his duty to strive for it, to the point where on his deathbed in 1832 he cried *'Mehr Licht!'* 'More light!' to make the servants fling the shutters open and bathe him in it as he died. He also said, more mysteriously, that truth was 'light rays flung out by a diamond'. Some encounter or revelation had persuaded him that this was so; he did not explain. Einstein, though, also approached the conclusion that light and truth were one. In his new world of relativity, shorn of absolutes of time or space, the only constant was the speed of light through emptiness. But what was it that travelled so, 'to all distances without end' in Newton's words, curving and 'fitting', as necessary, striking off colours as it went?

Near the end of his life, Einstein remarked that fifty years of conscious brooding had brought him no answer to the question, 'What are light quanta?' 'Of course today every rascal thinks he knows the answer,' he said. 'But he is deluding himself.' He had explained the physical phenomenon; the mystery remained.

Yet *God saw the light, that it was good*, Genesis said. This seemed to be the end of the story, with no need to ask why or how. Light was good both for what it did, bringing all things to be, and in itself: beautiful, simple, instant, pure. *And God divided the light from the darkness*, Genesis went on.

Darkness, though, was not so easily rebuffed. Light could not disown the black womb from which it had come. It needed it, worked with it and shone against it, as the blue sky was luminous only because

it was backed by the darkness of space. Without dark, light was nothing. 'Proud Light', *das stolze Licht*, sneered the demon Mephistopheles in Goethe's *Faust*:

> Strive as it will, it cleaves, as if bound, to bodies. It streams from bodies, it gives beauty to bodies, a body stops it in its course, and so, I hope, it will perish with bodies before long.

Light also held opposites within itself. It could be swift and still, tender and sharp, as Dante had experienced; and though it might be pure truth, as Goethe thought, it also bewitched and deceived with the shapes it made. 'Curse the dazzling of appearances, by which our senses are subdued!' cried Faust, lamenting that 'Red gold, volatile as quicksilver, melts away in the hand.' Traherne grieved over the 'Tinsild vanities' that had tricked him as a child, the glossy ribbons and shining farthings, and the 'dead' gold plate he had admired in the first noble dining room he had wandered into: always bright things, as flowers drew bees, or jewelled rings jackdaws. Any 'glitt'ring look', Herbert wrote, could blind a man.

Even daylight may be a distraction. It commands the stage so busily and glaringly that nothing prevails against it. Take away light, and the unseen garden lilac suddenly drowns the world in scent; the invisible sea breathes and purrs as loudly as a great cat stretching; and human instincts are sharpened like a reptile's, the whole skin alert to possible contacts in the dark with the unknown and the unimagined. But then light returns, doodling and dancing. Its artfulness is flame-like, and it was in this form that Ravilious most enjoyed it: fireworks, bonfires, wind-blown beams from lighthouses or cars, patches of

bracken ablaze on a hillside; even the simple, friendly flare of a match. 'I wish I had seen it,' was his reaction to any outbreak he missed. 'Have you looked up lambent yet?' he eagerly asked his lover Diana Tuely in 1939, perhaps having described her glowing skin that way:

> here it is – of flame or light – playing on surface without burning it, with soft radiance – of eyes, sky, etc, radiant – of wit – gently brilliant. Hence lambency, lambently – Latin Lambere, to lick. There you are.

It was good to touch, however elliptically, on the wittiness and intimacy, even cheekiness, of light.

Trickster-light was as ubiquitous as 'good' light, its con-man twin and other side. Wicked spirits in the Western Isles trod out lightning from ling and bracken as they journeyed back and forth. In Irish tales the devil himself turned crottins of sheep dung into glitter-balls to deceive girls, and poisonous yellow ragwort tricked the gullible into digging for gold underground. Marsh gas bounced and drifted before travellers, luring them from the safe road. Cohorts of jack-o'-lanterns attacked Coleridge on his night walks, as a student, outside Cambridge. They were something of a regional speciality; Newton, growing up in Lincolnshire, would amaze and terrify the neighbours by tying to the tail of a kite a paper lantern with a candle in it, and flying it in the dark.

In nearby Northamptonshire, 'will o whisps' frightened Clare whenever he saw them. Though crowds of them skimmed and danced round 'our fenny flats', especially in November and in misty weather, he could never get used to them, or feel that science and philosophy

adequately explained them. He cornered one odd luminosity near Nunton bridge; '& when I got on the bridge I looked down it & saw the will o whisp vapour like a light in a bladder whisking along close to the water as if swimming along its surface' – but, weirdly, going upstream. Returning home once from Ashton 'on a courting excursion', he met another:

> it came on steadily as if on the path way & when it got near
> me within a poles reach perhaps as I thought it made a sud-
> den stop as if to listen me I then believed it was some one but
> it blazd out like a whisp of straw & made a crackling noise
> like straw burning which soon convincd me of its visit the
> luminous haloo that spread from it was of a mysterious ter-
> rific hue & the enlargd size & whiteness of my own hands frit
> me the rushes appeared to have grown up as large & tall as
> whalebone whips & the bushes seemd to be climbing the sky
> every thing was extorted out of its own figure & magnified
> the darkness all round seemd to form a circular black wall &
> I fancied that if I took a step forward I shoud fall into a bot-
> tomless gulph which seemed yawing all round me so I held
> fast by the stile post till it darted away when I took to my
> heels & got home as fast as I coud so much for will o whisps.

The same *Irrlichter*, or false lights, guided Faust and Mephistopheles in their zigzag way through the obscene chaos of Walpurgisnacht, the witches' revels. (Mephistopheles mocked the *Irrlichter* for trying to imitate men; one false move, he told them, and he would blow their *Flackleben*, their flicker-life, clean out.) Goethe put no *Licht* in

this scene, for to him light was holy. What played across this land-scape was *Schein*: sheen, glister, surface flash, a sham thing. It created a witch-world, not a universe for the rational or the good. Goethe had seen such lights himself when young, walking near Hanau when the coach road was washed out by rain: a succession of little lamps in what seemed to be a quarry, arranged in steps, yet moving up and down, to and fro. They were perhaps not lamps at all, but 'shining creatures'. Given no chance to examine them, he could not decide whether these were false lures or blessings that danced before him in the dark.

At the close of the Walpurgisnacht scene Ariel arrived, bringing Faust visions of wonder. Yet this being, who rode 'on the curl'd clouds', was still an imp and a deceiver, who would dance as fire in the rigging of ships to terrify drifting sailors. His usefulness in Shakespeare's *Tempest* lay in his ubiquity: his ability to be here, there, everywhere and always, as agent, servant, enabler. (This was the very character of light described by Baruch in the Apocrypha: '[God] sendeth forth Light, and it goeth, and he calleth it *again*, and it obeyeth him with fear.') Yet Ariel was no more biddable than the wicked Mephistopheles, who could also ('Be here! Be there!') pop up in a cornfield, as a black dog, in a vineyard, behind the stove. And he was no less proud than Lucifer who, though fallen, preserved his name and with it the implication that he was formed and shot through with light, Christ's shadow twin. When Milton's heavenly forces sent angel-spies after him, Lucifer-Satan could still fly unsuspected past them:

> A shape Starr-bright ... or brighter, clad
> With what permissive glory since his fall
> Was left him, or false glitter ...

121

Traherne mistrusted angels ever after, once he knew that Satan too could pass himself as one.

The meeting of light and dark was sometimes explained, in medieval heads, as the clash between good and bad angels. The bad, created by Lucifer, became 'all that we perceive under the form of matter', Grosseteste wrote, while the good turned back to God. The bad were light in material shape; the good were light immaterial, of spirit, imagination or design. (Fairies, Hopkins was told by Father Byrne, an Irishman who evidently believed in them, were half-angels who had part-consented to Lucifer's rebellion, and therefore played their tricks on men both visibly and invisibly; they might be spotted, sometimes, 'thick as the heads of flowering grass'.) Some theologians taught that the first form of light was angels, and the Book of Enoch listed their names: Semyaza, 'the seeing of God', Kokabiel, 'the star of God', Yomiel, 'the day of God', and 197 others. They plotted, subverted and swore when they plunged down to earth, instructed men in weaponry, printing and the dark arts, and became the reverse of the luminous principles they were meant to be.

Yet this dualism between light and dark was too arbitrary and too easy. Matter itself, to revert to Genesis, was shaped by divine ideas, or light. Psalm 139 made the point that *the darkness hideth not from thee; but the night shineth as the day: the darkness and the light are both alike to thee.* In more pagan parlance, darkness or chaos was the pre-existing nature of the First Cause, before light; and to modern physicists the universe is made much less of impulses and shapes of visible light than of hypothetical dark matter and dark energy. A single photon, passing through a double slit, seems to become two rays and then, as

it constantly changes place, both light and darkness. And it was from the restless edge, clash or turmoil between these inseparable opposites that Goethe believed all colours came.

Much debate about the nature of light – whether material or immaterial, pure or adulterated, 'good' or 'bad' – revolved round colour. Did light have colour of its own? Even if not, could colours stain it? Did it merely produce colours, or was it also composed of them? Like fallen man, fallen light no longer had the simple glow of *lux* about it – a glow that could be built up steadily and unanswerably with thinnest layers of gold. Its close involvement with the dark left matters in dispute.

Transparency seemed to many the natural state of light, if purity was assumed to be its nature. That transparency might eventually become white, but only as crystal on crystal made up the whiteness of snow. Dante, standing in spirit in the sun, reported no colour there as light emerged. Light could mix with air, both Augustine and Grosseteste wrote, without the least corruption of its perfect nature. In Newton's day his critic Hooke persisted in the notion that colour was a compound of light and darkness, and that the prism merely added colours to immaterial, transparent light.

This equivalence of simplicity, purity and whiteness could barely survive what Newton discovered: all the colours of the rainbow in the differently refrangible rays of white light. It was true that sunlight, as it painted its way along his darkened chamber wall, was still 'perfectly and totally' white; but within it lay a whole kaleidoscope. 'The most surprising, and wonderful composition,' Newton wrote to a fellow scientist in 1666,

was that of Whiteness. There is no one sort of Rays which alone can exhibit this. 'Tis ever compounded, and to its composition are requisite all the ... primary Colours, mixed in due proportion. I have often with Admiration beheld, that all the Colours of the Prisme being made to converge ... reproduced light, intirely and perfectly white.

Palmer, at nineteen, seemed to prove this to his own satisfaction as he daringly sketched the sun: 'Each ray the finest possible line the lines many colours, the general tone golden – the sky just above the sun dazzling white.'

Around this time William Calvert, an engraver whose work he admired, told him definitively that light was orange. Palmer never forgot it, and said he disagreed, though the warm inherent glow of his paintings hinted otherwise – as well as the odd enthusiastic note, such as one of 1860, recording the 'raving-mad splendour of orange twilight glow on landscape' he had seen once at Shoreham. That same tint Jefferies saw in summer, deepening in autumn, 'suspended in the ... atmosphere, as colour is in stained but translucent glass'; he called it 'tawny', imagining that it added a fleeting undertone to the long bunches of wayside grass. ('The tawniness is indistinct, it haunts the sunshine, and is not to be fixed.') Many writers and painters assumed light must be yellow, the hue par excellence of happiness and brightness, as well as of the principal flowers of spring, when light returned. 'Life looks as fair at this moment,' wrote Thoreau in February 1841, 'as a blond dress in a saffron light.' Jefferies believed that the yellow of buttercups, which dusted children and made their chins shine, must also stain the rays that fell through the air.

Coleridge, typically, was less sure what he thought. In bed with a nervous attack in 1801, too prostrate even to say much to Wordsworth when he visited, he mused on 'the prismatic colours transmitted from the Tumbler' and found them changing into each other, orange to violet to 'Peagreen', when he closed his eyes. In this kaleidoscope, clear glass seemed lost. His observations of Nature also seemed to show light changing colour, as when he thought moonlight was modified from 'its natural blue whiteness' by the colour of a bottle-green sea. Hopkins seemed on principle to disagree: he was surprised, when lightning struck outside, to hear a colleague call it 'rose-coloured and lilac', and dismissed as 'sillybillying' the idea that white moonlight could be tinted, as Coleridge thought, 'blue or bottleglass'. Yet he too spoke of 'fond yellow hornlight' and 'bufflight' as night approached, suggesting such adulteration was possible. He also discovered in 1873, in Hodder Wood near Stonyhurst, that bluebells seemed to lend their colour to light; that light, 'beating up from so many glassy heads', became an emanation of their blue, '[floating] their deeper instress in upon the mind' until it flowed above as Mary's veil, sanctifying the woods. This effect could not be seen with flowers he picked singly, to sketch their inscape in his journal and 'know the beauty of our Lord' by them. Nor was it in 'the shock of wet heads' he brought back to his room in bunches, long leaves already languishing and the sweet milky gum (he had tasted it) smearing his hands. It was only in unpicked multitudes that bluebells made their holy light.

'Azuring-over greybell' was another phrase he used for them: strange words, suggesting again that the colour drifted above the flowers. (Coleridge, though, had seen the same effect on the Lakeland fells

in October, as the leaves changed: 'colors upon a ground, not colored Things'.) And there is a sense in which colour appears, like their honey-scent, to detach from bluebells in the mass, that improbable cobalt sea that washes the bases of the trees and splashes unhindered through arches of old barbed wire, while fresh green beech leaves float above. Anticipation of bluebells in April is so strong, amid the dusting and tinting blue of spring, that light and earth alike seem to carry their presence, even where they have never been known to grow. They do not grow in Friston Forest, between West Dean and East Dean; or so people say.

Friston Forest *April*

Mysterious notion
But nonetheless true,
If you wish them, you see them
The whole greenwood through –
Saturate blue

Hopkins was convinced, however, that the blue sky did not stain light. He declared both in poetry and sermons that it could not alter the sunlight, 'though smoke and red clouds do'. This was because, for him, blue sky had become a metaphor for Mary-without-stain:

Again, look overhead
How air is azurèd …
Yet such a sapphire-shot,
Charged, steepèd sky will not
Stain light. Yea, mark you this:
It does no prejudice.

Christ-light had passed through Mary, as St Bernard of Clairvaux had described the Incarnation, as a pure ray through glass; but, though ever pure in essence, light's look was bound to change by falling to polluted earth. Looking out, as Hopkins often did, over industrial Birmingham and Liverpool, it was hard to conclude differently.

Goethe would have none of this. His most passionate belief, outlined in his *Theory of Colours* and defended more fiercely than any other, was that 'shade and colours are not light itself', merely 'the deeds and sufferings of light' at the margin where it wrestled with the dark. Colours were 'half light and half shadow'. Light itself never changed, but appeared to be darkened by the thickness of the medium through which it was viewed. The blue of shadow, smoke or candle flame was merely darkness seen through light. When in 1829 his young friend Eckermann began to see 'coloured light' in moonlight, at dawn or on snow, Goethe snapped: 'You belong in the fourteenth century!' – the gaudiest age of stained glass. Light, he insisted, streamed from the sun in rays essentially unaltered by refraction or reflection, and its colourless purity arrived in the world unchanged, immutable as God himself.

Amid earth's turbulence, too, it did not alter. Light was 'a kind of abstract principle', Goethe said, which, on the slightest cause, could strike colour out of darkness. It could be acted on; it could be circumscribed, as by the dark, with which it continually struggled. (Light 'smiting … upon the shade' produced the tenderest tints in cast shadows, as Palmer reported; it reminded him of his own 'death-grapple with colour'.) But it was never weighed down or polluted. And it made itself known not by texture or staining, like some material thing, but by the energy it displayed, and the way it moved and lived.

Goethe's disagreement with Newton seemed white-hot, but in reality they were not quite so far apart. Near the beginning of the second part of the first book of his *Opticks*, Newton added a Definition:

> … if at any time I speak of Light and Rays as coloured or endued with Colours, I would be understood to speak not philosophically and properly, but grossly, and according to such Conceptions as vulgar People in seeing all these Experiments would be apt to frame. For the Rays to speak properly are not coloured. In them there is nothing else than a certain Power and Disposition to stir up a Sensation of this or that Colour … [by propagating] this or that Motion into the Sensorium.

He too thought in terms of the 'deeds and sufferings of light', or its 'innumerable vicissitudes', in his words. Light's alternating 'Fits of easy Reflexion' and 'Fits of easy Transmission' passed through his prism as many waves of successive light and dark. As a result colours sprang up still endowed with Light's qualities, nimble, 'copious' and 'brisk': especially his favourite 'very fair and lively' scarlet, and a 'good' willow-green. But to speak properly, the rays that painted colours on his walls and papers were 'blue-making', 'red-making' or whatever it might be, according to how thick and strong they were. In themselves, they were as purely white as the sun was.

Turner, the man who came nearest to painting light, was astonished at first by Newton's spectrum. He flooded his paintings with it – yellow, orange, red, blue, green, indigo, violet – but mostly in

the hope that some re-combination of these colours would recreate light itself. After all, Newton had seemed to suggest it would, and had even tried to prove it by experiment. The great scientist had had a go himself with painter's powders, mixing them by trial and error and sometimes on his study floor. By combining one part of red lead and five parts of *viride aeris*, he had achieved 'a dun Colour like that of a Mouse'. By adding 'a certain full purple which Painters use' to yellow orpiment, then dribbling in a little green and blue, he got 'a Colour equal in whiteness to that of Ashes, or of Wood newly cut or of a Man's Skin'. It looked considerably better when placed in the full dazzle of the sun: so much better, that a passing visitor glancing through the door thought Newton's puddle of mixed daubs looked whiter than white paper. Reading between his lines, though, 'dun' was the colour he mostly made.

Coleridge, ever seeking the One through the many, shared his enthusiasm for the all-inclusiveness of white. He delighted in the thought that white was 'the very emblem of one in being the confusion of all', and noted that a large single pearl, glowing with rainbow iridescence from that form-creating, cut-glass-faceted, shape-shifting sea, was called a *union*. All this was far easier for the philosopher to proclaim than for the artist to reproduce; but, nonetheless, Turner tried. Behind all colours, he felt, there was an essence, a *something*, to be discovered: he wrote of the eye 'piercing the mystic shell of colour in search of form'. Faced with a cliff of white chalk by the seaside – another relic and composite of that seething primeval ocean – he drew out the blues, reds and yellows in it, as if challenging real light to reveal itself. When one buyer grumbled that cliffs were only 'chalk,

and stone and grass', and that he failed to see those colours in them, Turner snapped: 'Hm, but don't you wish you could?'

He was forced to conclude, though, as the years passed, that even the most daring colour mixtures would not recreate light. Perhaps, therefore, Goethe's ideas were worth exploring. He read the *Theory of Colours* in his friend Eastlake's translation, kept a margin-scrawled copy in his library, and debated the issue as violently as Goethe himself did, until the subject of light had to be banned from conversations with his friends. He could still paint it, though, and in 1843 he did, as a blazing whirlpool of chrome orange, vermilion, chrome yellow, viridian, red lake and Prussian blue, giving way at the centre to yellow ruled by white, the sun's colours. He called this *Light and Colour (Goethe's Theory) – the Morning after the Deluge – Moses Writing the Book of Genesis*; or teasingly, when people asked, 'Red, blue and yellow'. He also added an explanatory poem of his own:

> The Ark stood firm on Ararat; th'returning sun
> Exhaled earth's humid bubbles, and emulous of light,
> Reflected her lost forms, each prismatic guise
> Hope's harbinger, ephemeral as the summer fly
> Which rises, flits, expands, and dies.

Where light forced out colours from the dark, in Goethe's view, it also conjured life. This thought too, in those humid bubbles, seethed in Turner's poem as a crowd of dim souls surged on his canvas, emerging out of the turmoil. *Am farbingen Abglanz haben wir das Leben*, declared Faust, rising from sleep in a sort of ecstasy of understanding: from the glance (or echo) of colours, we have life. It sprang forth

from them, evanescent as the rainbow joining heaven and dark earth, shifting and misting away even as it formed: *each prismatic guise, Hope's harbinger, ephemeral as the summer fly*.

On that same chalk track from Firle, in white-hot August, I had seen flints throwing off spectra like diamonds, as if about to spark fire; or life. (Hopkins once knelt before such spectra, flashing at dawn from potsherds on a frosted gravel path.) On the lower field in September I startled two peacocks, escapees from Firle Place, among the dun-white colours of ploughed chalk, gleaning the stubble verge as unconcerned as if they were in Rajasthan or Paradise, trailing their rainbows behind them. As Blake fell to wondering on Felpham beach, was everything, then, light? Line, raiment, life; Firle's great shoulder, its cloak of grass and the lovers laughing, as they swung down past me and I folded my book away.

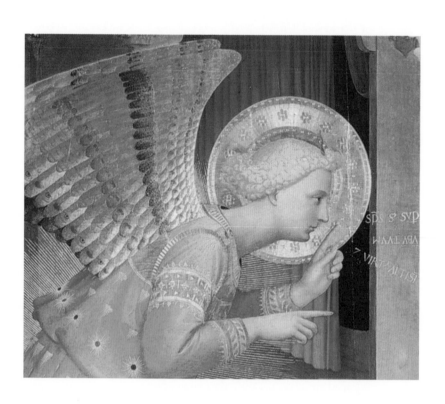

FALLING EARTHWARDS

Below the top of Firle Beacon, looking south towards the sea, there was once a field of oilseed rape that stretched for almost four square miles. We had a history, this field and I. In a baking July, I crossed it once, believing it was the shortest route from Newhaven to Charleston farmhouse to reclaim a scarf I had mislaid the night before. It was indeed the shortest, by the map; but there was a price to pay.

The walk began well enough. It was good to turn my back on Newhaven, a town now with none of the quaintness Ravilious loved it for, save the elegant white lighthouse on the jetty and the night ferry that slides, sidelit with windows, out of the port towards France. In 1940 he would go up to the cliffs above town 'twice a day like a man to the office'. Newhaven then was deep in war preparations, mound and ditch, concrete and gun emplacements, in which Ravilious nonetheless found lines of beauty as he painted on hazardous clifftop and quayside. Nights in Newhaven, he had written five years earlier, were 'so wonderfully pretty to look at' and obviously still were, 'except for raids', which hardly seemed to bother him. 'I could jump for joy sometimes,' he added. Now the town boasts a monstrous shiny incinerator, tangled ring roads, empty pedestrianised streets

and tired pebbledash houses, from which beauty has long since fled
into the hills.

I started out across the field. The turnip smell of the warm
flowers was intense, their yellow dazzling. Ravilious would have
loved them if they had filled the fields in his day, but I felt much less
confident. They were tall, up to my neck; this was a yellow sea in
which I might drown, one arm flailing, with no one there to notice.
I had no compass, which might have been a comfort; though in
light country, where the sea marks south, I could hardly miss where
north was. It lay ahead, and there was no way but *through*. The path
was perhaps a foot wide, apparent as I walked it but narrowing to
nothing before and after, as if it opened only to the uncertain pres-
sure of my boots. To north, south, east, west, the yellow field swept
relentlessly away.

At its centre – roughly, I suppose, for I had no way of knowing
– I began to panic. My chest was tight, my breathing too shallow.
The silence of the flowers roared in my ears; their glare deafened me.
Nothing lay beyond shoulder-high yellow except the hard blue sky.
Then, for some reason, I glanced down among the stalks. Thinner
stems were tangled through them and, above the stems, a small pale
face observing me, eye to eye. To my joy I realised it was heart's-ease,
the wild pansy of southern croplands: a cure for palpitations, I learned
later, appearing just in time. It was still shy, shaded by the rape flow-
ers and comprehensively outdone by them, until pulled close. Then
it revealed its own power: a tiny orange blaze at its centre, fading out
into yellow and pinpointed by tapering black rays as fine as if Palmer,
Blake or Ravilious had taken his pen to them.

In fact a trio of small flowers edged the path there, all of them tokens of light more delicate, and much more comforting, than the glare I was trudging through. Speedwell, the blue-eyed companion of dry summer walks, pressing, like its namesake Veronica, a cool cloth to the brow; eyebright, the sight-healer, its minuscule diamonds twinkling out of couch grass; and heart's-ease, the calmer of thoughts, carrying at its centre that glowing mark of the sun. All these appeared to have fallen from the sky, rather than to have pushed up from the earth. The heart's-ease, especially, seemed unrooted, woven into the tapestry of stouter, darker stalks as if a swallow, flying through, had left behind the straw it carried; as if it had materialised from some diviner place. Certainly Wordsworth took it so, as he recalled the little yellow mountain pansy, cousin to heart's-ease, in his 'Intimations of Immortality':

> The Pansy at my feet
> Doth the same tale repeat:
> Whither is fled the visionary gleam?

Other flowers too seem to have a higher origin: convolvulus, mayweed, even purple vetch, floating on their green wires. Favourite flowers of the poets were often loved for their sudden salutations of light. For Coleridge it was yellow broom; for Clare it was ragwort, with rough and tattered leaves, which nonetheless 'littered gold' about the fields; for Whitman the large drab yellow mullein, a weed of waste ground, which yet contained 'the suggestion of everything else' in his life, and whose soft leaves glittered with 'countless diamonds'. The sunflowers van Gogh loved, 'my own flowers' as he thought of them, were best

painted in a yellow vase, he wrote, as 'light on light'. But many flowers might do that service. Jefferies said that to hold any flower in his hand – a rose, trailing honeysuckle, the first harebell – was to see his soul reflected, as the sun in the brook.

Flowers of spring can appear so swiftly as to shock. White violets left beside the lane; crocuses 'dropping in', as Clare put it; glossy celandines piled underneath the hedge, cushioned by leaf-mould dark; a snow bank that separates into pink-flushed wood anemones at a glance. Their budding goes unnoticed; they arrive as full-blown light, 'like the thing that never knew the earth', as Hopkins wrote, each one apparently a gift for the eye that spots it. Thus, by my London bus stop, I saw an old man in a fisherman's waistcoat bend to greet bindweed with its paper-white, gleaming, flourishing trumpets, his mouth slightly and wonderingly agape, as if he had never seen such loveliness before; and on Worthing promenade I followed an elderly woman in a blue coat, hunched against the wind as if to protect, and keep secret, the bunch of fresh snowdrops in her stiff veined hands.

Primroses, especially, spill through the woods and on the railway cuttings as intense, condensed drops of the first warm sun of spring. Donne, 'being at Montgomery Castle, upon the hill', thought they made 'a terrestriall Galaxie,/As the small starres doe in the skie'; they might even turn into manna from heaven, if watered right. Clare thought each early primrose 'as delightful as if seen for the first time'. Hopkins in 1871, having put a few in a glass, marvelled at 'the instress of – brilliancy, sort of starriness' in them; and even massed on the banks, in their 'plots and squats', they looked like 'little spilt till-fulls of silver', Donne's galaxies indeed.

These light-shows of spring often come as unannounced as snow, and may be mistaken for it. On a mild January day at Cuckmere Haven, the sparse blackthorn blossoms on the hedge may be 'cloaths hung out to dry', as Clare called them – or perhaps paper decorations, blown on the twigs and tied there – or scatterings of stinging flakes out of the low grey sky. One February brought a solitary blackthorn tree to the southern slope of Parliament Hill, a white candelabra of fragile, almond-scented flowers. It must have been there before, but had not been there to me; and it was surely destined soon to melt away again.

Jefferies once found a bank of stitchwort that he greeted as stars, 'delicately white, in a whorl of rays'; they held 'but feebly to the earth', and often came away entire in his hand. Star-flowers or snow-flowers among the numberless fallen, in the war between winter and spring.

Above East Dean March

The wind belonged to Winter,
Pledged to him from the start:
Whipping the raw unguarded face,
Frosting the heart.

The sky overhead was Winter's too,
Scoured clear and blue at a blow,
But the clouds were Spring's, insubordinate,
Too delicate to snow.

Flints on the turf were Winter's shot,
Hard as enamelled glass,

But Spring deployed snowdrops, whose split pearls
Littered the grass.

In a downland copse, the last redoubt,
Blossomed a thin, bare tree
Tricked out by Winter in old man's beard
Where flowers should be.

But out of the brakes where Winter
Had marshalled his mounds of white,
Three sheep sprang up, stumbling, unwieldy,
Pregnant with light.

A mile or so from where those sheep surprised me, the first few daisies were open on the chalk: stemless, tiny, their round leaves drawn under them, scattered on the scrubbed turf as if they too were pebbles fired from the slingshot of spring. As a child I was so excited by daisies that I would run among them, and fall into them, as readily and scattily as I fell into the sea. Like waves, there was a suddenness about them, an unexpectedness in their swarming white presence round my feet. They surely did not grow or unfold in the ponderous way of roses or poppies, from their fat garden buds. Surely they were thrown down wholesale, as I tossed out breadcrumbs for ducks. Like waves, too, daisies were prodigal and inexhaustible: you picked them, pricked the so-thin stems with a slow nail, draped yourself with their strangely heavy heads in wilting dozens, and still there were more. From Walmer Castle and Polesden Lacey, two special days out, I remember the studded lawns of daisies and nothing else.

These were Geoffrey Chaucer's dearest flowers. In *The Legend of Good Women* he, or a poet much like him, walked in rapture among daisies, the eyes of the day, on 'the smale softe swote gras':

> Now have I therto this condicion,
> That of al the floures in the mede
> Than love I most thise floures white and rede
> Swich as men callen dayesies in our town ...

No devotion in him was more intense, for so tiny a thing.

> That blissful sight softneth all my sorwe ...
> And y loue it, and euer ylike newe,
> And evere shall tyl that my herte dye ...

In dreams the daisy appeared to him as a princess crowned with pearls, for in French – an apt and lovely pairing – the word *marguerite* means both the flower and the precious stone. Around his time, the jeweller-author of *Pearl* remarked that he had lost his little dead daughter as a pearl 'trendles' (slips) into grass, and he glimpsed her in Paradise, also in a dream, with double rows of them sewn on her sleeves.

In order to see the daisy's 'resurrection', that first unfolding with the first light of the first morning in May, Chaucer's poet would forgo sleep. Propped on an elbow, he would lie in the grass to see the daisy open, ray by ray, as the sun rose above the hill. Its petals were edged below with crimson, like the scattered clouds of dawn. These sleepings and wakings seemed synchronised, the flower's, the sun's and his own: for he felt his 'hertes line' sent out from him, as light from

his eye, in response to what he saw. He also sensed a mounting dread, powerful as his love, that the daisy might not open and the sun, therefore, might not rise. In his dreams daisy and sun processed together as lovers, she in her green robes and petal-crown of 'perle fine oriental', he with angel's wings and darts of fire; for though the sun was all light and majesty, she was his equal.

The humble spreading of light by smaller flowers was something Coleridge, too, treasured. He recalled with real feeling the lowly white fumitory on the roofs of hovels in Scotland and the star-white potato flowers in the fields there, pretty as 'the loveliest and richest flower Gardens', and urged himself not to forget them. In Malta he was entranced by orange blossom that, like daisies, 'oversnowed' the ground. In his notebook he copied out all Chaucer's lines about his best of flowers, together with the daisy-praises from William Browne's *Britannia's Pastorals*, 'Fair fall that dainty Flower!' He also jotted a memo to himself – having plucked a daisy he found blooming in the northern cold in March – never to pick a flower again, but to let it live and shine.

Another small white flower, the edelweiss of the highest mountain peaks, became for Emerson the symbol of Thoreau's rare purity of life. He did not truly understand why his friend spent so much time 'with muskrat and fishes' in the Concord swamps; he often condemned it as a waste of a fine intellect; yet seeing Thoreau botanising in his own woods, one day in 1858, Emerson understood him to be engrossed in something more than plants. In his eulogy for him in 1862 he remarked that hunters in Switzerland would scale the most dangerous cliffs to bring down edelweiss, and were sometimes found

dead at the foot of them with their prize clutched in their hands. Its German name meant 'noble purity', and it shared a genus, Emerson said, 'with our summer plant called "Life Everlasting"'. It seemed to him now that Thoreau was living in the hope of gathering flowers equally sacred and equally rare. The edelweiss perhaps most closely resembles the long-and-short sparkle of stars; that, and the white-flowered wild garlic, which sweeps for miles through the woods above Jevington in April in swirls of trailing, pungent leaves. As Jefferies said, 'Straight go the white petals to the heart.'

The Celtic Church celebrated such things. On the vigil of St Bridget's Day, February 1st, an old sheaf of wheat roughly modelled as a woman was carried round the villages of Ireland and the Western Isles. Each young girl would fasten to it a crystal, a shell, a daisy or snowdrop; even – if the weather was brutal – a spar of ice. For Bridget, or Bride, was the Christian incarnation of an ancient goddess of light, and she was decked with all the signs of heaven-sent brightness associated with spring.

Her special sign was the dandelion, 'the little flame of God' that both stared at, and tracked, the sun; she would appear at dawn with its yellow-rayed disc newly alight in her hand. This flower symbolised, in the old accounts, the gladness of children after winter playing at last outside (as the children of London a century ago would travel out to Kentish Town, then in the fields, to pick sheaves of drooping dandelions and buttercups, and ride back on the clanging tramcar with the sun wilting in their laps). Dandelions were Palmer's special flower; he mourned when they were uprooted as weeds from his garden in Redhill. Even when their rays fade their thistledown heads make points of light across the fields, together with glittering

dung beetles, dew on grass blades, darting tansy-flies: all the world 'sprinkled and showered with a thousand pretty eyes', as Palmer put it, and strove to paint it. As ghosts – tethered to a seed, dispersed at a breath – the flowers still shine.

Telscombe churchyard April

Dandelion, dinted dazzle in the grass,
sun-yellow yet, brave in your full brass
flourish and flare of flowers;
see here your fate, inwardly netting
ghost-globes of gossamer, each fine cross-fretting
pearling to pinpoints the escaping hours –

I thought them unkempt among the graves at first: weeds which the sexton, like Palmer's gardener, should have taken out. Later I found them most suitable for graveyards, perhaps nothing more so. Ravilious once buried the family cat in a wreath of dandelions, the sun underground, as in those Neolithic mounds near the Wilmington Giant; yet even picked and discarded and left in the dark, they form their perfect globes. Dandelions, as much as dwarf thistles, seemed to make up the clouds of thistledown Hudson saw in late summer on the Downs, so thick in the air, turning their glittering spokes towards the sun, that they appeared to be falling from heaven as much as rising from the ground. He had last seen the same thing in Patagonia, on the other side of the world. Thistledown as it drifts – bruising itself on clods and stones, somehow never quite landing – makes slow continuous revolutions, like a Ferris wheel or Fortune's wheel, fickle

as the stars. Coleridge, watching it in Cumbria in 1800, thought it flew among the mountains 'like life'.

St Bridget was also the patron of cows and milking: of the dairy, with whitewashed walls and sanded floor; of the gleaming tin bucket with its foaming, slopping load, and the quiet gold crust of cream. Heavenly light was at home there, and made useful. On her grass farm in Connaught she had twelve cows to be cared for; as she milked, pressing her fair head to the broad, warm flanks, she would pray for butter in her kitchen, 'the kitchen of the white lord' or Christ, and for milk that was pure enough for him:

> Thou wilt give me milk from the top of the club-moss,
> And not the grey water of the sand-drift …
> Thou wilt give me milk from the heather tops,
> Not grey milk of the taste of rowan berries,
> But honey milk and white as the sea-gull …

The cows gave abundantly, sweetly. Bridget's 'level lawn of kine' became an Irish idyll, her 'chalk-white starry sunny glen' a poet's dream. (Hopkins, confined to smoky Dublin in 1888, longed for a farm like hers in the western counties, with glow-worms and new milk.) In one corner Bridget kept her white wand, stripped from birch or willow, which conjured milk from the udders, white clover from the grass, cotton tufts from the bilberry-black moor and white-breasted oystercatchers from the shore, all her 'signals'; in another stood her loom, with its white warp-threads. And with her white hands later she would churn the milk, stirring and chanting, setting the gold flakes

dancing, until at last she could lift from the thin grey whey the dripping butter-globe of the sun.

Light in its various heavenly-lamp guises could often be brought down to earth: sometimes by mere homely comparisons but sometimes, too, with a bump and a blaze. Young, eager poets often claimed to possess these lamps anyway. ('The Skies were mine,' cried Traherne, 'and so were the Sun and Moon and Stars'; Hopkins told his mother there was no one, no matter how poor, who was not already 'owner of the skies and stars'.) They could thus be packed up or pocketed or, in Jefferies's words, treated like parlour furniture. St Bridget, not content with picking or churning the first sun of spring, hung her rain-soaked cloak on a sunbeam that spanned the room – what else was it for, indeed? – until, long after dusk, she allowed it to go. The beam bent, bowed, gathered itself from bowl and board, and vanished. She had mistaken it, she said, for a beam of wood, like one of those wheel-spokes of sunlight and shadow that sometimes roll slowly across fields or sky and pause, as though planted there. Hopkins, again, noticed 'splays of shadow-spokes struck out from any knot of leaves where the sun was/ like timbers across the thick air'.

It was the Greeks who first domesticated stars, tracing high above them not only heroes with their clutter of horses, belts and swords, but milk spilled in pale profusion across the sky (the thin, watery, bluish milk, flecked with froth, of goats pastured on dry grass and sharp herbs, bitter as the rowan berries of Bridget's northern moors). Milton and Whitman saw the stars as wheat thick in the ear, of God's sowing; a companion of Thoreau's thought a poor man could find them 'a kind of bread and cheese that never failed'. To Hopkins they

were sheaves spilling out sparkling grain, as well as jewelled versions of his 'May-mess' apple blossom and the 'mealed-with-yellow sallows' of March. Having seen trees as stars, he naturally compared the heavenly lights to 'wind-beat whitebeam' and 'airy abeles [white poplars] set on a flare' – besides the goldsmith's-haberdasher's list he jotted in an early notebook:

> The sky minted into golden sequins.
> Stars like gold tufts.
> – – – golden bees.
> – – – golden rowels …
> Stars like tiny-spoked wheels of fire.
> Lantern of night pierced in eyelets …

They 'peaked' in the sky, he thought suddenly. Peak with a sense of 'peek' in it.

> Altogether peak is a good word. For sunlight through shutter, locks of hair, rays in brass knobs etc. Meadows peaked with flowers.

Stars might also be hanging lamps, low enough to be trimmed or winged by birds; they might be Blake's silver and gold moths fluttering on nights of misty weather, or Herbert's beams-turned-to-bees, among which he longed to 'Glitter, and curle, and winde as they'. ('Twiring' was Hopkins' word for star-dances, an old word for 'winking', in which twirls and gold wire combined.) Vaughan, though dazzled by their 'Emanations/ Quick Vibrations/ And bright Stirs', also saw them chalked on the sky like tailor's marks. More often they were

145

embroideries stitched into the black backcloth of the world, like the 'tinsel' of metallic and silk thread that Traherne had so admired when he was a foolish boy. It was thus possible to imagine walking, brushing away fireflies and sparking at heel and toe, among what Galileo called 'the old and familiar stars'.

They could be plucked down, too. Surely winter elms, their bare branches scraping the January sky, dragged down stars with them – those pallid five o'clock stars that appeared half asleep through the teatime window – and wore them as a dowager pokes pins in her grey hair, not too many, not too bright, here and there. On Hampstead Heath my favourite copper beech, tossing at night in a winter gale, seemed held together only by a few stray, wavering light-grips, the flotsam of the constellations.

> Now when the bare night branches heave
> With January wind, and intricately weave
> Around me watching shadows of the far
> West-wheeling constellations, each pale star
> Stipples the tree, and me, in place of leaves

If winter stars clung to twigs, in summer leaves replaced and hid them. Jefferies was surprised once, when a leaf moved on the pear tree that overhung his window, to find a star behind it, ostensibly as pickable and close. ('I feel that there are infinities to be known,' he wrote, 'but they are hidden by a leaf.') Venus shone 'like an apple of light' above Hopkins in Birmingham, while Antares in the Alps was 'a bright crab-apple tingling in the wind'. Each was potentially tangible, as well as unimaginably removed. Whitman, meanwhile,

let his gaze roam among 'quintillions ripen'd … and quintillions green' in the tangled orchards of the night sky.

Stars might also be jewels for the taking, only slightly out of reach. Coleridge's son Hartley, aged five (his stretching for the stars as an infant already tenderly noted by his father), planned to reach the 'pretty Creatures' on a ladder, once he was a man. There he would 'pick 'em out with a knife', as he might pick the raisins from a pudding, and 'give them to Anny Sealy'. Perry Como, a 1950s crooner, put a falling star in his pocket and kept it there; when he felt for it later it seemed to have decayed to mere romantic glitter, as one might find a pocketful of crumbs.

Or coins, perhaps. A character from Spanish fiction, the miser Torquemada, reimagined the stars as pesetas, duros and half-duros scattered on the dark baize of a money-counter's desk. He could put them in piles, tip them tinkling into his scales, bite them to test if they were true (their taste, tingling on the tongue, part metallic, part stone). And he could wonder what they might have earned, at five per cent interest every century, over all the years they had shone there since the very beginning of time: since God had stamped His seal on them and shaken them out, too many to count.

But it was Traherne who, in the most uninhibited way, found his treasure there. His aim was to be 'Clothed with the Heavens, and Crownd with the Stars'. This majestic feeling, he wrote, was the natural state of anyone who understood that God's creation had been made expressly for him. As St Bridget might have said, what else was it for? He could pull on the sunshine like a cloak over his cheap leather clothes (with which he was perfectly content, as with his

'10 pounds a yeer' to serve his little parish). Casually, he could fetch down a star as a buckle for his 'old' high-crowned hat, the only possession he bequeathed in his will, save for his beloved books. He lived frugally, mostly on bread and cheese and apples, for he had been taught that 'He lives most like an Angel that lives upon least Himself.' But he could sometimes dine, also like an angel, on butter and cream, and presume that he owned – locked in a cupboard, pressed in a case – his own heavenly diadem, shut up safe.

Out of their sphere, stars were sometimes huge. In Revelation the star called Wormwood, the only one named, fell 'burning as it were a lamp' on the third part of the rivers of the world, turning them so bitter that men died from drinking them. (As a child I loved the idea of this star, wiry as a grey thorn, dangerous too, yet necessarily – because a star – winged and beautiful.) In the Ethiopian Book of Enoch seven transgressing stars 'like great mountains' were left trussed together in a terrible desert place because 'they did not come out at their proper times'. More often, though, they came down as unfearsome things that fitted in a hand.

One fell earthwards on my uncle's farm on Romney Marsh when I was seven or so. No one saw it drop; but Uncle picked it up from a furrow in the field below Teddy Lord's house, brushing off the dirt with his big, black-nailed thumb, and knew what it was. It looked a little like a fresh-dug potato, but smoother and much heavier. He broke it in half with a hammer; the inside was silvery and striated, raying out from a central core like a strange filamented fruit. It was

placed in the glass-fronted cabinet called 'the Museum' in the sitting room, together with a Samian-ware dish and blue-green glass beaker from a Roman burial found in a ditch; a dozen stems and bowls of delicate clay pipes; a golden guinea from the reign of Queen Anne, picked up as if also fresh-fallen from the grass beside a gate; and the egg box in which my cousins had arranged, in cotton wool, the mottled, mostly-blue birds' eggs we had carefully stolen over the years, blown end downwards. I was not surprised our meteor-stone had fallen near Teddy Lord's, for though the old man had died long ago his collapsing house, a corrugated-iron shack, might well magnetise a star. Besides, on a nervous trespass I had found among the rubble, in a wooden box, inside a small blue tin originally for Carter's Liver Pills, a dulled silver coin with strange swirling marks. I did not recognise these as Arabic then, and long preserved the coin as a token from another world.

In November 1872 Hopkins recorded a shooting star '[radiating] from Perseus or Andromeda' that fell one night on Stonyhurst College in Lancashire, where he was teaching: 'sending the kitchen boy with a great todo to say something redhot had struck the meat-safe over the scullery door with a great noise'. But Hopkins could find no fragments in the yard, and only 'the slightest of dints as if made by a soft body' in the meat safe, 'so that if anything fell it was probably a body of gas'. Smaller still, microscopically, stars grew in their quains across his bedroom window, north to south, when frost formed in winter: stars that were also veined leaves, flowers and trees. More scrunched on hoar frost mornings under Thoreau's boots, 'the wreck of jewels and the crash of gems'. Jefferies compared

these brittle frost-stars to the tiny shells of the chalk, but this time fallen, as it seemed, from unimaginable heights. Clare watched them shoot lines of ice from weed to weed on the banks of the little brook where he walked, lines from the Book of Job repeating in his head:

> Hast thou entered into the treasures of the snow? or hast
> thou seen the treasures of the hail,
> Which I have reserved against the time of trouble? ...
> Hath the rain a father? or who hath begotten the drops of
> dew?
> Out of whose womb came the ice? and the hoary frost of
> heaven, who hath gendered it?

A star fell into Herbert's lap once; he jumped up, brushing it off in fright like a spark from the fire, only to find that it began to speak in a small, disturbing voice. Another, he supposed, must have fallen into the communion wine, sweetly dissolving there like a piece of sugar. More stars lodged in Thoreau's coat at the outset of the New England winter, 'not cottony and chubby spokes ... but thin and partly transparent crystals':

> about a tenth of an inch in diameter, perfect little wheels
> with six spokes ... or rather six perfect little leaflets,
> fern-like... raying from the centre...
> A divinity must have stirred within them before the
> crystals did thus shoot and set. Wheels of the storm chariots.
> The same law that shapes the earth-star shapes the snow-star.

As surely as the petals of a flower are fixed, each of these count-
less snow-stars comes whirling to earth, pronouncing thus,
with emphasis, the number six. Order, κόσμος … six, six, six.

On second thoughts, they did not 'pronounce'. As they melted on his
rough woollen sleeve he thought they sang, as the farther stars seemed
to do.

Smaller yet, minutely small, they also came down in legions
through the air. In December 1784 Gilbert White found 'icy *spiculae*
[little wheat-ears] floating in all directions, like atoms in a sun-beam
let into a dark room'. He supposed at first that these were 'particles of
rime falling from my tall hedges', but realised they could not be. What
were they, then? Ravilious, commissioned to engrave the scene, made
the starry visitants more or less interchangeable with leaves, webs and
snow, creation dissolving round the forms of still and mystified birds.

So stars could be snow, coins, gas, or humbler still: embers, cin-
ders, sparks on a hearth to be swept up and thrown away. They could
be ashes and dust, as men were. Just stones, thought Traherne in extra-
buoyant moods, as small and close as the apple of his eye. The answer
to Captain Boyle's plaintive question in Sean O'Casey's *Juno and the
Paycock*, 'what is the stars, what is the stars?', was 'Any blocks, coal-
blocks; blocks, coal-blocks!' shouted by a vendor in the street outside.
In a Dublin tenement, it seemed, a star strayed to earth would be
hustled from the rug with brisk brush and dustpan, or stamped on
with a boot.

They might fall no more safely over water. On Coleridge's vari-
ous voyages to the Continent whole galaxies danced, sparkled and

perished in the foam by the ship's side. ('What these stars are, I cannot say – the sailors say, that they are Fish Spawn which is phosphorescent.' Or fish scales, he mused elsewhere; or 'bodiless Forms, colour but not substance … moonlight Elfins?') From the heath-slopes of the Quantocks, skylarks trilling overhead, he also counted 'diamonds' through half-closed eyes on the distant sea, each one immediately fading too. (This glare of light off water, so much brighter than from metal, puzzled Newton, who observed it in a fragment of 'Island crystal'; it was not understood until, very much later, scientists deduced that when light fell perpendicularly to a surface, its own reflection bounced back as dazzling interference.) Similar star-falls in water fascinated Thoreau, flashing off Walden Pond as 'an infinite number of eyes, to see for you and report the aspect of things each from its own point of view'. 'A hundred separate mirrors vibrating' was how Jefferies described them, each inclined at a different angle and 'casting a tremulous flash into the face': mirror to mirror, as when creation began.

Even ice could not trap stars, if they fell. The boy Wordsworth, in his clumsy wooden skates by night on Windermere, 'cut across the reflex of a star'

> That fled, and, flying still before me, gleamed
> Upon the glassy plain …

On the Ganges at Benares by night tiny lights on leaves float out from the hands of worshippers, rocking among the wreaths of half-drowned marigolds, to make a constellation all across the sleeping breast of the Mother River. The same effect was observed

by Whitman on the Delaware at night as the shad fishermen paid out their nets, marking the line with 'little buoy lights', or candles on floats, 'undulating delicate and lonesome on the surface of the shadowy waters'.

He could follow both false stars and true from the Camden night ferry, where the amiable Mr Whitall, an amateur astronomer, pointed things out to him and answered his questions. But any more facts than that – 'the proofs, the figures, the charts and diagrams, to add, divide and measure them' – made him 'tired and sick':

> Till rising and gliding out I wander'd off by myself
> In the mystical moist night-air, and from time to time
> Look'd up in perfect silence at the stars.

He did not care to 'dismount' them, or the planets he hailed as stars, but nonetheless they were acquaintances, each one displaying a different character of light. Red Mars walking the heavens as Lord Paramount; Sirius, 'calmly arrogant'; Lord Jupiter, 'dominating, majestic'; Saturn, distant and pale; Venus, 'languid and shorn of her beams, as if from some divine excess'; and 'vast-spread, roomy Orion, chief histrion of the stage, with his shiny yellow rosette on his shoulder'. Through that 'loose-clear-crowdedness' he seemed to stride, as if through the streets of Manhattan.

It may well have been under his influence that van Gogh began to paint his own star-filled skies, as lit up and bustling as the promenades of London or Paris. It was after reading Whitman that he began to feel the close companionship of the stars, 'greenish, yellow, white, rose … flashing like jewels', hanging low over the sea or calling

to him down the chimney; and began to wonder why he should not travel to them as easily as the train could take him to the 'black dots' on metropolitan maps.

They remained, however, street lamps to him, or at best a curious, jostling crowd; he did not grant them the familiarity of names. Whitman always did, and one in particular. With Venus he had a special understanding, or she with him, 'as if [she] held rapport indulgent with humanity, with us Americans':

O western orb sailing the heaven,
Now I know what you must have meant as a month since I walk'd,
As I walk'd in silence the transparent shadowy night,
As I saw you had something to tell as you bent to me night after night,
As you droop'd from the sky low down as if to my side, (while the other stars all look'd on,)
As we wander'd together the solemn night …

Venus was forewarning him of the assassination of Lincoln, though he did not know it then, nor how to interpret both her closeness and her distance: 'you, off then, aloof, moody as myself …'

Other poets, though, claimed the same special tie to her. Clare, on his 'love rambles' after Patty in the Helpston fields, declared that he kept company with Venus at evening and morning alike, greeting her as 'the Shepherd's Lamp' that he took along with him. More innocently Coleridge, when a schoolboy at Christ's Hospital in the East End of London, came back from swimming in the New River to find Venus, too, fresh-bathed and watching him, and fell in love with her. Up on the leads of the school roof, high above the City,

he kept solitary vigil at night with all the stars, the only beauty he knew.

The Plough, or Charles's Wain, or the 'seven stars', was also widely hailed as a friend. It was known to all observers in the northern hemisphere, parked in its homely ground near the North Star with the blade lifted from the furrow, and the work done. (In Africa, Asia and America it was a gourd, ladle or dipper, and hung in Whitman's sky ready to be plunged in meal tub or water barrel.) Other constellations tended to be ignored by artists. The Plough, though, sparkled delicately on Blake's fairies as they danced in enchanted woods, and hung low and brilliant as the moon over Palmer's fields; he depicted it so often that he thought he might make instant money, in a bad patch, by painting it with sun and moon on tavern signboards. It lingered, too, in Turner's dusks, bravely pricking those immense yellow skies. Hopkins saluted it, 'all golden falling', just before sunrise. Ravilious, who counted it among his 'objects of delight', engraved it hovering over rooftops in London suburbs, or peeping in at attic windows where careless girls lay asleep. Once he submerged it in an inky dewpond at the foot of Wilmington Hill, below the Giant, as the astrological bull-sign of Taurus gambolled heavily nearby. The Plough was abandoned there as in his other paintings rollers, harrows and ancient tractors were left to rust in the rain.

As easily as birds became stars, those seven stars could become birds. W.H. Auden turned them into squawking geese; Cecil Collins set them floating on a pond, seven swans, towards which he and his wife Elizabeth floated in a rowing boat. Stars could be rounded up, like hens, with a flap of an apron, or gathered in with bread like the

doves of the Pleiades. 'Flake-doves sent floating forth at a farmyard scare!' Hopkins wrote of them. They were tame. The medieval Irish author of *The Ivy Bower* had 'stars to my wish' around his little hut, as Thoreau did around his tiny cabin at Walden.

Nor did they necessarily shine in silence. To me, as to Thoreau, there often seems to be a faint, far song in them, closest to the needle-notes of linnet or goldcrest or the first crow of the cock, and continuously sounding. Yet it is also a near song, cold at the base of the skull; a song silver-sharp, curtain-quivering, blown past the window at which the thin rays scratch –

> *And where one quill, drifting from unknown height,*
> *Writes on the dark in quaver-strokes of light –*

Occasionally there is a vast chorus of such voices, as I heard one night when I was about fourteen. We were staying in the camper van on a seaside site, possibly in Ireland; I had crept out, avoiding the washing of plastic plates and the chaos of putting up the roof bunks, climbed a little hill, and found a deserted playground with a single swing. It was too high, but I half jumped, half pulled myself on to the wooden seat. I was quite alone. I swung slowly, the chains creaking, while above me and around me – as it seemed – the huge vertiginous sky of stars wheeled and sang with a single, steady, collective note. Though incalculably far away, the sound, and the presence of the sound, also seemed to creep under my skin. Without perfect pitch, I could not tell in what key the stars sang (unlike the evening in Brighton when I ran home to prove, with a tuning fork, that the sea sang in F). But it was hard to leave, in case as I climbed off – the

old seat banging in the small of my back – I should somehow disturb it or, worse, end it.

'In the holy eloquent Solitude,' wrote Coleridge in his notebook, the rest of the household asleep,'… the very stars that twinkle seem to be a *voice* that suits the Dream, a voice of a Dream, a voice soundless and yet for the *Ear* not the *Eye* of the soul …' And, specifically, for his own soul.

The moon, whether new or old, never sang. It moved across the sky in chill silence, an object rather than a character of light, at least on first appearance. In its first quarter it might be a feather adrift from bird, or hat, or pillow. As it waxed it might be a hair-slide, badge or brooch, or a lamp beside the door. This, too, could be reached with a ladder by an enterprising child; Blake engraved such a one, pointing to the lovely crescent and shouting 'I want! I want!' Failing a ladder, parental arms could lift a child closer, as when Coleridge ran out into the orchard plot with the weeping Hartley to show him the moon:'he ceased crying immediately – & his eyes & the tears in them, how they glittered in the Moonlight!' The babe was as enchanted as when he had seen long icicles hanging from the eaves with their drops shining in the thaw, each drop with a tiny lunar crescent at its tip.

Light's moon-guise was often heavily domestic. It might, according to the quarter, be cheese rind, a knife blade, a leather needle, a melon slice ('paring of paradisaical fruit', wrote Hopkins), or a hook to fish him up and part him delicately, 'leaf and leaf', like transparent mica stone. Coleridge wrote a soliloquy for the moon as a demented

housewife, complaining that poets had turned her into a sickle, a barley mow, an ostrich egg, a bowling ball and 'the half of a small Cheshire Cheese'. One night she was 'a round of silver completely lost in egg-tarnish' which then, with cloud-scouring, came good again; Dorothy Wordsworth watched her rise 'large and dull, / Like an ill-cleaned brass plate'. A slattern, then, in cahoots with idle maids, who might turn a coin in their pocket at the new moon to make their small wealth increase.

The moon's true size was for centuries a riddle. If near and lamp-like (or perhaps, as Heraclitus declared of the sun, 'the breadth of a man's foot'), rings might be run round it or hoops thrown over it, as with jars of sweets at a fair. It might float down far enough to tumble into ponds from which hungry village idiots, or jolly Welsh huntsmen, would try to fish it out again. ('Three Welshmen – moon in the water' Coleridge added to a list of jokes.) At Piddinghoe outside Newhaven, where the muddy Ouse winds round the base of a wooded hill and a neglected, round-towered church, moon-fishing was once a local habit, with 'fools' guarding barrels of smuggled brandy in the creeks by pretending to fish there and save the moon from drowning. The moon in water could be laughingly jumped over, as it was by Traherne's small brother Philip, who delighted to have leapt it in 'a little pearly River' on the king's highway – despite the danger of a fathomless fall into the upside-down sky. It could also be pissed on from sea cliffs by stout drunken men in frock coats, as Pieter Bruegel the Younger painted it, the crescent moon still lovely under the silvery impertinent stream.

At least one medieval poet saw the moon as a tramp: a wanderer of the hedgerows with lantern, dog and knotted handkerchief of crusts, the man in the moon brought low. Often the branches caught it fast,

and thorns tore it, while the ragged clouds snagged its long, rough hair. Even beauteous Diana, shooting her silver arrows, thrashed her way through bushes and thickets. For unlike the other lights of heaven the moon was entangled deep in earth's affairs, and with the intimacy and emotion of a woman. She controlled the running of tides, the sprouting of seeds and the menses of girls; the souring of milk, the catching of herring and the dulling of copper bowls. A stone called selenites (Thoreau noted) grew whiter or darker with the phases of the moon, and men reported that their beards grew fastest, in rhythm with her influence, every fourteen days.

But the moon was far less often vigorous than pale, sick and swathed in shawls. Her pockmarks, which the ancients too had noticed, were proof of unwise liaisons and amours. Blake called her 'leprous' once, and Hopkins at fifteen described her as 'pale with piteous dismay', seeking only a place to die. In crescent form, waning, she can seem to clutch with a fingernail the giddy slope of the sky; Coleridge detected 'a melancholy something' in her then, and a curse in her last crooked look at the earth. At harvest time, reddish and barred with low cloud, she can look like a rouged courtesan behind the slats of a Venetian blind. Whitman, seeing her in that season, thought her blotched face was swollen with tears.

Galileo had first played ungallant with the moon, intruding with his telescope to point out the spots and craters on her. Yet he did so in a series of six beautiful small watercolours, swift and borderless on a single sheet, using the newish technique of chiaroscuro to show her as both light and dark, half hiding. Pliny the Elder said long looking at the moon had induced the shepherd boy Endymion to love her, as she

him; and Galileo may have been drawn into the same intrigue. His last studies of her in his near-blindness involved lunar libration, or the 'most marvellous appearance' of the way she moved, swaying and tilting in the sky, flirting still.

> This was the last thing he observed of her:
> That when she turned her face to him, she moved
> To left and right, up, down, and to the side,
> As if she understood him and approved.
>
> Coquettish then, she leaned a little way
> To glance at him across her shining shoulder,
> Daring a smile; he could have stroked her cheek
> If he had been both livelier and bolder.
>
> He saw this too: that when she climbed the sky,
> Sculpted, some said, of phosphorescent stone,
> She shone with borrowed and reflected light
> That was some part the Sun's, but more his own.

The last treatise of his old age was on the secondary light of the moon. No, he declared, she was not made of Bologna stone, nor lit by Venus, but was given that ghostly glow by the light of the earth – which was thus a heavenly body itself, and a member of the company of the stars.

On a stormy December night in Brighton, walking home to my flat, I had a typically strange encounter in which the moon was involved. I consigned it to the notebook as soon as I had struggled indoors.

Tonight a woman I didn't know approached me in the street. She was perhaps forty, blonde, with a strained and windswept look, wandering alone. 'I know this is really random,' she burst out as I passed, 'but have you noticed how beautiful the moon looks tonight?'

It was indeed very beautiful: haloed in a clear sky, with Coleridge's star or two beside. The new moon with a bright star, Ravilious wrote, was 'really rather lovely and surprising' every time.

We stood and gazed, and talked more about it; how especially striking it seemed in its stillness, when the wind was fierce and the sea roaring.

When we had parted I looked at it again, and all had changed. Tattered clouds were surging across, the aureole had gone, and now the moon struggled upwards like a refugee, her waif-child lost, dishevelled in the noisy darkness, wandering alone …

For with the moon serenity is fleeting and the outcome is always in the balance, as it is with us.

Thoreau was deeply impressed with that struggle between the moon and the clouds. It seemed to him that the war was conducted especially for night owls like himself. The moon rebuffed the dark like a lamp set in an apartment or carried in by a woman, shining specifically 'for us'. But there was much more, he told readers of the *Atlantic Monthly* in November 1863, to be learned from her:

> Suppose you attend to the suggestions which the moon makes for one month, commonly in vain, will it not be very different from anything in literature or religion? But why not study this Sanscrit? What if one moon has come and gone, with its world of poetry, its weird teachings, its oracular

suggestions, – so divine a creature freighted with hints for
me, and I have not used her, – one moon gone by unnoticed?

To avoid that mistake he walked often by moonlight, and let her bright
tide enter his thoughts. For there was such a tide, he said, that poets
could feel. After his own immersion he sometimes slept a deep, sweet,
besotted sleep, like Endymion. On his rambles with the moon the
fields and trees seemed flooded, as though by a general inundation.
He could not see the path, but somehow felt it; could not see the bot-
tom of the grass but sloughed through it like water, fumbling still, out
of habit, for huckleberries in the bushes. Though her light was often
diffuse and pale, he noticed it reflected more sharply from particular
stumps in the forest, as though moon-seed were being sown in cho-
sen places. Whitman in Washington, more surprisingly, watched her
move through the White House, hanging the columns and porticos
with 'hazy, thin, blue moon-lace' and carpeting the marble in white.
But neither man learned a word of the moon's 'Sanscrit'. No more did
Coleridge, though when the moon came 'dim-glimmering thro' the
dewy window-pane' in 1805, he found himself reaching for 'a symboli-
cal language for something within me that already and forever exists'.
Goethe, in his own poem to the moon, described her wandering not
in the sky but through 'the labyrinth of the breast'.

Palmer's first memory of the moon – or of anything – was 'long
shadows' of moonlight stealing across his bedroom, seen through the
branches of a great elm outside. He was then 'less than four years old',
a child in petticoats. Later in boyhood he imagined Milton's 'Shady
roof/Of branching Elm Star-proof' as this tree. Stars were caught

by dozens in its branches, 'glistering … through the loop holes in the thick woven canopy', though the tree gently permitted the moon to disengage and rise. Beside him in memory stood his nurse Mary Ward, who had first read Milton to him and, years later, bequeathed him her treasured two-volume edition of his poems. Softly she repeated lines from that best-selling book of the time, one Blake had already illustrated, Edward Young's *Night Thoughts*:

> Fond man! The vision of a moment made!
> Dream of a dream, and shadow of a shade!

In later years Palmer often tried to paint this scene – himself, the shifting moon, the shades that were light – but could not do so to his own satisfaction. Instead he focused on the moon strong, steady, amber and supreme, or a tilted ark of peace. At nineteen, as he recorded in his one surviving sketchbook, he saw her as she rose standing tiptoe on a green hill, 'to see if the day be going and the time of her viceregency be come'. At her height a surge of unwavering silver turned the world strange, as she turned milk and metal; he preferred to show her just rising or just setting, assuming or tenderly relinquishing her full command of the sky.

There was no doubt, though, that she was 'his' moon, the ornament of his visionary landscapes, the guardian of his dark green dusks and apple trees, accompanied by her train of stars. At Shoreham, where the Ancients sustained themselves mostly on eggs, milk and gunpowder tea, many nights were spent walking or waking to watch 'natural phenomena'; the moon seemed then to 'blush and bend herself towards men' as she did not do elsewhere. Palmer, who loved the

Endymion story, drew his young sleeping shepherds sparkled and showered by moonbeams, as he was when he walked with her.

She was 'our moon' equally to little Philip Traherne, who not only jumped boldly over her but, 'brought home from Nurse' and running to the cottage door

> To do som little thing
> He must not do within,
> With Wonder cries,
> As in the Skies
> He saw the Moon, *O yonder is the Moon*
> *Newly com after me to Town,*
> *That shin'd at Lugwardin but yesternight,*
> *When I enjoy'd the self-same light.*

As for Ravilious, who thought it 'a waste' not to look long at the moon whenever it appeared, he left a college friend in 1927 with the remark: 'I should like to spend a whole night walking towards the moon – Good night' – and strode away in better company. In his country, on the clifftop near Beachy Head, I once saw a picnic seat set out for the moon as she hung, full, solicitous and undecided, at the shoulder of a well-dressed man determined to read by her, and keep her close, as soon as the sunset light had gone.

Men and women could be just as casual and familiar with light in its sun-guise. In common parlance it 'rose up' and 'went down' as if it circled the earth, or just one place in it. Clare as a child assumed that the sun

of Emmonsales Heath, down the road, was not the one he knew at Helpston, 'shining in a different quarter of the sky'. Even as an adult he supposed that Newark-on-Trent had its own sun, rising in the west and setting in the east. Every day brought a new one to serve him. Coleridge as a child waited for the sun to beam fully and particularly on his gilt-covered copy of *The Arabian Nights* before he would open it each morning; that service done, he would bask and read. The boy Ravilious covered his school sketchbook with spiky red-crayon suns in the midst of which his name, just as resplendent, rose over the hills.

Long after Galileo had declared the truth of the matter, the sun was still widely considered subservient to earth and men. 'The Sun serves us as much as is Possible, and more than we could imagine,' wrote Traherne. But like some silly servant, or some persistent pedlar, it might push in light where it was not yet wanted. Folk in the Scottish Isles talked of the *neb*, or nose, of the sun poking above the hills at dawn, and his loud *scriach*, or snuffling, at cockcrow. Donne shooed the 'busie old foole' away from gaps in the bed-curtains, eclipsing him 'with a winke', but he got through the glass. He climbed into the bedroom, into the nest of love itself. There, though, Donne put him in his place:

> Thou sunne art halfe as happy as wee,
> In that the world's contracted thus;
> Thine age askes ease, and since thy duties bee
> To warme the world, that's done in warming us.
> Shine here to us, and thou art every where;
> This bed thy center is, these walls thy spheare.

165

The sun was often dallying, or in beds, when he descended. Clare, in his poem 'Rural Morning', was relieved to see a sensible farm maid milking in the shade of a tree, where 'scarce a sunbeam to molest her steals'. In Wales shy young Francis Kilvert, after a parish visit in July 1870 to a fatherless girl at Penllan, found himself imagining that the sun had got there before him:

> [He] looks through her window which the great pear tree frames and lattices in green leaves and fruit, and the leaves move and flicker and throw a chequering shadow upon the white bedroom wall, and on the white curtains of the bed. And before the sun has touched the sleeping village … he has stolen into her bedroom and crept along the wall from chair to chair till he has reached the bed, and has kissed the fair hand and arm that lies upon the coverlet and the white bosom … and has kissed her mouth …

Some similar visitation may have inspired the haunting observations, precise and gradual, gradual and cumulative, as if lit by a sunbeam entering and strengthening, of a fifteenth-century poem:

> The maidens came
> When I was in my mother's bower;
> I had all that I would.
> The bailey beareth the bell away;
> The lily, the rose, the rose I lay.
> The silver is white, red is the gold;
> The robes they lay in fold …

And through the glass window shines the sun.
How could I love and I so young?
The bailey beareth the bell away;
The lily, the rose, the rose I lay.

Ravilious came across this poem in an anthology of 'Amorous and Fanciful Medieval Verse' he read in 1940. It was 'as moving as any', he told a friend; 'I loved it', though 'Heaven knows what it means'. There lingered in it some of the atmosphere of the bedrooms he painted, in a Navy hostel in Dundee and in farmhouses in Sussex and Wales, with their patterned wallpaper and high single beds, embroidered coverlets and neatly turned sheets. Here was that same quiet registering of everything on which light fell: the orderliness of it, and the sense of place. A chair would wait on the bare boards, by the wall. A door would stand open, perhaps leading to a stair down which someone has just gone; but the room would be empty, save for the sun.

Kilvert's Diary may have been in his thoughts, for Ravilious read and recommended him. The young minister heard from his parishioners that the sun did not merely enter houses but also sometimes plunged, like a bold young blood, under water. An old woman told him that at the Wild Duck Pool above Newbuilding, on Easter morning, it came down to dance and play in the lake to celebrate the feast. Modern travellers who fly above the Bay of Bengal see something similar: through the high cloud of the stratosphere the dazzling latticework of creeks, lagoons and paddy fields imprisoning the otherwise unseen, shaking-Shiva sun, like a gold crab under glass.

The sun in water, Jefferies believed, had 'more to do with us', and was 'a part of earth'. Its 'long, loving touch' left dreams there for him; when he scooped and sipped the sparkling water, he held the sun in his hand. (Less lyrically, he also thought he held it when he smoked a cigarette, that tight-rolled tube of 'sunshine dried and preserved'.) Beneath the surface its face could be surveyed at leisure, and its halo observed – though in a puddle, where Traherne once ambushed it, tramping feet got in the way, fascinating him with their suggestion of the order of things inverted. Turner, too, studied the underwater sun attentively, for hours, while he was fishing. Colleagues might have imagined he was contemplating only the effects of light on water. But he was also communing, in agreeable silence, with the great submerged star.

The alternative was to gaze at the sun through branches or a screen of leaves. I did this once in childhood through autumn chestnut trees on a day strangely warm for conkering, and with enough of the polished treasures in my pocket anyway. Gazing up from the grass, with the same sort of flashing defiance with which I would jab, then snatch, my finger from a flame, I found to my surprise not only that the rays were iridescent but that they swarmed in circles or spirals about two opposite poles, north and south, like iron filings round a magnet: movement inwards, as well as movement out. The orb seemed to pulse, too, like a heart – my own heart? – dilating and contracting. Since I couldn't look longer, I left my close acquaintance with the sun at that. Maybe Jefferies did better beneath his favourite apple and elm trees, absorbing rather than looking; maybe Hopkins did in July 1873 under 'one light raft of beech ... the sun sitting at one

end of the branch in a pash of soap-sud-coloured gummy bimbeams rowing over the leaves but sometimes flaring out', almost like a frolicking child. At times he dared to look it straight in the face, glancing up from mackerel-fishing off the Isle of Man in 1872 – cormorants screaming round him – to see the cliff brow 'crowned with that burning *clear* of silver light which surrounds the sun, and then the sun itself leapt out with long bright spits of beams'.

Ravilious seemed cavalier about it. His paintings, like Turner's, proved that he often gazed straight in that direction. 'I … looked into the eye of the sun as long as it could be borne,' he reported from Beachy Head in February 1939; 'the sun is no trouble, it is the wind I don't like.' His unflinching gaze seemed to tell him that the sun shone in a pattern of geometrical webs, something like a dartboard (he loved darts), towards which he could send his feathered missiles flying. In his engravings the sun was typically central, brutal and close, tangling in trees and once striking to the ground a terrified bird-nesting boy. He felt no such fear himself. He dreamed once of a sun with six rays, close enough to count, hanging in the sky with a gibbous moon, and his cartoon of himself on observation duty in Essex in 1939 ('Here is a picture of me saving the country,' he told Helen) showed him, in trench coat and tin hat and armed with a steaming cup of tea, calmly outfacing at dawn the spiky old sun of his schooldays.

Not so far from Beachy Head, as the crow or the gull flies, John Dudeney the shepherd boy also outstared it. Observing the transit of Mercury across the sun through some lenses he had 'met with', fixed in his pasteboard telescope, he forgot the danger in his eagerness, 'and in looking at it without due precaution I very much injured one of my eyes'.

The damage not only made 'lookering' difficult for a while but, worse, curbed his joy in the close, cramped types of his hidden store of books. One sort of enlightenment drove out the other.

Another such risk-taker was Benvenuto Cellini, sometime gold-smith, permanent brawler, who in 1539 was escorted from his dungeon in Rome by a beautiful, sadly un-wanton young man, and taken to a strange street in what appeared to be heaven. Cellini had prayed to see the sun in his dreams, for daylight never slipped inside his prison; and here it was. Like a huge lamp, it shone on the wall of a house; by climbing a great staircase, with care, backwards, he came right up beside it, the whole sphere dazzling while its rays shifted to the left and fell away. He saw visions in that circular 'bath of gold' of Christ on the Cross, Our Lady and St Peter, before he was thrust into the oubliette again. Strangely, his coat of mail had been replaced, during his sun-gazing, by a white shirt. In the sonnet he managed to scrawl afterwards, on a sheet of paper the castellan gave him, he wished he had left some mark of himself, some carved graffito, on the wall under the sun, just to prove he had been there.

The risk of any such boldness, though, was blindness, or possibly the shock of immense and real fire as the sun plunged near and landed. Walking in Lambeth around 1802 Blake saw the sun descend, 'fierce glowing fire' burning his back and then his very face; it stooped low, in the form of Los, and helped him bind on the jewelled sandals in which he could walk through eternity. Then, like some old friend, it wished him health and kissed him.

Another point of view held that the sun was never a threat, since he was lazy, timid and weary with advancing years. ('Thine age askes ease,' Donne had told him.) The cock and the lark, after all, had to prick him to

make him rise. Herbert once said he would find another 'willing shiner' if the present one would try no harder. Traherne, typically, could easily imagine 'a better Sun, and better Stars'. Palmer's sun sank behind the hills like another labourer going home, though his strength still glowed in sheaf and fleece. Clare's lingered 'as a traveller glad to rest … leaning his enlarged rim on the earth like a table of fire'. As for Vaughan, having watched the sun's slow decline each evening, he would then more or less dismiss him: '*There's one Sun more strung on my Bead of days.*'

The masculinising of the sun, like the feminisation of the moon, seemed to draw him closer. Newton invited him, almost bowing at the honour, to shed his beams through the holes he had cut for him in the shutter, and to paint his yellow-white body on the study wall – much as he had invited him, when a boy, to run across the pegs and balls on strings he had hammered up all over the farmhouse, and thereby tell the time for him. He noted the equal days and nights 'when the Sun comes to his Tropicks', a royal progress. Galileo, though, had spotted blemishes in the sun as well as the moon, for which he paid with the sight of his eyes; and by the late eighteenth century William Herschel, using a giant telescope fitted with reflectors, found the solar face covered with 'ridges, nodules, corrugations, indentations and pores', like a grotesque old man. Turner, whose father had been a Covent Garden barber, sometimes painted the sun that way, as if with an impudent shaver's brush. He may have cried on his sun-filled deathbed, as some claimed, 'The Sun is God!'; but he could take the measure of him, cheek and chin, between his thumb and finger.

*

Close shaves with the sun were rare. Heaven-light, though, could become familiar in the shape and guise of angels. They made for trees, roosting and resting there, and were sometimes summoned in Irish legends to interpret the songs of birds. St Brendan on his voyage in mid-Atlantic identified angels on Paradise Island, flapping their white wings and singing the offices of vespers, compline, sext and lauds; St Columba found miniature versions on every leaf of the oaks of Derry, where he kept his cell. Blake as a boy spotted some in the sootier trees of Lambeth, modern Peckham, 'the bright angelic wings bespangling every bough like stars'. (His father made to thrash him, but the next moment the irrepressible boy saw winged Joys there, 'sitting singing'.) At Felpham – a good place for 'Celestial inhabitants', with no London vapours clouding his windows – small silver angels 'planted in Hawthorn bowers' grew prettily from each twisted branch. Blake might almost have caught one; after all, he had once caught a fairy in his hat 'as boys knock down a butterfly'. Nor did they disappear when dusk fell. Around his poem 'Night' in *Songs of Innocence*, angels loitering in the forks of trees slid down to patrol the sleeping earth, accompanied by stars. Coleridge, who all his life invoked the four angels round his bed against his screaming nightmares, loved both the poem and the 'very wild and interesting pictures', tentative though he was about Blake himself.

Kilvert, whether ministering in mid-Wales or Wiltshire, often thought he saw angels. On July 21st 1873, as he sat under the linden tree reading *Memorials of a Quiet Life*, a figure in an azure robe strolled towards him across the lawn; 'but it was only the blue sky through the feathering branches of the lime'. At Clifford Priory, again in July, the light dresses

of the ladies and the tall garden lilies made him think that heavenly visitors were there. Three more angels appeared in a summer sunset, in the little open glade by the gamekeeper's cottage at Langley Burrell, when the keeper and two other men walked among the oaks 'in the gilded mist'. Vaughan confirmed that angels liked not only to rest but to 'grow' beneath trees, especially oak and juniper, where the shade was strong. Light and dark ever needed each other.

The purest angels were those that did not linger; they delivered their message quickly, and sped away. In most medieval depictions of the Annunciation the Archangel Gabriel did not venture far from the doorway, as if contact with earthly clutter – that chair, that book of hours, that vase of irises and modestly dinted bed – would pollute him. He stayed in his own light, the Virgin in her world of half-shuttered casements, and handed the lilies over from his realm to hers. They did not touch. Fra Angelico's crimson-robed angel at Cortona, his gold wings brushing the marble columns, shouted his 'Ave!' from the terrace, one foot poised to flee back through the garden, the golden letters delicately ranged in the air before him. The word of light became incarnate, though in code or shorthand, indicated by the angel's finger raised before his lips. (Blake said his writings were 'published' this way, the fire-words flying round the room as soon as an angel had dictated them to him.) In some instances, the message may have been hard to catch. In Edward Burne-Jones's painting of the scene Gabriel hovered as a tree of mild flame just beside the door, out of which Mary came with an expression suggesting that she had noticed nothing. The daylight had shifted somehow, perhaps; but nothing else had changed.

Traherne as a boy conceived 'a most infinit Desire' that an angel would come down to him like this, carrying from heaven 'som fair Book Fill'd with Eternal Song' to leave it at his foot. For surely legions of them were employed about God's business, in busy and continuous motion between earth and heaven. Jacob, dreaming in a place he later called Bethel, saw them ceaselessly climbing and descending a ladder, that back-and-forth motion of light; Blake's vision made this a broad spiral staircase down which his angels wandered with scrolls, charts and compasses, to build the world. In Dante's Paradise they wheeled, paused and wheeled again on every step, like a throng of sparkling birds; in Milton's Eden the cherubim, approaching to drive Adam and Eve from the garden, were as numerous as the 'will o whisps' that had chased Clare across the fens:

> Gliding meteorous, as Ev'ning Mist
> Ris'n from a River o'er the marish glides,
> And gathers ground fast at the Labourers heel
> Homeward returning.

Gliding implied silence; and it seemed that angels did not say much, as if their light was message in itself. There were exceptions, however. The Archangel Gabriel, visiting Blake in his study as he sat reading, got into heated debate with him about the merits of Michelangelo as a painter of angels. ('How do you know?' Blake asked. 'I know, for I sat for him,' Gabriel snapped back.) Blake challenged Gabriel to prove himself; with that 'confident insolence' angels had, he swelled up in light, forced open the roof of the study, ascended into heaven, stood in the sun and 'beckoning to me, moved the universe'. That settled the matter.

Blake claimed always to write 'under the direction of Messengers from Heaven, Daily & Nightly' – welcome or not, dangerous or not. Perhaps artists were visited more than others: young Palmer's sketchbook contained careful sketches of birds' wings rotated vertically, or angels' wings, as though they had unusually stood still for him. (He was of the opinion later that 'a whipping from an angel each Monday morning would ... do us all much good'.) In a set of mysterious drawing plans Ravilious wrote that the eye, hand and brain of an engraver 'might be various angels' and his soul their graving block, their possession of him complete. Cecil Collins caught one in his sitting room among the Windsor chairs, entering without knocking, naked, with a flower of inspiration in his hand.

Modern spotters of angels, especially in America, often see them beside highways and at bus stations, casual in T-shirts and jeans, helping the lost or distressed. They sometimes travel country districts as pedlars or salesmen in strange, patchwork clothes. Characteristically they say little or nothing, perform their acts of rescue, and vanish. They are also continually on the move, as light is bound to be, barely eating or sleeping between one small town or farmstead and the next. Having materialised in an instant, they are gone. I have never knowingly seen or heard an angel; but perhaps one bounced past me in full Lycra on a racing bike as I stood, completely lost, at twilight in a field on the Downs, pointing the way as he zigzagged uphill to a faint stile on the horizon. The sudden appearance and disappearance, the silence, the rescue, were all typical and thought-provoking; and the shiny Lycra, with its coloured flashes at thigh and shoulder, perhaps as good as wings.

Wings might be a hindrance anyway, for much angel-work was menial or hazardous. In Ireland Ariel and Uriel were supposed to attend the laying of each cottager's morning peats, the kindling of the flame and, at evening, the 'smooring' of the fire that left the room in darkness. They stood on bright guard beside the ash, as Milton's 'Bright-harnest' angels sat 'in order serviceable' round the dingy stable at Bethlehem. The angels St Cuthbert met on Lindisfarne made messy poultices of milk and wheat flour, thrust packages of bread into old roof-thatch and laboured, manhandling rough stones and filthy peat, to build his hut for him. Ravilious, to illustrate July, engraved the star-figure of Andromeda – a sort of secular angel – in short, plain work-robes on a Sussex haystack, too far up her ladder, teetering and about to fly, or fall.

For angels often fell too fast, violently as a peregrine smashing into the hedge. They could be hurt. The original fall of the bad angels, 'Hurld headlong flaming' into the dark, was not the end of the matter. On the west face of Bath Abbey they not only climbed Jacob's ladder but pitched headfirst down it, arms outstretched and hair streaming, like the terrified speeding angel engraved once by Ravilious in wild snow-flecked robes and with lightning in its hair. Milton's Uriel, 'Light-of-God', spying on Satan, plunged in haste perilous himself,

> On a Sunbeam, swift as a shooting Starr
> In *Autumn* thwarts the night ...

The crepuscular rays sent out by the sun are surely not to be climbed up, especially over water; they pour down slippery as oil, and at their base the gold of fresh-fallen angels pools on the bitter cold of the sea.

They also fell over land. Blake at fourteen, already imagining himself an angel or a lark, got tangled in Phoebus' silken nets while his golden wings were still wet with dew, too heavy to bear him up. Cecil Collins etched an angel spiky as a grasshopper, broken among broken rocks, his wings useless – as shocking as the dead swan I saw wrecked in the lane in Alfriston, somehow impossible as well as wrong. Gabriel García Márquez wrote of an angel grown old, trailing enormous buzzard wings and dressed like a rag-picker, who was found in a courtyard on the coast of Colombia and shut up in the hen coop. At first people threw stones and fruit peel at him, as if he was some sort of circus animal. Then they came to him for miracles, but he was no good at those. (A paralytic almost won the lottery; a leper's sores sprouted sunflowers.) When at last he flew away, his wings pecked clean of parasites and freshly feathered, little had been established about him and little deduced from his 'antiquarian' eyes: save that he did not know Latin, did not care to eat mothballs and was not, as some had supposed, a Norwegian with wings.

Or even a Finn; though a painting of a fallen angel by Hugo Simberg is almost a symbol of that country. It hung, the only picture, in my almost bare pine-plank bedroom in the farmhouse near Hankasalmi where I stayed in the summer of 1970, learning to drink sour yogurt from a glass, sew blue felt and swear in Finnish, and to sweat in the sauna until the outside air stung me like a flicking knife. Mosquito bites as large as boils kept me in bed for a day or so. I had only Simberg's strange picture to stare at; that, or the view from the small window of unbroken forest into which a white path ran, and vanished.

The painting showed two peasant boys carrying a primitive stretcher through drab fields past a bay near Helsinki (the same

landscape in which Sibelius saw sixteen wild swans flying, their wings rising and falling in alternate beats). On the stretcher, clinging on to the struts, sat a young angel robed in white with his head hanging down. He was blindfolded, so as not to see the muddied dreariness of the strange earth; or bandaged, perhaps, because wounded in the forehead, as well as in one faintly bloodied wing. He held a bunch of fresh snowdrops, as though to announce the spring.

What had happened? No one could say. The children of the family I stayed with, pale-haired and pale-skinned as angels themselves, did not understand the painting either; Simberg had always refused to explain it, or even to give it a name. This was perhaps an angel astray, drifting down into the wilderness without maps or instructions: out of orbit, like the Russian cosmonauts carried out carefully in blankets, silver suits shining, from the scrubby wheatfields of Kazakhstan. Or something stranger and crueller: a vertical crash through the forest, like one of those tapering streamers of sunlight suddenly blocking a path, spinning with wasps and dust; or an angel simply discovered, grounded, wings lifting painfully from the mud and thaw, with snowdrops in his hands.

Once out of heaven, however, angels were earthy as often as celestial. Blake saw one steal a peach from a tree and then, with a wink, 'enjoy' the lady who sat beneath it. The angels in the Book of Enoch mated like stallions with earth-girls, engendering babies with wool-white hair and sun-blazing eyes. At Bethel an angel wrestled till daybreak with Jacob; he played unfair, pretending to be an ordinary man, dislocating Jacob's hip (with a mere touch) when he saw he could not win, and refusing to give his name when Jacob asked him. 'Let me go,

daylight is coming!' he cried, the words of any wriggling vampire, but Jacob would not, until the angel blessed him. Dante was surprised by an angel in his chamber as, wretched with love for Beatrice, he slept the fitful, tearful sleep of a beaten child; the angel would speak to him only in Latin riddles, before answering his one timid question in crude, ordinary Tuscan. *Non dimandar piu che utile ti sia*: Don't ask more than is good for you.

In heaven the mouths of angels opened only to sip and sing; but nectar and ambrosia were not necessarily their chosen food when they descended. Milton's Raphael, feathered head-to-toe with rainbows, cleared his plate with real hunger when Adam and Eve invited him. ('Think not I shall be nice,' he said, and fell to.) The angels who ate with Abraham feasted on roast veal and flatbread until Sarah exclaimed at it; Rembrandt drew them unshaven and thick-winged, squatting to eat. The Archangel Raphael, sent to guide young Tobias, knew how to take a fish with a bent hook, disengage the bloodied gills, slit the pale underbelly, scoop out the greenish guts and fling them away, wiping his hands like a fishmonger on his pure white shirt. In the twentieth century Roger Wagner, an English artist, painted angels with blue wings and greasy robes like plumbers' overalls, picnicking in the shadow of the Sizewell B nuclear power plant.

Wagner was, and is, imbued with Fra Angelico, Blake, Palmer and Traherne. His light was theirs, and his angels were often rough. Typically they were reaping 'the harvest of the end of the world', sun-bronzed and strong-armed, barefoot, and with black straw hats crammed on their heads. (Whitman had seen them before him, 'Three scythes at harvest whizzing in a row from three lusty angels with

shirts bagged out at their waists'.) These celestial beings would sweat, undoubtedly; they would drink and swear (though their thrown-away beer bottles surely shone opalescent in the straw). Implacably they cut down the wheat with scythes and then, fiercely, tied it into stooks. In regular order they moved through the flat Suffolk fields, their wings spread taut as the blades of a machine. If any sign was left behind them, it was likely to be the sort preserved from the Archangel Gabriel in a church in Mecklenburg, as Clare read in the newspaper in May 1825: big, brawny, yellowish wing feathers, like those of a goose or a swan. One of Kilvert's parishioners heard angels of this kind over-head at night as 'great birds travelling', which 'sang and whistled most beautiful ... down the mountain towards Caedwgan'.

In a night sky, angels and clouds could be hard to tell apart. Both, according to the Book of Job, were God's agents:

> ... by watering he wearieth the thick cloud: he scattereth his bright cloud:
>
> And it is turned round about by his counsels: that they may do whatsoever he commandeth them upon the face of the world ... whether for correction, or for his land, or for mercy ...
>
> Dost thou know when God disposed them, and caused the light of his cloud to shine?
>
> Dost thou know the balancings of the clouds?

It was, and is, a common pastime to make something out of clouds; to shape them to things familiar, as Clare said, remembering his cattle-minding summer days spent dreaming on the grass. Hamlet twitted Polonius with camels, whales and weasels in them ('Very like

a whale!' agreed the foolish good old man.) Yet other clouds, as in Job, seemed more purposeful. They came low, as though they had something to say; as though they might disturb the trees, graze the river, enter buildings. Adam and Eve after the apple-tasting, trembling with apprehension, wondered why they saw in the east

> Darkness ere Days mid-course, and Morning light
> More orient in yon Western Cloud that draws
> O'er the blue Firmament a radiant white,
> And slow descends, with something heav'nly fraught …

This was the Archangel Michael, coming to expel them. In the *Vita Nuova* Dante saw a smaller cloud, *una nebuletta bianchissima*, that was the soul of Beatrice going before a band of praising angels as one of them. (Coleridge in Keswick saw a 'little fleecy cloud … above the mountain ridge … rich in amber light' that acted as a rearguard for the unseen setting moon.) Clouds too raced overhead, their white forms barely visible, by night – or stretched above the hills, protectively, at evening – or even fell to earth, as the poet John Masefield reported, when in his boyhood a cumulus like 'two enjoined beings' came speeding towards him, its long legs dangling over the hills. Jefferies, too, was startled when after a hailstorm a cumulus dragged along the ground,

> and one curved fragment hurled from the ridge fell in the narrow combe, lit up as it came down with golden sunset rays, standing out bright against the shadowed wood. Down it came slowly as it were with outstretched arms, loth to fall, carrying the coloured light of the sky to the very surface of the earth.

On the footpath that climbs up from Litlington towards West Dean I once encountered a chaotic cloud of trembling pink and white on the grass: an old apple tree in full blossom, blown over by the wind.

Single clouds, pillows puffed full of light, were 'gateways to Paradise' to Cecil Collins when he watched them from bed as a boy; later he would put them in his paintings 'to make everything happy'. Others took them for harbingers of hope – announcing, for Jefferies, the first blossoming of gorse in the hedge, and for Whitman the longed-for election of Lincoln as he stepped out, in March 1865, on the portico of the Capitol. A 'curious little white cloud' hovered over him then, like a dove. 'What do I heartily love?' Palmer asked himself in his notebook, and answered: 'One focus of cream white cloud.' He often painted this 'glorious' effect, and in one picture, *The Bright Cloud*, showed lovers on a hill entirely overshadowed by soft, massy heaps of radiant white. At Shoreham not only the moon, but those clouds too, 'rolling volumes and piled mountains of light', involved themselves almost overwhelmingly in the world of man.

Other avatars of light were less apparent. They stirred and flashed among pebbles, or thistles in the wind, or in the dappled leaf-fall under apple trees. One, no bigger than my hand, burst out in blue flame on the downland turf and, in a moment, vanished. They glanced, and were gone. 'Some lovely glorious nothing', Donne said angels were; 'Extreme, and scattring bright', with 'face and wings/Of aire, not pure as it, yet pure ... ' Milton's bad angels on the wing were compared to 'Starrs of Morning', but tiny –

> Dew-drops, which the Sun
> Impearls on every leaf and every flower.

In Dante's Paradise they gleamed 'as through the still and cloudless evening a sudden fire shoots from time to time, moving the eyes that were at rest, and seeming a star that changes place, save that from where it kindles no star is lost'. These celestial oddities and sparklings could be all the more mischievous on earth. García Márquez's ragged old angel last appeared 'as an imaginary dot on the horizon of the sea'. Coleridge was teased with something similar over Ullswater, while the lake itself lay unmoving like a slab of silver. 'A bright ruffledness, or atomic sportiveness – motes in the sun? – Vortices of flies?' he asked himself. Who knows.

Like him, pausing in mid-wander (this time at a stile, the foot-plank still glistening with frost), I fished the notebook out.

> *These things half-settled*
> *uncatchable by eye or word –*
> *shade-shift at my shoulder,*
> *flight of a frightened bird –*
> *a glance from the blank sky,*
> *inscrutable Morse code –*
> *my shadow, the day sunless,*
> *cast on the curving road –*

There was no end to the tricks, the winks, the distractions and the optical illusions. But nor was there an end to the efforts to pin light down.

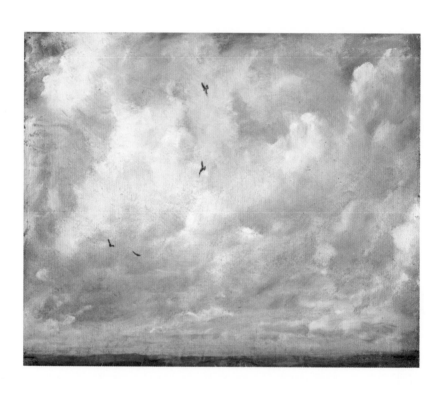

CATCH AS CATCH CAN

'I can't recognise that,' says Jack to George. 'Can you make it out?'

'No, I can't recognise it. Not at all,' agrees George.

The two old men are sitting at a corner table in the sun lounge of the Birling Gap café, a mile or so west of Beachy Head. It is a winter Friday afternoon; they are in no hurry to finish their tea. They have wind-beaten faces and silver hair and wear many layers of matted wool, like fishermen. From their slow, ambling talk, they turn out to be retired policemen. This was their patch in the old days: a terrace of drab Victorian coastguard houses slowly tumbling down the cliff, the café with a chain-link fence along the precipitous edge, and the steep metal steps down to the beach. At the top of the steps is a planking deck where a few small girls, armed with chunks of chalk, are carefully sketching out six-pointed stars.

Ravilious knew it well. In October 1927 he bought a postcard of the Devil's Chimney at Beachy Head by moonlight, above the lower lighthouse with its great beam shining, and drew on the tip of the pinnacle a lean young man reading a book. 'The stylite meditating is not a self-portrait – not this time,' he wrote, though it certainly looked like him. Some years later, from roughly the same spot ('a projecting

bit of cliff about four yards square'), he fervently admired 'an immense bar of light on the sea [that] is splendid and must be done'. His post-card stylite, however, was contemplating a huge full-breasted cartoon Venus, rising from the regular moonlit waves with gladly open arms.

Venus would cause a commotion in the café and a minor tsunami on the beach; but Jack and George are looking resolutely the other way, as though they have had enough of the wide, pale, winking sea. They are staring instead at a large wall-mounted photograph of the Birling Gap Ravilious knew. It shows a Scout camp of a dozen tents on the clifftop, a run of high, square cars on the road, and a different tea room on the edge. They struggle to remember it.

'That's not this bit of cliff,' says Jack. 'It doesn't look right.'

George wonders. Cliffs crumble and fall very fast round here. The Devil's Chimney went long ago; in a few weeks even this sun lounge will be gone, declared unsafe, together with the steps to the shore. But that is not what Jack means.

'You know the place where the pulley was, with the sacks that went down to the beach? I don't recognise it.'

It emerges that he means the sacks to haul up heavy contraband, or flotsam, or the dead bodies – shipwrecks or suicides – that are cast up here by weather and by cruel, tricking light. Some of those were the unknowns who lie at Friston, washed ashore among the white chalk, all along this coast. On a happier note there have been wrecks of timber; wrecks of mercury slowly silvering the rock pools; flotsam of velvets, lace and copper ore; wrecks of wine, caught from the leak-ing barrels in their shoes and caps by swiftly intoxicated sailors; and in 1790 a wreck, from the *Two Brothers*, of thousands of lemons, strewn

on the beach like hard yellow drops of Mediterranean sun. The locals turned them into tarts, curd, cakes and lemonade. Had the wine and the lemons arrived together, they could have made primrose-pale syllabubs the whole length of the shore.

'Maybe it's the light,' continues Jack, for the photograph really troubles him.'That's a funny light. I think they must've took it in the morning.'

Maybe they did, and some passing shiver or shadow made the scene mysterious. Yet on that day the photographer must have hoped he had caught light exactly, glancing off the peaked tents and the boxy cars, spreading its wings on the rocks. Just as surely Ravilious, painting his own Beachy Head panorama a few years later, hoped he had seized the way light lay on grass, crept on chalk, netted the sea; he described being driven out there time and again by Tirzah 'to see how the light looks'. But light had already been and gone, silky as Ginger Rogers – or as Venus diving back beneath the waves.

It proved elusive to scientists, too. Einstein at sixteen surmised that if he could run as fast as a beam of light in a vacuum he could draw up beside it, panting, and see it as 'an electromagnetic field at rest, though spatially oscillating': a wave frozen in motion. His second thought was that 'There seems to be no such thing.' He would never catch up with light, and might as well save energy. Where he gave up it would take a poet like Seamus Heaney, also by the sea in angel-filled Derry, to carry on:

> At any rate, when light breaks over me
> The way it did on the road beyond Coleraine
> Where wind got saltier, the sky more hurried

And silver lamé shivered on the Bann
Out in mid-channel between the painted poles,
That day I'll be in step with what escaped me.

Later Einstein pinned down, at least in an equation, the velocity of light in free space where nothing could obstruct it: the only constant in his universe of relativity. He called it 'c', as in $E = mc^2$. It was calculated – astonishingly – at 299,792,458 metres, or 186,282 miles, a second; and in 1983 the distance travelled by light in 1/299,792,458 of a second became the standard for the metre, as if the passing streak had left a solid mark behind, and those marks in succession – length, height, depth – mapped out everything.

By that minute fraction of the track of light the draper's assistant deals out tape, stretching and bundling it in single movements of her plump, ring-glinting hand; the builder, crouching, stakes out with string the foundations of a house; the jogger guesses at a glance the wingspan of a crow above Hodcombe, and the distance of a hawk on a post; and I measure my stride over the brush-dry January grass at Beachy Head, from one grey-green daisy platt to the next, and between the powdery chalk stones. By two of those infinitesimal winks in time you may span the height of a man, and by two hundred the height of the cliffs at the lower lighthouse: 'and you don't want one of those bodies brought in,' says Jack to George in the Birling Gap café, 'on a Sunday afternoon at the station, especially when you've been on nights the night before.'

They nod together, contemplating their empty cups ('Sure you won't have another drink, Jack?'). And light, which by Newton's calculation has taken seven or eight minutes to join their table from the

sun, careers ever onwards, across the wide sea behind them that is pinkish over the shallows, green above the deeps, to the prairies and lakes behind the clouds. Or perhaps that particular ray started out from the Horsehead Nebula in Orion, to pick out one sparkle among many: 1,500 years of travel for light between that point and Jack's eye, and for Jack a minute, because a friend who does upholstery in Eastbourne has taken a photograph of the Horsehead with his telescope, and Jack has a copy in his wallet. He shuffles it out from among the notes and cards. 'The colours have gone a bit funny, reddish,' he admits. But there it is, 'a really nice thing', with the farther stars glittering through the red haze round it. Somehow that light makes more sense and is more familiar than the flat, preserved sunshine from the 1930s at which they have been staring all afternoon.

'Just like a rocking horse, isn't it,' he says.

'And do you suppose,' George asks, 'it always looks like that?'

'I doubt it,' says Jack.

Grosseteste knew how to catch light. He set up mirrors, lenses and globes of water in his Oxford study, pursuing it as keenly as he sought heavenly grace. Newton could do it, too. Having induced light to negotiate a hole 'in the Window-shut of a very dark Chamber', he persuaded it through the crude, bubble-filled prism he had bought at Stourbridge Fair, to cast a coloured image on the opposite wall. By doing this, he wrote, he had done no violence to light – had not split or dilated or shattered it, merely turned the rays 'more or less out of their Way' – and he noted that the incident and emergent light, light going

in and light coming out, was 'of the same Kind and Nature', unharmed by the experience. It might show better, he admitted, if the prism were 'without those numberless Waves or Curles which usually arise from Sandholes a little smoothed in polishing with Putty'. He could snare even more light with bigger traps, such as his 'prismatick Vessels made with pieces of broken Looking-glasses and filled with Rain Water', or the polished glass plates he cemented together and filled with salt water or clear oil. His industry meant that where Grosseteste had merely begun to explain the rainbow, he completed the task.

The essential, he said, was to be quiet; to wait in silent contemplation for these effects, as for any truth. The more 'nice and troublesome' the effort to pin down light, the more circumspection was called for. Sometimes a racket couldn't be avoided, as when he had to lean with all his strength to grind down the concave metal plates for his reflection experiments. ('Then I put fresh Putty upon the Pitch, and ground it again till it had done making a noise, and afterwards ground the Object-Metal upon it as before.') But having waited so long for light he would then swiftly snatch it, rippling and wriggling before him. 'Are not the Rays of Light in passing by … Bodies, bent several times backwards and forwards, with a motion like that of an Eel?' he asked. It certainly seemed so; but possibly light was 'put into such fits at its first emission from luminous bodies, and continues in them … For these Fits are of a lasting nature.' Moreover, 'what kind of Action or Disposition this is, whether it consists in a circulating or a vibrating Motion of the Ray, or of the Medium, or something else, I do not here enquire'. He noted, however, that three eel-bendings seemed to produce the three rainbow fringes he saw round things, separated by thin lines of dark.

This was slippery stuff indeed. And his analogy was not as odd as all that, since his contemporary Izaak Walton reported the belief that eels were bred 'of a particular dew falling in the months of May or June', which was then transformed into elvers by radiant solar heat. On the surface of one river, near Canterbury, young eels would lie glistening 'as thick as motes are said to be in the sun'. Coleridge might have liked that image, for in his *Ancient Mariner* the eel-like water-snakes round the doomed ship gave off 'elfish light' and flashes of fire and were, in the Hebrew, *seraphim*, sun-flares that cleansed and burned.

An eel, Walton wrote, was most easily caught by snigling, or teasing a hook directly into the nest-hole underneath the bank. A warm summer day was best for it.

> *Snigling's the way to take*
> *an eel, they say; slithering hand and hook*
> *down the slick bank, mud-slathered,*
> *grass-sloughed (yourself prone,*
> *breath-held), to underwater lair –*
> *where, with nibbling finger*
> *flickering, flicking, in and out among*
> *a writhing squirm of tails, sleep-slippery*
> *skins slipping past, with nicked nail or needle*
> *you catch on something,*
> *pull it up to sight –*
> *line-jiggling, coil-wriggling bright –*
> *and thus (so Newton said) he fished up light –*

He even devised something like a net for it, testing the distinctness of his refracted prism-images by '[lapping] several times a slender Thred of very black Silk' round thin pasteboard which he had painted least-refrangible red and most-refrangible blue. ('I might have drawn black Lines with a Pen, but the Threds were smaller and better defined.') The finer mesh, naturally, the better. Clare was shown a similar grid of threads that was intended to simplify landscape drawing, but thought it not a patch on the 'instantaneous sketches' made by sunlight – not least when, crouching with wet trouser bottoms in the flooded meadow stream, Walton's 'delicious' *Angler* in his pocket, he saw 'a sizable gudgeon twinkle round the glossy pebbles or a fish leap after a flye'.

Turner, too, caught light by fishing, as well as by noticing less obvious places where it lurked. He would spend hours pondering and drawing stones, prodding them occasionally with his huge black umbrella. The time he devoted to such lowly objects astonished his friends. 'That's pretty,' he would growl, of some mossy stone, and mark it down for a light-carrier in the foreground of a mountain scene. He would squat, too, on the silty flats of the Thames foreshore, a short unprepossessing figure in a tall black hat. Passers-by might suppose he was mudlarking for coins dropped out of boats, for he was said never to part with a ha'penny without looking at it twice. But he was marvelling instead at the parallel ripples made by wind, tide and light.

Sitting on a bank of the Thames, or floating in a boat, he would trap light with hook and line as it danced upon the surface or glided on the gravel bed, a trout. 'There it is,' he would remark, to no one in particular, as he began to fish. His edible catch he might draw

later, flanked and filleted with yellow sun, or mottled with the fast-fading 'rose-moles' treasured by Hopkins, who fished too. His inedible catch he would paint from secret colour-scraps behind a locked door, constantly revising the tints and, if necessary, keeping them fresh by dunking his efforts in a bucket, or under the pump in the yard. The bread in his pocket (never to be mislaid, and sent back for if forgotten) was both bait for fish and a sponge to lift paint off paper, revealing the mistier half-lights. Blotting and scraping, some of it with a long black thumbnail like a hawk's claw, might get light itself. Once caught, the shining scrap would be flung on the ground to dry beside the still-convulsing fish threaded on a grass.

For Palmer, etching and painting required the same level of solitude, silence and contemplation. He reached this understanding late. 'Mad I mean to be, till I get more light,' he cried in a letter – unconsciously echoing what Goethe had shouted at the end. Much of his working life was spent in hectic pursuit of something flickering before him, ever eluding him, and vanishing. 'And wherever I find it,' he went on, 'I will turn to it like the sunflower … like a little child crying for food.' Light, air and bread, he told his eldest son, though the commonest things, were also the best – and in that order. As a young man he tried to catch light in words as well as paint: his 1824 sketchbook contained a poem in which, in ten lines, he invoked 'trembles', 'glimmers', 'twinkles', pearled flowers, the pure white moon, silvered brightness and a 'sweet visionary gleam'. Yet the passion calmed. He described himself in 1867, in late middle age, working with 'sweet Tranquillity' on a painting called *The Haunted Stream*, touching light on leaves and water in 'a much-musing mood'. For there was no other

path to success. Quietly, slowly, with dabbing brush, he would capture a sparkle or two in the 'chasmal hollows' he had made.

Writers who longed to waylay light sometimes followed it under water. Coleridge in nostalgic moments dreamed of being a fish, specifically a trout, 'gliding down the rivulet of quiet Life'. Leaping – just occasionally, gracefully – in the sunshine, he would spread on the surface his own 'concentric Circles of Light'. Thoreau, who could take fish calmly in his hands and pull them from the water, wished 'to lurk in crystalline thought … under verdurous banks, where stray mankind should only see my bubble come to the surface'. Jefferies noted that while the shadows of trout darted on the river bed, their higher swimming bodies were invisible in light: light and fish lurked and rippled together, as he would do, once sun-life had invaded him. The contribution of Ravilious to this line of thinking was to engrave swimmers moving slowly, thoughtfully and half submerged, with dipping hands about to scoop up curls of sunlit cloud from the bottom of a pool.

It seemed that light might also reveal its animate nature, shadow-faint, against whiteness. White walls might betray it, or white paper, sometimes carried out deliberately into the glare of the sun. Newton saw two subsidiary streams of faint light, flicked from a knife-edge, shoot out from a sunbeam into the shadow, crossing a white paper 'like the Tails of Comets'. Hopkins reported, on the wall of his room at Stonyhurst at sunset, a 'fuming of the atmosphere marked like the shadow of smoke' that might have been live light. Light coming through leaves, or 'without a break from the brim of the fells', had produced the same effect, 'and this got less and less distinct on white paper which I moved towards the window'. Coleridge saw 'coral-shaped'

shadows, though they were hard to disentangle from the long flower-
ing of a teaspoonful of laudanum down the sides of an adjacent glass.
He caught, too, the after-image of the moon, which slid down the
white paper after his pencil in a yellow spot the size of a shilling; as
well as the 'Beautiful luminous shadow of my pencil point following
it from the Candle – rather going before it & illuminating the word,
I am writing.' Light and word as one. It was, he added, eleven o'clock.

The presence of light on a white surface, though, could have a
more frightening effect. Its sheer unmarked glare might make impos-
sible demands, and also threaten mayhem once it was touched. One
pen-dot or brushstroke would do it: a challenge, as small as a midge
landing, to light's own potential to create the world. Vincent van
Gogh described the white canvas staring him in the face, saying 'You
can't do a thing.' He called it 'paralysing'. Goethe felt the same, reach-
ing instead for 'grey old common paper' on which to draw his trees, 'as
if my awkwardness feared the touchstone of a white ground'. Again
that awe crept in, of light as truth. Even Turner, who certainly rec-
ommended 'respect' for blank white, preferred 'blue' paper – in fact,
flecked grey – and used stacks of it, torn into smaller sheets as needed,
when he was travelling. It was especially good, he found, for flatter-
ing light by emphasising the white he used for the crests of breaking
waves.

Palmer wrote a note to himself, 'Make friends of the white paper',
as if acknowledging his nerves in the face of light. He succeeded up
to a point, but confessed that he would rather sketch on 'brown-
ish paper', heightening with white chalk, or on 'the lightest whitey-
brown … or buff tint': something with the warm tone of washed

rags in it and not, on any account, smooth and bleached. Light was too hard then: so hard, shiny and brittle that Ravilious felt obliged to apologise when he used such sheets to print out his engravings. White paper turned Hopkins's bluebells 'steely', and made 'wretched' the little bunch of first snowdrops he picked to send – but could not send, in the end – to his mother in the spring of 1871. His implacable, too-much-demanding God was in that paper: 'God is light,' as St John wrote in his first Epistle, 'and in him is no darkness at all.'

Yet a white ground still seemed the best trap for light; white paper brushed with watercolour, so that the paper shone through the paint. Oil paint, in the minds of many artists, was too opaque to give that beautiful transparency. Turner managed it consummately, priming his canvases with lead white and chalk. But Ravilious, dealing as he often did with whole landscapes underlaid with light, thought oils were like 'using toothpaste'. Blake loathed them. Oil paint, he remarked, became 'a yellow mask' over all it touched: 'a fetter to genius, and a dungeon to art'. The best paintings, in his opinion, had historically been done on 'Plaster or Whiting grounds' and nothing else. Real gold and silver, he also complained – those medieval substitutes for light, with which he sometimes flecked the borders of his watercolours – could not be used with oils. The glow of fresco and tempera was what he was after, occasionally sparkled with shell gold; and 'real fresco', though in watercolour, was something he claimed to have revived, in an age when it was completely out of fashion.

Accordingly he primed his boards with a secret mixture, 'Blake's white': fundamentally lead white and carpenter's glue, the use of which St Joseph had revealed to him. That sticky ground laid down

on copper or pasteboard, the pigments went straight on; and never more luminously and beautifully, perhaps, than in the little books of 'Songs' he produced ostensibly for children. Palmer, entrusted with the secret recipe, followed with his usual devotion. 'WHITE in FULL POWER from the first,' shouted a slip of cardboard pushed into his notebook, a slogan to live by. A dark ground, in oils especially, 'puts out the light and then puts out the light', he said, invoking Othello at the moment of murder. Another try at oil-painting, in 1852, called for an almost aggressive list of 'necessities', starting with 'A brilliant white ground' and ending with 'a little copal, and spike oil, with very stiff white, painted freely and boldly with hog-tools, so as to get a permanent thread and texture'. Palmer switched from paper to white London board because 'it reflects light through the pigments', a vital point. When the new zinc white came out in the 1830s he laid his grounds for watercolour with that – producing, to his great satisfaction, a ground somewhere between white paper and the very fine ivory on which he had occasionally painted, heightening with shell gold, at Shoreham. The radiance of zinc white, he said, was like light through a stained-glass window.

That hint of sacred revelation, too, may well have come from Blake. His new way of 'illuminated printing' – engraving text and pictures on the copper, melting the background away with aqua for-tis, then painting the relief engraving in watercolour thickened with chalk – had, for him, a singular importance. This was 'printing in the infernal method, by corrosives, which in Hell are salutary and medici-nal, melting apparent surfaces away, and displaying the infinite which was hid'. The infinite meant, for him, everything that might be seen

once man's perception was cleansed. Infernal methods were those used by devils, who in his cosmology were revolutionary, iconoclastic and wise. To catch light, violence might be necessary: either corroding copper or, when etching directly on the plate, digging and gouging, as he had done when scraping light with the burin out of hard-grained wood. To catch a stream in moonlight, tears on a cheek, sun diamonding the waves, his advice was 'Etch the whites & bite it in' – beginning, and stabbing deepest, to bring out the point or focus of light on every single object.

That focus was the cause of my own first conscious struggle with light. I was eight, and with my new Christmas present of Faber pencils in their green cardboard case – the lid prettily decorated with a girl in Bavarian dress – I had decided to draw a still life of a bowl of apples and a glass of wine. I did not copy them, since wine was never seen at home in my childhood, save the sticky, mellow bottle of ten-years-in-the-sideboard sherry that was produced on grand occasions. The montage simply appeared in my mind, grandly framed by curtains. Lying on the floor near the fire in my grandparents' house, snow banked outside the windows, I pressed my sharp new pencils as firmly as I dared into a piece of pristine white card. A very hard line seemed essential to the enterprise. I was careful to leave, though, some points of shine on the apples and lustre on the glass; these were clearly, I realised, the life of the thing, and had to be as bright as possible. But as the rest of the picture grew steadily darker with vigorous 2B strokes, the precious white spots I had reserved were constantly smudged by my hand, and had to be rubbed clean again with the corner of my smallest eraser. It was a continuous effort to rescue light

from the grubbiness, haul it up again and buttress it safely with deep, dark lines, until I felt wearier with drawing than I had ever been. My picture won a prize, though, of a green mapping pen with a beautifully fine curved nib, like a little claw; and with that I learned to scratch light out of black boards in which, far from bullying and smudging, it seemed to lie dormant, and delicate, and quiet.

This was quite out of character, however. Light was the swiftest, subtlest thing there was, 'instantly here and instantly among the stars', as it seemed to William of Conches in the twelfth century. In the outer regions of Paradise, as Dante reported, even the *lux perpetua* shivered and swarmed with angels, who were all light. Perhaps light, then, really was entirely angels, good and bad, as some of his contemporaries claimed. Dante saw light so living that it quivered as he looked on it, and flashed with frequent lightning before it spoke. And this was within the eternal shrine of heaven, where light was presumed to be virtually at rest.

In everyday life it often sprang from friction and agitation. Newton listed the many ways light broke out: from seawater fretted in a storm, the rubbed back of a cat or the neck of a horse, steel struck with a flint, amber struck with a stone, axletrees igniting in a chariot race. A glass globe, rotated very fast, shone against his palm and made his finger 'lucid like a Glow-worm'. These effects lasted a mere 'second of time', uncatchable and uncontrollable. Hopkins sparked light unintentionally as he took off his thick wool jersey in the dark, 'with an accidental stroke of my finger down the stuff'; Coleridge claimed to have tried the cat experiment, to see if the fur-sparks were refrangible through a prism, and come away covered in scratches.

Even in still life, light was not still. On the painted walls of Pompeii it was a burglar in the kitchen, tumbling the apples and ruffling the breasts of the shut-eyed hanging birds. Closer inspection showed it was often scribbled or stippled on, as though it scratched objects like a vengeful child. In Caravaggio's table scenes, among the vessels and grapes and mocking looks of brown-skinned boys, light roamed like a wolf, where it would, when it would. The most luminous compositions by painters of Newton's day – Spanish lemons on a pewter plate or Dutch tulips, beaded with dew, thronging a vase – featured light as an agitator, about to break out, throw china, fling the flowers aside.

Catching light in such passing 'fits' was bound to be frustrating. At one point Claude Monet, painting in London in 1900, had fifteen canvases set up simultaneously to snare chill, windy March light in sunshine, mist and rain showers. He worked 'in a frenzy, following the sun and its reflections on the water ... God, it was beautiful ... One marvel after another, each lasting less than five minutes, it was enough to drive one mad.' Turner began to scan these transient wonders as a boy, lying on his back on Hampstead Heath, studying the changes of sun, shade and atmosphere for hours together, before running home to dingy Covent Garden to paint them. Running was not just a boy's exuberance, but light's imperative. A burst of sunshine so beckoned Ravilious once, as he sought a pitch to paint the chalk figure of the Cerne Abbas giant, that 'I took a 5 bar gate a bit close and all but cut my breeches in two on a prong of barbed wire'. It was reminiscent of Coleridge on his first visit to Wordsworth in 1797, leaping over a wall on sighting him to reach his inspiration faster.

Out of doors, light tangled in things: stacked up in clouds, sowed confusion in leaves and water and hung, as if impaled, on tower, spire or tree. It sometimes seemed to pause long enough – lie smoothly enough on that field, that slope – to beguile Ravilious into racing out, setting up the board or sketching easel, nailing up his sheet, working in swift pencil to define the forms, opening the paint tubes and charging the portable brush he kept in his pocket – the wind all the time tearing at the paper and, 'in lovely ascending spirals', blowing away his hat. 'But what of it,' as he liked to say. He was not deterred by that, or even by the rain; only by his beloved snow, which soaked the paper and rendered it useless.

Under most conditions he could still try to catch the essence of light, as he had understood it from Rich's *Water Colour Painting*: the 'transparent atmosphere' or 'bloom' or veil that lay over everything in Nature, and which in principle could be evoked by sweeping the colour on in thick washes and allowing it to dry undisturbed. This, Rich wrote, was watercolour's greatest beauty, and its magic. Ravilious did his best, supplemented by memory and dreaming when he had carried his efforts home. But he felt he produced a 'pretty low' percentage of good pictures, maybe one out of three or four, before the principal subject worked free and fled. The failures he would tear into many small, neat, pathetic squares; really 'I'd like to dig a hole like a cat, and bury [them].' Rich called such events 'mortifications'.

Equally small scraps of paper or squares of card trapped these episodes of light for Palmer, Constable and Turner. It was the swift-brushed work of a minute, done on a lap, in a lid – speed to catch speed – and thrust in a pocket or a box. Palmer called these his 'blots',

but preserved them carefully; in 1848 he spent much of a holiday in Cornwall teaching himself to draw the scintillation of light on the sea. Between 1817 and 1819 Turner kept a 'Skies Sketchbook' of translucent watercolour skies and clouds, light looked *through* (as Goethe recommended) rather than *at*; the tiniest streak on paper was so precious to him, and potentially so lucrative, that he would never throw any scrap away. Appropriately enough, he bound each day's catch round with fishing twine.

Constable's cloud-and-sky studies, though much more elaborate, were still timed to the instant. He would waylay light just as it reached the top of a cumulus, broke through the stratus or responded to the wind, much as a spy or detective might record the movements of his quarry. ('11.O clock A.M. very hot with large climbing clouds under the Sun'. '5 Oclock afternoon August 1821 very fine bright & wind after rain slightly in the morning'. '29 July 1822 looking east 10 in the morning – silvery clouds'.) He called this 'skying'. Later, working from these scraps and from whatever feints or flurries had lodged in his memory, he would try to reproduce the effects on canvas.

His magic addition was what he called 'powder', in flake or China white. He splashed it over his landscapes, according to the *Times* man, 'like whitewash', and with as little care. Turner (Mr 'Soapsuds and Whitewash' himself) mocked him for it, told him it looked like drips from painting a ceiling, and urged him to get rid of it, but Constable insisted that this was how summer light played: the sparkle and freshness of scattered drops of white among leaves, off water, under dark trees, in grass. Horses reared up in it, white-shirted reapers lay weary in it; trees thirsted. This light was 'exhilarating', 'blowing' 'beautifully

silvery' and 'delicious', to use only some of his words. Yet it also adhered to its place, as if caught there. In autumn, Constable promised, it would be 'washed off', this summer glitter; for it vanished then. All the more ironic, perhaps, that Palmer thought the 'particular glitter of white' never vanished from Turner's paintings, whatever the season.

For Hopkins the snaring of light with paint was something he both longed, and feared, to do. 'You know I once wanted to be a painter,' he wrote to a friend in 1868, already aware at twenty-three that his path was bound elsewhere:

> But even if I could I wd. not, I think, now, for the fact is that
> the higher and more attractive parts of the art put a strain
> upon the passions which I shd. think it unsafe to encounter.

His brother Arthur, four years younger and unburdened with such restraint, had become a successful painter of romantic and rural scenes. In 1888, almost the last year of his life, Gerard wrote to him from Dublin, asking him shyly for a *porte-crayon* and some drawing chalks, which he could barely afford with his 'seldom seen pocketmoney'. He enclosed with the letter some of his sketches, 'to shew you how far my hand is in', and asked him, too, whether he knew of 'a way of bringing out high-lights in a drawing better than the watery Chinese-white I have employed on the ox in Phoenix Park'. He was still in pursuit of light, trying to go one better than white chalk, though he thought there was 'nothing like it' for catching the instress, the *being* of a thing. At an exhibition in 1873 he had encountered the technique of scraping off paint for highlights with a knife, a stick or a fingernail while the colour was wet – Turner's trick. Daisies and blossom, he noted,

had been 'brought out by scratching and even rudely'. He supposed it might last longer than the wretched Chinese white, but shuddered at the thought. Palmer, with his properness, would not use his nails, but instead incised 'sharp bits of white' into his sheets for the moon, for reflections, or for wing-flashes of birds. Ravilious sometimes used a razor blade or, when painting snow, a penknife, to scratch the colour off. He loved doing it; this was almost Boy Scout stuff, like tracking, nesting, trailing.

There were other sleights of hand, or brush. One was to reserve the paper or canvas, leaving it blank among the colours, to depict the sun, the moon or light on things. Dürer did this, realising that the paper itself expressed light, whether emitted or reflected; and that by doing nothing – by ceasing to do, make, strive, fuss, spoil – he too could produce light, like God. Turner and Ravilious both used the technique so freely, sometimes blocking out with wax or paste, more often with little skips between the brushstrokes, that their surfaces sometimes seemed as much untouched as painted on. What a pleasure it would be, Ravilious exclaimed when he saw the chestnut candles in flower, to leave them as bare spots of white paper ('a trifle larger than life of course'). Like Turner he also kept light alive by washing, using a sponge to lift the paint off and running to the bathroom to sluice the paper vigorously under the tap, so that the springing of his shoes overhead, and the water running, was what one friend most vividly remembered when he stayed. (Paradoxically, he would then worry that 'I so want the thing not to look washed out as they so often do.')

A further trick, often performed by Palmer, was to cut a piece of white paper in the shape and size required and glue it to the board.

This was as crude as a stage technician gumming stars on a backdrop ('Feel free to squander the stars,' as Goethe told the stage manager of *Faust*). But it worked. Turner sometimes made a large white button of paint do duty for the sun; he did this in his favourite *Sun Rising through Vapour* where, though cracking, it still clings on. A visitor to his murky home gallery in Queen Anne Street noticed that in the pervading damp one of these sun-buttons had fallen, or been picked, off. Turner did not seem too bothered.

For Blake, catching light needed none of these stunts. It called only for definite lines, since line was light's essential nature. As an engraver, he had learned to express light and shade with cross-hatching and with meshes of diamonds and dots, varying only their number and intensity. He had no patience with the 'Blotted & Blurred'; line must prevail, for then light would. This was why he had invented his gluey white ground, which when dry would take crisply and perfectly every stroke of his pen; this was why he expressed his visions of Dante's hell and heaven, which Palmer watched him draw, in thinnest pencil, clothing the forms later in watercolour washes through which the lines still showed. He always began with that first lead trace, the most important; almost his last act, with his little remaining money, was to send out for a shilling pencil. 'I know too well,' he sighed at the end of his life, 'that a great majority of Englishmen are fond of the Indefinite.' To him, though, 'a Line is a Line in its Minutest Subdivisions: Strait or Crooked It is Itself.' That sounded very like a description of a ray of light.

For many years, Palmer followed Blake. In his drawings and paintings, lines trapped light: 'When a pure and expressive outline

is on the paper,' he wrote, 'the prey is caught.' By the same token, in the words of an old engraver he knew, 'Lose your line and you lose your light.' There was 'might' and 'mystery', to Palmer, in the way a pen line registered on paper: both challenging light and seizing it, in the same stroke. In 1824, blinking in Blake's gaze, he began to insert 'masses of little forms like the leaves of a near tree' to serve instead of shadows, making mazes of patterns first in very faint pencil and then in fine, faint ink, leaving the clear areas next to them to shine all the more. He also found that against the hard dark angles of buildings and walls grew 'the most dotty light things what a contrast!' Light as dots, or as leaves, would have got past 'the Interpreter', as he and his friends called Blake; he dared not suppose, for a time, that anything else would.

But Palmer was also capable of straying into vaguer territory. As time went on he often expressed a fondness for mottling and dappling, as under trees or in the breaking-up of clouds. In the wooded glens at Hartland in north Devon he noticed that light lay in 'detached *shapes or patches*', ready to grab. At sunrise, especially, it formed 'massy lumps of brightness', and figures or sheep front-lit against shadows were 'like plates or *bassi relievi* of wrought gold'. That shadowy light-dark, *chiaroscuro*, had always appalled Blake, at least as it was employed by Titian, Rubens and Sir Joshua Reynolds ('This Man was Hired to Depress Art'). Blake would print such blobs of colour merely as preparation, in order to corral them into shapes of light with his pen. On the other hand Palmer had long known that chiaroscuro, not always exquisitely defined, also launched that restless life-glance that was the essence of light. He suspected, too – and told others – that Blake had

picked up his notion of Titian from 'picture-dealers' Titians', not the real thing. 'The ANIMATOR is CHIAROSCURO' he shouted to himself in 1845. In 1849 another note, almost treacherous to Blake, flagged up 'The principle of the Borghese Titian':

> viz 1st, globose lights contrasted with *sheets* of dark, and 2nd, *added* INTENSE spot of light and dark on figure; as, for instance, black and white cow. Remember this, O thou dull brute!

He remembered. Ten years later he noted that the month of July brought 'an immense power of Light; searching vast depths of gloom, and woods are *very deep*'. 'Mystery, and infinite going-in-i-tiveness' now enchanted him. No woods were too dark for him, he declared once, because against them the fields, wheat, moon and stars shone with redoubled brilliance. (Ravilious, watching with Palmer's eyes for enemy aircraft at the start of the war, rejoiced to see at dawn 'the church lit up vividly at the tower a lovely pink in a black green surround'.) Palmer's most successful 'look of light', in his own opinion, was achieved in 'two little moonshines' in which he had strongly intensified the dark with sepia and Indian ink: not unlike what Galileo had done, in his first chiaroscuros of the moon. The cow was not a perfect *aide-memoire*, he admitted, for shadows were full of colour, not 'sullied with blackness'. 'Do not forget; all is full of colour,' he nagged himself for the umpteenth time.

Van Gogh made this point to his brother Theo. One of the most beautiful things painters had done, he told him, was 'the painting of *black*, which nevertheless has *light* in it'. He had tried it himself in

a sloping beech wood near The Hague, intrigued by the 'enormous force and solidity' of the deep reddish-brown ground covered with mouldering leaves, the streaks and blottings of tree-shadow, and the 'dark masses of mysterious shadow' that resolved themselves into wood gatherers, 'a bonnet, a cap, a shoulder', against the sky. 'I perceived for the first time while painting it,' he wrote, 'how much light there was in that dusk.'

I first saw this effect one June evening in Staplefield, about a dozen miles from Brighton. It was nine o'clock, the very end of the day; the Victory Inn had finished serving, and the cook had gone home. Deprived of dinner, I tried instead to record what light, and the dark, were doing.

We came here down a lane of tall beeches and mauve rhododendrons, the trees flushed in maximum leaf, the bushes fully out. Both the green and the purple still glow out of deep and deepening shade, as if all the light that remains has shrunk back into them. This is a slow light, thickened, heavy, rich, like a decoction of liquor half condensed away to make purple, to make green, and to paint the shadow-drowned crimson of a young copper beech, its leaves still silver-crinkled with unfolding.

These colours are Light holding out to the last – painting the night even as it retreats into it, as when a candle burning down sinks into its own glow, and its own dark.

Chiaroscuro was still the key to everything. Both Turner and Palmer, as it happened, kept their best paintings in the dark – Turner taping

up his sooty windows with brown paper, while Palmer stacked his glowing Shoreham 'relics' dustily on top of a cupboard – so that, in the gloom, they shone. As Goethe wrote, 'The greatest brightness acts near the greatest darkness': acted, struggled, suffered, *lived*. He was almost cripplingly aware of that himself. When he was young, he had tried etching; but since he was unable to 'bring in that essential point', light challenging shade, he quickly gave up trying.

For Turner, chiaroscuro was fundamental to what he called 'the English effect': 'masses of light and shadow, or local light and dark'. In his *Snow Storm – Steam-Boat off a Harbour's Mouth* (1842), he interlaced white and black brushstrokes, or no brushstrokes, until light was meshed and wrestling everywhere on his canvas. This was the storm, 'on the night the *Ariel* left Harwich', in which he claimed to have been tied to the mast for four hours, simply to observe luminescence bursting out of the raging sea. (In September 1935 Ravilious, with Turner's 'extravagant and formless pictures' in mind, walked out to the end of the jetty at Newhaven in a wild storm of breaking spray, commenting later to Helen that 'I got very wet and I think now it was almost a dangerous walk out there, but worth it.') Turner may have made the mast story up, however; the *Ariel* was not a ship known at Harwich, though Ariel belonged to the trickster-history of light, and this Turner captured in a great swirl of black and white right in the middle of his canvas, a perfect vortex of snow. 'You can never reach the brilliancy of Nature,' he wrote to little Mary Potter, aged ten, when he was old; but 'you need never be afraid of putting your brightest light next to your deepest shadow, in the *centre*'. As he had done.

The colour of light itself remained a tendentious question. Palmer kept in a drawer in his etching cupboard a tiny box labelled 'BRIGHTS' in which, his son Alfred reported,

> there dwelt, protected from all contamination, and each in a white paper jacket neatly fitted over the upper part of it, certain cakes of the colours with which my father worked on the brightest passages in his drawings.

There was little doubt about the chief of these. 'Use the zinc-white (in tube) freely,' Palmer wrote to himself; '... only mind (and this is very important) when you use heightening lights, on a tree already painted for instance, do the lights first, delicately and sharply with white; when dry, add the colour.' He had not forgotten Blake's delight in certain 'untouched and unscrubbed' paintings by Claude in which, 'when minutely examined, there were, on the focal lights of the foliage, small specks of pure white which made them appear to be glittering with dew which the morning sun had not yet dried up'. (The Interpreter discoursed on these all through an evening walk, so warmly that, though the sun had set, his Claudes 'made sunshine in that shady place'.) His search for 'pure white' led Palmer to return to barium sulphate or calcium carbonate for his thicker impastos, such as those required to paint his Shoreham apple tree exploding with blossom in 1829. He still loved zinc oxide; but it showed very faintly blue in daylight, and therefore wouldn't do.

After white, yellow needed working on to yield up its maximum quota of light. 'Make washed gamboge and raw Sienna the key of yellow,' Palmer jotted later, and tried cadmium yellow, which

arrived in the 1840s, to see what it could do. (Monet, asked what colours he used for light, also answered: 'Flake white and cadmium yellow.') Any colour, not least yellow, could be mixed with gum arabic, gouache or egg white to make it shine. The tint Palmer most often aimed for was amber, because this was translucent rather than reflective: light might be trapped in it as surely as fine ferns and long-legged flies were caught within the fossil-stone. And yet in the end real light (as he called it) was 'wholly beyond the reach of mere colours'. Even the 'ever fluctuating colour' in Blake's painted books – those 'Spires … of fire vibrating with the full prism' that seemed to make the very pages, like a butterfly, quiver to life in his hand – were separate, Palmer thought, from the 'living light' in them. What he really needed to add to his pigments, he mused one day, were drops from 'little bottles of sunbeams'. Only then would it be possible to paint a scarlet cherry-leaf with the sunlight on it; or anything else in sunlight, for that matter.

Turner stuck, notoriously, to pale Naples yellow, patiently ground for him each day in Queen Anne Street by his slatternly, bandage-swaddled serving woman, Mrs Danby. His critics accused him of swabbing it on his canvases with a mop out of a bucket. It brightened things up, he snapped back; and in any case this was the spectrum-colour that got closest to light, though he soon believed, with Palmer, that light's 'secret' essence could not be caught that way. A little red book with a clasp, dated 1813 when he was thirty-eight, contained nine pages about yellows, including orange oxide, Naples yellow and paper-maker's yellow, together with a scrap of paper detailing a process by which potash added to a solution of

iron made a 'beautiful yellow oxide'. Another, a chloride of lead oxide, was actually called 'Turner's yellow' in the trade. The 'economy frames' he made himself were ropes slathered with tempera yellow ochre. He would carry on, then, with his yellow-sailed boats and swimming yellow skies, even if the Italians accused him of painting with mustard and his fellow diners of dabbling with mayonnaise. He would gruffly beat them off, even when Constable (getting his own back) accused him of 'stagnant sulphur', and critics complained of 'a devil of a lot of chrome'. The foregrounds of some of his sketches for seascapes were scratched yellow, as though he defiantly applied it with his nails.

If Ravilious wanted a focus of light he too used yellow, though he also favoured it, as Turner did, simply because he liked it. Though fond enough of white – white posts, yachts, mills, whalebones and peacocks were all eagerly commended – he was instinctively drawn to a yellow tie (out of the many options provided by Helen), a yellow phaeton, a yellow knife-grinder's cart and 'ochre' railway carriages, as much as to a pretty girl in a yellow dress. (He took pride in saying, though, that he never dabbled in either egg yolk or gold leaf to get a shine.) His painting of the baker's cart at Hedingham in 1936 dissatisfied him because '[it] is a bit too pale, and whenever I see the cart opposite in full daffodil yellow, I wish I'd laid on the colour more.' A group of fresh-cut tree trunks, which would have made Hopkins mourn, pleased him for their 'Naples yellow … with a rind of sienna.' He delighted in a 'capital' rowing boat that was washed up at Dover in the war: 'bright red and banana yellow – I wonder if somebody landed

in it? It was so irresistible I made a tolerably good drawing of it, with some shelling going on at sea …'

Yellow, for Coleridge, was summed up by a birch or an ash in autumn: 'Fire & Gold' solitary on some rock, or dappled in the River Greta like 'a painter's sun shine'. How he wished he might be that painter. (As it was, he could barely draw a line; his clumsy notebook doodles were captioned 'Miserable scribble!' or 'I cannot even mock it'.) The Head of Glen Nevish, he sighed on his Scottish tour in 1803, 'how simple for a Painter/ & in how many words & how laboriously, in what dim similitudes & slow & dragging Circumlocutions must I give it –'. And a few days later, trying to describe a 'sweet delicate birch' near Loch Ness, 'O Christ, it maddens me that I am not a painter or that Painters are not I!' If he could not paint light, perhaps he could nonetheless *make studies* (his emphasis) with his pencil and memorandum book, his quills and portable inkwell, 'moulding my thoughts into verse, with the objects and imagery immediately before my senses'. Or, lacking the book, perhaps he could impress the scene permanently on his mind, blink it in, as when in December that year he confronted the marvel of Helm Crag, Easedale and the Langdale Pikes under snow: 'O remember it – The eye – let it be a spectrum in my feverous brain!'

Few men have hungered for light as Coleridge did. He was not merely born but 'sprang to light', ardent to be part of it. Bullied at school, as fat boys fond of cake tend to be, he would seek solace in some sunny corner, rather than the shade. That, as well as his tendency to berate himself in his notebooks, may account for why Palmer

felt such sympathy with him, loved to read about him, and made a pilgrimage to his house in Highgate, long after his death, to look at his things and sit on his seat in the garden. It may also have been why Hopkins, whose boyhood diaries were already full of the gleam, flash and patterning of light, considered him a forerunner and, in a way, a friend.

In his Lakeland years, especially, Coleridge tracked every last effect of light: the 'rainwet silver' of slate roofs, sunspots moving 'slowly and sadly' up a mountainside, flecks of summer beams on moss, the 'silver-gilt' polish of sun-gleams on thinning ice, the 'shower of diamond Spearlets' dropping from a wind-driven cloud of snow. The very purpose of his notebooks, he wrote, was to try to make 'the *Light* … permanent for myself'. Awake at night (how often awake!), stumbling to the window to empty his chamber pot, he observed the silver struggles of moon and clouds, or tried to count the stars. Moved to love again (how often moved!), he described that jolt of the heart as 'a flash of lightning, or the strike of a Horse's Shoe, on a Flint, in utter darkness'. Before a scene or a painting he searched always for the *Licht-punkt*, the 'single sensation', the *Sparkle* in it, as if he could pluck it out like a pebble from a pool. In fact, when he considered it, each moment of time was a *Licht-punkt*, 'the Sparkle in the indivisible undivided Duration'.

At his desk he tried to pin down the effect of his candle on paper or the nature of the flame, whether conical, tapering, squared-off or 'somewhat rounded'. This was never idle musing, and never purely scientific; it fell into metaphysics very fast. On December 30th 1803 at half past one in the morning ('or rather therefore, Dec.

31st') he constructed for himself a species of candle out of rolled bits of paper, little bits of wick, some tallow and the soap, which when lit gave a huge but ineffectual flame through which his book blurred, 'just as thro' Tears, or in dizziness'. ('Every line of every Letter dislocated into angles/or like the mica in crumbly Stones.') This, he claimed rather outlandishly, was an experiment to illustrate his idea of motion – 'namely, that it is presence & absence rapidly alternating, so as that the fits of absence exist continuously in the Feeling, & the Fits of Presence vice versa continuedly in the Eye/' – the to-and-fro velocity of light, indeed. A few days earlier he had pondered the image, diamond-shaped, of his candle in his pot of urine, casting light and shade through the brown-yellow transpicuous liquid in which the contents of the snuffers floated, and thought how beautiful it was.

Light trapped, even in these ingenious ways, was not calmed. Whether in branches, clouds, water or a chamber pot, it flickered and danced in continual unrest. Some painters, though, seemed almost to hold it still. The more meditative paintings of Jan Vermeer or Georges de la Tour were lit not by a hectic dazzle of light but by a concentrated glow of it, diffused through small mullions or high dim apertures or by the blue wisp at a candle's heart, which burned more steadily than the flame. Vermeer in one famous scene filtered this light through greyish glass and the slow flow of milk from earthenware, evoking St Bridget in her dairywoman's cell. This seemed to be how light might be caught, as if in a deep well of quiet. In the paintings of Claude – which made the

young Turner weep in the gallery as he viewed them, for he was sure he could never emulate them – whole mythical scenes were filled with such a light, seas suffused with it and temples honeyed with it. This was surely the closest earthly light could get to Paradise.

Even these scenes, of course, were not as still as they appeared. Palmer pointed out that light was 'the accident which most quickens such beauty', and that Claude's 'pearl' and 'golden' influences were in motion as well as repose. Claude's friend Joachim confirmed that he snatched and grabbed at light like anyone else; that 'when he discovered anything in the fields, he immediately prepared his colours accordingly and ran home'. Nonetheless, the effect was of serene and silent gold.

This rare Claudian light might suddenly gleam on particular small fields, filling them to overflowing before it passed. Hopkins gazed on one from the balcony of the Jesuit house at Beaumont, 'a square of pale gold-leaf' apparently caught up in the elm in front of it – treasure, certainly. On such a patch of ground, bathed by ladder-rays glittering with back-and-forth angels, Jacob dreamed that he was in 'the house of God,' and 'the gate of heaven'. The message in that case was clear. More often, though, it was cryptic, or not understood in time, as R.S. Thomas ruefully reported:

> I have seen the sun break through
> to illuminate a small field
> for a while, and gone my way
> and forgotten it. But that was the
> pearl of great price, the one field that had
> treasure in it.

Coleridge was tormented by such a thought. He seldom failed to notice 'Jacob's ladders', with the hawks falling through them like stars and the 'sunpatched fields' they led to or from; he once even bloodily nicked himself in his excitement when, as he was shaving, he saw one in the glass. But they reminded him only of failure, of impossibility, of golden opportunities slipping through his hands. 'This is Oct 19. 1803,' he scribbled after sighting one:

> Wed. Morn. tomorrow my Birth Day, 31 years of age! – O
> me! my very heart dies! – This *year* has been one painful
> Dream/ I have done nothing! – O for God's sake, let me
> whip & spur …

Among painters Constable loved these singular, glowing fields, but he was not the first. In 1494 Albrecht Dürer, on his way from Nuremberg to Italy, dismounted from his horse, opened his small pack of dry-powder colours, and ambushed light in a tiny painting now called *Trees in an Alpine Landscape*. The scene before him was a simple composition of three principal colours, light green, dark green and blue-grey; it was the light green, sunlit field that sang. He laid the colours down in pure, transparent washes, touched the bright field with ochre and yellow, and did not work them up into anything more. There was no need; God had made it, he remade it. *Das ist gemacht*, as he liked to say. His monogram showed that he considered it done.

The light in this painting, now in Vienna, is more than 500 years old. In oils it would be aged and imprisoned by layers of varnish, as

Blake would have groaned; but here, in this little watercolour, the sunshine is of now. You might walk in this field, part the tall, flowering grass, feel a brown butterfly brush your hand, and only then, looking up, see a man in a fifteenth-century hat wiping away sweat, and a girl in a white shift (crowned with the poppies and ox-eye daisies you had thought to pick) walking with her psalter, suddenly aware of you.

A single field illuminated in a distant landscape has much the same effect on time. This light is so confined, so specific, that it can seem ancient, left over from when the first terraces were dug or even when the hills were formed. Light so intense bleaches out modern crops and machinery and rubs away footprints, if they were ever there. Henry Vaughan thought such fields – 'Jacob's Beds,' as he called them – were virgin soil, to be trodden only by 'prophets and Friends of God'. They become untouched places where every possibility awaits. Memory lays a similar bright screen across once-familiar streets, lawns and sands, Coleridge's 'sweet sunshiny meadows of Childhood', whose innocence is never shadowed and where light no longer moves.

My own earliest memory is of light through window-glass, spattered with rain and the bluish trails of rain, and shadowed on the left-hand side by blue-and-red seaside windmills whirring on wooden sticks. I've been told that this must be Bognor, just beside Blake's vision-filled Felpham, and must be a certain boarding house where we were kept in by bad weather among the chintz occasional chairs.

Behind the pane white heaped-up light, perhaps reflected off the clouds and sea, pressed close to us, like something that must come in yet was kept out, and my own small hand went up to greet and touch it. It did not try to get away.

Perhaps, then, light could find tranquillity only within or behind glass: 'light without winde', in Herbert's words.

> A man that looks on glasse,
> On it may stay his eye;
> Or if he pleaseth, through it passe,
> And then the heav'n espie.

To 'stay the eye on glass' was easy enough in Herbert's day. Glass was thick, mullioned and pocked with flaws, as Newton grumbled. Light could barely get through. In those half-lit days Traherne, 'about 4 yeer old', and sitting on a stool by the fire in 'a little obscure room in my Fathers poor House', fell to wondering why God did not give him some of the infinite riches He possessed, including infinite light; why all he had were dim, barely illuminated things, and in the silent hall 'saw nothing mine/ But som few Cups and Dishes shine':

> A painted Cloth there was
> Wherin som ancient Story wrought
> A little entertain'd my Thought
> Which Light discover'd throu the Glass.

That creeping light nonetheless hinted at other worlds, both outside and in. Not so long before, Jakob Böhme had been drawn into 'the secret heart of Nature' by a sunbeam striking a polished pewter plate in the murky room where he sat, mending shoes. The 'real whispering' of Nature fascinated the child Traherne too as he sat there, the shoemaker's son, a prisoner with imprisoned light. Windows of his time rarely opened because, through the gap, light might escape. Glaziers held it captive by twisting the thin lead frames inwards and outwards, creating a wavy grid in which more rays could be caught. Light seemed to push and fret at this obstruction. Traherne complained that crystal windows bound his sight as much as 'Walls of Clay or Mud' – without them,

> The Moon and Stars, the Air and Sun
> Into my Chamber com

– as he wished them to, like friends. For Jefferies, during his agonising last illness in 1887, the sunny windowpane of his seaside villa in Worthing was 'as impenetrable as the twenty-foot wall of the Tower of London'.

Ravilious, though, seemed to relish light through glass. (All transparent structures pleased him, from table jellies upwards; he also loved the 'marvellous' light in big tents at country shows, turning the white onions 'all yallery-green'.) He had a special liking for greenhouses, in which a measure of light was boxed and held apart from the ambient quicksilver, and was almost still. In his engravings for White's *Selborne* he featured greenhouses wherever he could:

rhomboids, trapezoids and prisms set in the Downs landscape, shining from within. One of his Victorian favourites, the last of eight, survives at Firle in the grounds of the big house, hidden behind the high red-brick wall that runs from the church to the back gate alongside a muddy lane. Nothing can be seen of it, no peeling wooden gable or wink of verdigris panes; but at the foot of the wall bags of leafy beetroot and small, bitterish, pricking cucumbers are laid out for sale, and from a green door invisible hands refill a jam jar with sweet peas.

Here, day by day, having charmed the gruff old gardener, Ravilious came. He barely needed his coat; light was warm, and drowsed, in the pungent stalk-and-leaf spice of tomatoes, the curve of cucumbers and the pink curlicues of cyclamens separated out in pots. Tendrils and vines crept out of the light and into it, but did not trouble the soft glass-sheltered calm. Fruit hung heavily within it. Light settled and grew deep on the whitewashed tables and along the window frames, mingling pleasantly with the whitish smoke from Ravilious's cigarettes. The windows themselves were seldom open, perhaps sealed up with green moss; all were dimmed by layers of cobweb and the dust of summers past. But at the end of a worn brick footway a glass-paned door might stand ajar, leading to other doors, and thence to ever deeper, brighter and stiller interior space. If doors were not half-open, Ravilious made a feature of their handles, as if daring the viewer to turn them and go in.

Naturally, almost all these greenhouses were silent and unpeopled. In one, the grape-house, a faceless figure with a watering can paused

before another open door, a ghost passing through. As in Traherne's world, no landscape lay beyond the glass; the purpose of the windows was to capture light, calm it and diffuse it. This was the effect that Coleridge obtained from under his mosquito net in Malta, and that Blake sought by pinning muslin over his windows or straining lamplight through tissue paper (as Palmer saw at their first meeting) over his copperplate etchings. It was, in its way, a return to dipping or fishing for light by passing it through nets; or creating some sort of magic veil, as Ravilious had learned. He once went overboard with butter muslin, draping a whole room with it (at sixpence a yard) for Diploma Day at the RCA in 1936; and then wandered off the stage, hands in pockets, and disappeared, as he had a habit of doing.

He also peered into shop windows, rectangular dim boxes filled with fur coats, diving helmets, saucepans, bread-loaves, model boats – and with light, too, neon or electric as well as natural, held prisoner among the stock. In a hardware shop light sharpened the saws, rimmed the bowls and swelled, as if to burst, the stone hot-water bottles. In an undertaker's window light ruffled the robes of a flying marble angel; in the plumassier's it sneaked down coats, feathered and furred, and perched, stiffly flying, in a glass case of silhouetted birds. In the window of the newsagent's it lay coiled in Catherine wheels and stuffed in Roman candles, or spilled in gold-paper stars from a rocket that stood unlit, but ready. Each shop proclaimed that light was about to break out and lead, harum-scarum, somewhere else. For the moment, though, it was just about held down.

Ravilious went to the fabric shop of his friend Enid Marx; his pencil caught light swagged on the walls and, with a slow thump,

unrolled before the customers. He lurked in Buzsard's cake shop at Marble Arch, where light was held in glass cases and under glass domes with iced spires of sponge. It was on the way to the bus stop at Euston, though, that he discovered the purest temple of light, a tiled milk shop with high windows in which a girl in a white cap and apron, a modern Bridget – a Lyons tea girl, really – poured light from a large jug into a smaller one. This was 'a beauty altogether', he told Helen, 'and if you ever come with me there I must show it to you'. His other shop windows he published in 1938 as lithographs; the Euston dairy he left, perhaps deliberately, in pencil and wash so faint that each shape of light seemed held within a membrane, like milk itself, or bubbles blown in air.

Working artists often made use of extra-strong, light-focusing glass, and with a purpose. Blake needed his huge, round, steel-rimmed lenses and his loupe, or magnifier, for the 'Minute Neatness of Execution' and 'EXACTNESS' he so prized in drawing, which caught as perfectly as possible that creator-line of light. Everything in art, he declared, was 'Definite & Determinate'; he had learned this not 'by Practise but by Inspiration & Vision because Vision is Determinate & Perfect'. Spectacles, his own 'Perspective-Glass', helped him to copy down those Visions 'without Fatigue'.

Blake's glasses, blurred with years of use, were handed down to Palmer, who preserved them as sacred relics of his kindly, nervous, brilliant master. He had several pairs of his own, however. First, the round-lensed ones he always wore; then an old-fashioned pair,

with very thick silver rims, for distant things; large round ones, with neutral-tint lenses, for sunsets and catching light in water; a diminishing mirror for compressing wide views and, lastly, opera glasses, 'which bring close and make evident the most minute work', as Blake demanded. All artists, Palmer agreed, should repeat to each other the word 'exactness' every morning, as the sun rose.

A choice selection of these glasses were stuffed into his drawing-coat, contributing to his baggy, foreshortened look. The state of his 'goggles', 'so scrat'd and spoil'd ... and scribbled over', not only put off the ladies; light sometimes mocked him too, so that 'The least bit of natural scenery reflected from one of my spectacle-glasses laughs me to scorn, and hisses at me.' But in 'the present state of our faculties', as he often sighed, perhaps he could hope for little better. The exception would be when visions came with their own light and sharpness, as in those glowing apples and those haloes round wheat; and they came seldom, after he left Shoreham.

Alfred reported what was left to his father in old age. As he walked out with him through fields of green corn or sweet trefoil on summer evenings, the older Palmer would use 'peculiarly well-chosen words' for the tints of the sky; but 'there was something far more subtle than this, and beyond the power of words to describe. It was probably akin to what he himself had experienced when walking with Blake'. What he had learned then – his father told others – was 'to perceive the soul of beauty through the forms of matter'.

Coleridge, too, strove to enhance his sightings of light in Nature – almost to wrestle with it, as Jacob had wrestled with the angel at the foot of one of those slanting, shining ladders. In the Lakes and

in Germany, like many contemporary painters and tourists, he seems to have made use of 'grey' or 'Claude Lorraine' filter glasses, which concentrated the landscape into picturesqueness and gave it a twilight glow. He probably also tried the 'Gause Spectacles' used 'to great advantage' by his friend Sir George Beaumont in his attempts to draw from Nature, reproducing on a small scale that diffusing, muslin effect. More experimentally, Coleridge also looked at scenes in convex mirrors, which made them miniature and exquisite, and played around with coloured glasses, both lenses green ('O what a lovely Purple when you pull them off'), or a red lens pressed to his left eye and a yellow to his right. ('These experiments must be tried over again & varied.')

Thoreau, thrown back as usual on his own woodsman's devices, liked to squint through the bottom of a tumbler, which clothed the landscape in 'such a mild quiet light':

> The rough and uneven fields stretch away with lawn-like
> smoothness to the horizon. The clouds … are fit drapery
> to hang over Persia. The smith's shop – resting in such a
> Grecian light is worthy to stand beside the Parthenon.

He saw as clearly, through this 'pure unwiped hour', as when he stood 'at the very abutment of a rainbow's arch', admiring the sudden crystal definition of every leaf and grass. This was a lake of prism-radiance so wide that he sported in it like a dolphin: a scene 'so washed in light, so untried, only to be thridded by clean thoughts'.

The clearest light of all, though, seemed to spring from himself. It came from the 'sort of exquisite personal alacrity and cleanliness'

with which he approached the solitudes of the deep woods and the huckleberry meadows just a few miles outside town, striding into them as if he stepped through 'an open window' or 'a true *skylight*', into a world where he was 'expanded, recreated, enlightened'. This was a world of his own vision, one he had made – and which the merchant, lecturer or congressman could not make, for all their money or verbosity. Equally, Blake had no need of spectacles to see Ololon, his skylark muse, alighting in his Felpham garden, or Enitharmon weaving the glistening fibres of Los on the nearby shore, or the scaled and glaring Ghost of a Flea on the stairs. Those he created and saw for himself. As he explained to one doubter in 1799, 'I see Every thing I paint In This World … As a man is So he Sees.'

The point was made for Palmer in a different way. Like Blake and Coleridge, he strove to find 'foci' in objects or in a landscape, the site where light struck and lingered: especially when it held, like a magnifying lens, the last strong rays of the sun steeping and sinking. For him these were the 'eye' of any work, 'a well-head of dazzling light' that contained 'the precious and latent springs of poetry'. He fretted that when the sun had set, no such focus remained anywhere. At nineteen, however, he had already noted on the first page of his sketchbook a different and strange effect:

> the tower on which the last light glimmered seemed luminous in itself & rather sending out light from itself than reflecting it and I noticed it on other stone buildings going along it was as if they had inherent light somewhat reminding one of mother-of-pearl – it was luminous though pale faint & glimmering…

On another page of his sketchbook, he thought about it further.

> [It] sends out a lustre into the heart of him who looks – a
> mystical and spiritual more than a material light – And with
> what a richness does it beam out from the neutral coolness
> of the quite flat sky behind it – it is indeed such a precious
> luminous tone … silver to paint all the lights in with at first
> would be invaluable …

It might be futile, though, to rummage in a box of 'BRIGHTS'. This
light was the sort that came unbidden, and from within.

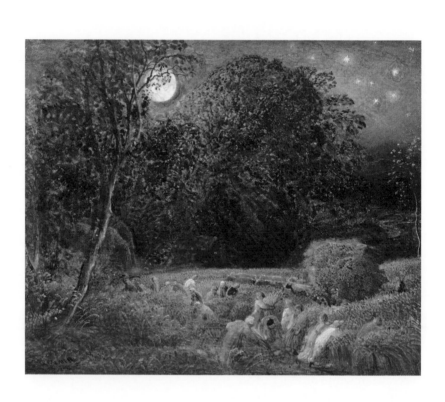

IMMORTAL DIAMOND

The undercliff path that runs from Brighton to Saltdean may be the most light-filled in England. The cliffs are white, their smooth footings white (until they reach the black line of slimy and tenacious seaweed), and midway between the two, as if suspended between water and air, snakes a white concrete path with a low wall on the seaward side. At high tide, with a moderate wind, white foam crashes over in a wild, free, floating cascade. It becomes a game to avoid a soaking, guessing what the lurking sea has in mind beneath the wall. It is not a game – but might be – to wonder which rocks above your head will tremble and tumble, shattering on the path into fan-bursts of white stones.

Almost nothing offers contrast in this scene. Even the sea stocks on the cliff face are white as often as purple, and the grey sea lavender is a scrawl in white dust. (The sea stocks' clean-petticoat white explains itself; but where that dark, lustrous purple comes from, the colour of Advent chasubles and Lenten veils, is a mystery. Perhaps among the debris of ancient shells in chalk lurks the murex that gave its juice for Roman togas, the pungent treasure of Phoenicia.) Out towards the sea lie black-fringed rock pools, lightly mossed with green, but

these fill up rapidly with foam or the reflection of the clouds. Seagulls might be the same white stones that shatter from above, Hopkins's 'sparkles … as bright as snowballs', this time falling in a longer, slower trajectory through the thinly glittering air. High-nesting hawks scare off the crows with short, terrifying jabs of flight, not merely because crows are raucous and malicious, but because they are black, and have no place here.

Small wonder that Ravilious, accustomed to this degree of light – the almost abstract severity of land and sea, the persistent brilliance of the sun – fell in love with Iceland and north Norway when he was sent there on his war service in 1940. Working on the deck of HMS *Highlander*, 'long past midnight in bright sunshine', he painted the snow-cloaked distant mountains which he called, in deference to Edward Lear, 'the hills of the Chankly Bore'. 'Chankly' had much of 'chalk' in it. White Arctic terns flew past him; he found himself dreaming of fair-haired women and marvelling that he never saw either them, or darkness. It was 'like some unearthly existence'. Having seen this place, he hoped to go on to Russia or to Greenland, the land of narwhal horns, camouflaged with his white canvas draw-ing bag against the permanent snow. Going north, as he seemed to imagine it, was a progress into more or less uninterrupted light.

For some hours each day on the Undercliff walkers and cyclists soak up their own quota of brightness, together with dogs, children and the bronzed habitués who come to eat bacon rolls and sip large mugs of tea at the Ovingdean kiosk, which is seldom closed. Daringly, they unfold the communal Sunday papers against the battering breeze – yet more white, regularly inked and slightly yellowed, flapping over

the hard white china plates. The low wall keeps off some of it, both wind and glare. I usually buy a slice of banana cake in a white paper bag, and eat it down on the shingle or the rocks with an unobstructed view of the sea.

The rocks are not from hereabouts; they are chunks of grey granite imported for sea defences and for good, hard seats in more placid times. They make a berth to watch occasional fishermen standing in the sea and crab boats fitfully rotating, their sterns stuck with poles of black streamers to mark the pots they are dropping. Both are marooned in light and the flopping, purplish, seaweed-sodden swell. And light is all they catch, for a long time.

Here and there, visitors have left chalk scribbles on the rocks. In fact they have scribbled all along this path, especially on the flat top of the wall, leaving behind names and loves and the languid, looping lines that result when you are wandering and talking with a piece of chalk in your hand. 'Jaz is Kool.' 'Cetaceans are Mega!' 'I love you.' 'Fulmars rule!' 'Down with unpleasantness.' 'It's Saturday.' And 'The Sun was here, 9.3.14.' The lines meander like the track of a snail. They also last longer than you might suppose; so that on deserted evenings or midweek winter storm-days the pure white doodles, names and squiggles still shine in the low light, and will do so until time effaces or replaces them.

The same effect can be seen on the bus that runs back into town. On the top deck in winter the windows are fogged and clouded with cold, criss-crossed with a pattern of old inscriptions: a palimpsest of fading names and, on the wide front window, once-flamboyant initials laid out in faint equations. HC plus JL have sat here, snuggling

in thick jackets, a little drunk perhaps to draw so wildly and large. They may be the same pair who ran up the stairs once from the stop in North Street, both laughing, he shouting to her: 'You really don't understand "one decimal place"? You don't know what "two significant figures" means?' Two significant figures equal love. The letters shine through, suddenly ignited, when the bus turns a corner into the sun.

Packed on the bus, imprisoned in our breath,
Fogged up and clogged, we sometimes with a sleeve
Sweep a wide arc to wipe the window clean;
So too the sun, struggling and pale beneath
Shroudings of cloud, now elbows a reprieve,
And in his dazzle our graffiti's seen:
Frost-swirls and curlicues of ancient art,
Lost names – and, finger-drawn, a perfect heart –

All these are ways, at least, of writing ourselves in light; of leaving some memento of our travel through 'this glassy interval', as Thomas Lovell Beddoes called life.

The sixteenth-century version of this game was to scratch names and thoughts with a diamond ring on a windowpane. At the Old Hall in Buxton in Derbyshire, now a hotel, Mary Stuart was among those who left her mark there. The mottoes are in Latin, Italian and French as well as English, delicately and beautifully incised. They have lasted far longer than scribbles on a sea wall or fingers in breath-mist could; yet they declare even more eloquently how earthly life flares out, and slips away.

Times change, and we change with them –
Faith, like the breath of life, once departed never returns –
By chance, not intent –
Oh life of mine so full of toil, how brief your happiness,
 how fleeting your tranquillity in the chill of winter –
My careless care hath brought me to that pass/ What is,
 shall be, and wishe yt never was

Penses de Moy, wrote one 'TG' (Sir Thomas Gerard) beside a careful engraving of a pansy, for thoughts. His sunlit quip was thrown away on readers who might have no notion who he was. A man as a thought; thought as a flower; the flower delicate and bending, already fading out of the light within a window past which new hotel guests wheel their luggage, shouting at one another about car keys and theatre tickets, and never think to look his way.

Glass, too, would not last. There was no perfection or long life in it. Newton's prisms, as he complained, were never quite pure and whole – as men were not. At Haddon Hall, not far from Buxton, a local glazier scratched his message on a diamond-shaped pane with fine, northern emphasis:

That man nare Lived
nor never Shall
that did all well
& had no fault att all

Yet since glass both transmitted and reflected light, the comparison suggested a body that was translucent as well as frail. 'A Mortal

Worm … translucent all within', was Blake's formulation. 'What Heavenly Light inspires my Skin' wrote Traherne on St Bartholomew's Day, the feast of a saint who was flayed alive, as he observed his own flesh glowing with inner fire. It seemed to him 'a temple of ETERNITIE!' in which an angel lived and moved. Herbert described God striking rainbows from the stone of his heart, his body being glass; Vaughan's flint-heart, under God's steel, sparked off poem after poem of transparent, breathless devotion. Donne, having also incised his name on a windowpane with his diamond ring, hoping to draw in thereby the power of the reigning stars, marvelled that glass should be 'As all-confessing, and through-shine as I'.

The fascination persisted. Newton recorded that William Halley, he of the comet, many fathoms deep in a diving bell 'on a clear Sunshine Day', saw the upper part of his hand illuminated by the sun through water and glass to the colour of a damask rose, while the under part took on the green reflections of the water. He seemed, in short, to assume a strange transparency. Light played such tricks at the surface, too. In August 1867 Hopkins, on holiday in Devon and lying in the grass, noticed a curious exchange, a sort of melting, between his body and the light. As he held up his hand (fingers splayed a little) against the pure Mary-blue sky, brightness invaded the 'four fingergaps',

> swarming and blushing round the edge of the hand and in the pieces clipped in by the fingers, the flesh being sometimes sunlit, sometimes glassy with reflected light, sometimes lightly shadowed in the violet one makes with cobalt and Indian red.

He had tried the same with a petal – he did not say of which flower – to find it 'diapered out by the worm or veining of deeper blue', just as 'white-rose clouds' became mistier against the invading sky. Now, with his own flesh, the operative word was 'glassy'. (Jefferies too, a few years later, watched the sunbeams gleam on his fingernail 'like a prism' and fall on his hand until he could feel the sun-life entering him.) Hopkins, lying there, found himself wondering at his own translucence. Some time later, shielding a candle, the effect was even more startling: the middles of his fingers and the knuckles dark as ash in the bright vermilion of his hand, while his veins swarmed like 'juices of the sunrise'.

The image was bizarre, but in his world all things inevitably dissolved into elements, essences and light-and-shade: the 'dappled-with-damson west', the 'drop-of-blood-and-foam dapple' on blossoming apple trees, 'pied-and-peeled May'. Men too (usually men, seldom women) broke into surf and flowers and light. The sailor, for example, pitched from the sinking *Deutschland* 'through the cobbled foam-fleece', soldiers 'fretted in a bloomfall', Harry Ploughman's 'wind-lilylocks laced'; and, in an unfinished fragment, a young man refined entirely into sunlight and the gleanings of a walk along the hedge:

Then over his turnèd temples – here –
 Was a rose, or, failing that,
Rough-Robin or five-lipped campion clear
 For a beauty-bow to his hat,
And the sunlight-sidled, like dewdrops, like dandled diamonds
 Through the sieve of the straw of the plait.

At twenty-three, hiking in the Alps, Hopkins decked his own sun hat with harebells and gentians 'in two rows above like double pan-pipes'. The flowers made him, too, 'sunlight-sidled'. Clare noticed this effect when, with other boys, he raided wheatfields for poppies or blue cornflowers to make cockades for their hats when they played soldiers; Ravilious experienced it when he and John Nash went out to lunch in London in May 1936 'wearing sprigs of "Jew's mallow", a lovely yellow flower and looked gay and like a flag day in Kensington'. The same elation transfigured a released prisoner who bounded past W.H. Hudson on the flinty, hilly road from Rodmell to Southease near Newhaven, a fistful of yellow flag iris stuffed in the breast of his ragged old coat, boot heels springing with the joy of being out; as well as the long-haired downland shepherd boy who, in the midst of his grassy kingdom, had ornamented his grey cap with a big, woolly, purple thistle flower, which 'gave him a strange distinction'. From that thistle flower, before too long, stars would form and drift away.

Perhaps the oddest transfiguration was one I glimpsed on a November morning beside the main line from London to York, approximately in Clare's country: a cheerful scarecrow leaning his long shadow across the bare, flat, cold fields, while gold-foil streamers flashed and flew from his jacket.

Seen from the train Northamptonshire (perhaps)

Base metal to gold
may occur unawares –
take this scarecrow, old,
tilted, grey, who scares

nothing; torn suiting
rags against the rain,
tired arms saluting
ploughland, sky, train;
yet gilded pennons flutter from his breast,
while, close at hand, five swans alight and rest …

The streamers of foil were presumably pinned on for the same reason that old CDs are strung on wires over currant bushes: to dazzle threateningly, and keep the birds off. They exalted him. Yet they did nothing to deflect the swans, who gathered in the next field as though he had called them with a sweep of his broken hat and wide arms of invitation. Perhaps they were his swans; for too many as they were, and waddling awkwardly among cabbages, they were certainly not mine.

Palmer, writing yet more admonitions to himself in his notebook, remarked that if he wished to put human figures in his landscapes it was best to dapple them with darkness and light, matching the chiaroscuro of his trees, rather than giving them a solid bodily shape ('figures most beautiful under this effect'). Turner had already discovered this, and gone way beyond it; in the raging white and yellow of his world, all forms and figures had virtually become light. This seemed unnatural and impossible, when viewed coldly on the walls of the Royal Academy. Yet I saw the same effect on Parliament Hill on a day of high summer, when a sudden wind whirled the white undersides of birch and poplar into a storm of confetti across the path, and amid them a girl came down the hill reading a letter, her body shivered into

fragments by flying green shadow and white glare. Wind is optional; the same dappling and dissolving can be seen, as Palmer painted it, on a woman in a garden in the heat of summer, standing perfectly still.

In Palmer's etching of *The Lonely Tower* from Milton's 'Il Penseroso' (a favourite with both him and Hopkins), two more dreamers lay beside their flock under the scattered infinity of the stars. They were shepherds in work-worn clothes and shapeless, brimless straw hats. Their gaze was fixed on a dark tower where 'the Platonist', by lamplight, sat reading Hermes Trismegistus. The shepherds, in their thoughtful stillness, seemed to mirror his studies, but they needed no illumination. Their bodies were flecked, as the heavens and the fields were, with an infinitude of points of light. This, Palmer wrote, was the charm of linear etching: 'the glimmering through of the white paper even in the shadows, so that almost everything either sparkles or suggests sparkle'. In Claude's etchings, he thought, the effect was exquisite, like 'moving sunshine upon dew, or dew upon violets in the shade'. It marked, too, for Palmer, the glimmering through of the angelic and the divine. The shepherds hinted at Milton's cherubim, 'all their shape/Spangl'd with eyes', and it was richly suggestive that these seemed to move behind his Milton etchings, and tenderly gaze on him.

This was yet another lesson he had learned from Blake. On one of his early visits to him – after he had tremblingly kissed the bell-pull at 3 Fountain Court off the Strand, 'the chariot of the sun' as he thought of it – he found Blake printing off his woodcuts for Thornton's edition of Virgil's 'First Eclogue'. These were the only woodcuts the Interpreter ever made. Lost for words, Palmer

inspected them: these 'visions of little dells, and nooks, and corners of Paradise'. A windswept tree reached for the waxing moon; a stream flowed, by night, past a deep-eaved cottage; the shepherd-heroes of the *Eclogues*, Colinet and Thenot, debated in the fields and by the fire. The small, dense, dark prints, deep-cut and flecked with the burin on boxwood, showed landscapes and figures outlined, touched and vivified by light, 'such a mystic and dreamy glimmer as penetrates and kindles the inmost soul'. Those were the same 'thousand pretty eyes' Palmer had already worshipped everywhere in Nature, scattered in the fields and hung in the ancient elm that had swayed outside his window. Here, called into being on Blake's press, they gleamed through the black ink, completely unlike 'the gaudy daylight of this world'. The effect is as beautiful even on thin, foxed wartime paper, as in my treasured Everyman edition of Gilchrist's *Life of William Blake*, picked up cheap in a Brighton junk shop: a book that also has a title-page design of Blakean arrows by Ravilious, and his endpapers of webbed and blazing suns.

Palmer was given a sheet of four Virgil proofs to take away, 'impressions taken there ... by [Blake's] own hands, and signed by him under my eyes'. They were stored in the 'Curiosity Portfolio', his heart's delight. Ever after he strove to get the same effect, especially in his etchings. He was not tempted to try wood-cutting for himself, finding the shadows too dark and without variety, though 'the sparkle of its light is joyous'. He fretted sometimes that he cared so much for those little specks of Paradise that they stopped him considering the larger picture, 'the full sweep of a great brush'. But no sooner had he thought that, than he was pondering the best way to achieve the same

'glimmering' and brilliancy in watercolour as Blake had done, as in the luminous figures he had painted to illustrate Dante.

The immanence of light in scenes and bodies could also be suggested in other ways. Blake deeply admired Fra Angelico, calling him 'a saint', partly out of envy for the way he laid on gold; but Angelico's murals for the monastery of San Marco in Florence, which Palmer visited on his honeymoon in 1837 and revered for their 'humble, heavenly love', no longer made use of gold to portray light. Gold, in fact, was almost absent from this place, where the Medicis among others laid their worldly wealth aside. Instead, light was inherent in the smoothness, silence and simplicity of things. It shone from the vellum page St Dominic sat reading, one finger pressed to his lips; from his pale forehead, full of thought; from a stone floor, columns, walls; and especially from the rapt and watchful faces of assembled saints and the plain, unshadowed colours of the robes they wore. This smoothed-out light, sometimes seen lingering in the deep sky at evening, was described once by Dante as 'fire behind alabaster'. Blake recreated it in his later copper engravings by rubbing away, with a burnisher, the network of etched lines with which he had once caught outer, visible, play-around light.

Palmer too learned from this older, quieter style. His paintings often included small figures grouped in the middle distance. Typically, in the amber softness of his evenings, they were walking home along a path, or gathering in corn-thick fields to cut or glean the harvest. Their bending bodies were clothed in white, and shone. Kilvert reported similar scenes in his diary, and sensibly explained them as women stripped to their petticoats to work better in the heat.

In Palmer's paintings, though, the daytime heat had gone, and the harvesters did not seem earthly any more. They moved freely and without self-consciousness, hints of sunset or moonrise bronzing their naked arms and burnishing their hair, like creatures fallen from heaven. ('The petty coat intense white,' the teenage Palmer noted to his satisfaction.) The men worked in shirts or smocks, also gleaming, and in shapeless hats bleached white by sun and rain. Here and there a glinting sickle reflected the low sickle moon. Hopkins paused a long time in a gallery before a similar watercolour of a young man mowing in his shirt, blazing with sweat and effort: 'a great stroke, a figure quite made up of dew and grace and strong fire', as any angel would be.

The angels Blake famously saw, walking among the sheaves in the fields at Lambeth (singing 'Mercy, Pity, Peace' over the new-mown hay and the brown haycocks), may well have been such men and women. They went laughing, cussing, arms and legs scratched by the glassy stubble, throats dry and eyes reddened in the dust; but in regular order, bowing earthwards, and clad in white raiment, like the heavenly host. A jug of harvest beer (the worst drink in England, Jefferies said, reputed to be muddy water stirred with a besom) then became a vessel of ambrosia; a satchel of dry bread and onions, manna in the desert; a cotton bonnet the halo of a heavenly creature, ribboned and rayed around the sunburned, singing face. Children, in the cornfields or out of them, slumbering or tumbling, were framed with angelic curls. Van Gogh lamented to his brother Theo that nineteenth-century men and women could not be painted 'with that something of the eternal which the halo used to symbolise'. Yet he found his own way to express their 'divine beauty' in colour by, for

example, contriving the richest possible blue background behind a girl's fair hair. 'I get a mysterious effect,' he reported, 'like a star in the depths of an azure sky.'

More random transformations could also occur. On late-autumn nights John Clare, working as an apprentice in the kitchen garden at the great house at Burghley outside Stamford, sometimes lay down to sleep under a tree in the park. In winter, similarly, he might slide into repose in the fields closer to home, because 'I had taken too much of Sir John Barleycorn & coud get no further'. If the night was cold, with a frost, he would wake to find his whole right side sheeted and diamonded with light.

> It was a winter season just like this
> at Stamford, in the park, that he lay down,
> his pockets full of snail-shells, and next day
> rose up half-rimed. His one side fustian brown,
> beer-stained and worn, the other dazzling white
> drapery of angels; one side his paper, pence,
> used handkerchief, a crust, the other frost-bright
> pearls, diamonds, opals. See, by the lordly fence,
> close to the glistening ranks of armoured grass,
> his shadow-body sprawling in the leaf-lace
> left behind; hear now the early-morning bells
> stroking and cloaking him with Sunday grace.

He ached, and that side was never right afterwards; but he glittered. He was a country 'clown', knowing no place but Helpston and the fields about it, reduced to dullness and red-faced silence in the

presence of strangers, especially those whose marble floors echoed to the banging of his hobnailed boots. But now he was transmuted, a creature of sparkling ice – as the common trees turned beautiful when they were cloaked in 'magic foliage' by the frost, and the 'spire points' of grass, in a winter freeze, 'Shine whitend on their northern side'. The lowly foddering boy, too, struggling to the cowsheds 'with straw-band-belted legs' and a brown beaver hat jammed on his head, beating his fingers against the blast, was 'all attired in the brilliancy of a snowstorm like some supernatural prospect just stept out of the Arabian Nights Entertainment':

> When in huge fork-fulls trailing at his back
> He litters the sweet hay about the ground
> And brawls to call the staring cattle round.

Traherne's local ploughman at Christmas, in 'gayer Weeds and finer Band,/ New Suit and Hat' and 'neatest shoos', was transformed as he sang in Credenhill church, his breath like incense smoking round him.

Ravilious also drew and painted bodies made mostly of light. No spiritual conviction lay behind this; the constant service-going and sermon-battering of his boyhood had instilled in him mostly silent embarrassment, and a determination not to set foot in church again if he could help it. Just before Christmas in 1938 he hugely enjoyed a heaven charade, 'capering with sheets and harps and halos of cardboard – I loved playing a string harp'. But that was just a bit of fun, like 'progressive ping-pong' round the kitchen table, or the village cricket-match tea with its 'wicked-looking cheap cake'.

At its simplest he just liked bodies unburdened by clothes, and in Essex once in winter not only swam naked with friends in the River Pant but played catch-as-catch-can nude round the garden afterwards, 'pale apparitions in the yellow fog'. The lightness and ghostliness extended to his work. In his murals his characters danced and flew, unconstrained by walls or roofs and no more tethered to the ground than seaside kites. On paper, too, they were weightless, and not quite connected to the earth. They might be in naval rig and waders, inspecting Kentish mudflats for mines; they might be riding half-vanished bicycles down the high street of Great Bardfield, his home for a while, or running out to watch fireworks. Their faces were featureless, and their bodies shone. Passengers cramming on a London bus, top and bottom deck, lost their lower halves to light. Other bodies he left as white space, as he often left his flocking birds. On the ground they imposed no weight, only stippled or cross-hatched shadows: shadows made of light, as the old engravers knew. From rooms and scenes they had often just gone – a sunbeam, a shade – leaving a coat on a hook, a table set with butter, bread and mismatched cups, a chair pushed away. Or they were caught in uncertain movement and ready to move on, like the small bright clouds that sailed above them, in regular order, across the sky.

Ravilious gave his figures space to shine, but space was not necessary. The most densely crowded places could also produce this effect. Rabindranath Tagore's childhood house stood (and stands) in the heart of Calcutta, in a warren of narrow streets not far from where the great Hooghly, or Ganges, swells slowly to the sea. Every way through is crammed with human and motorised rickshaws, coconut-milk sellers

chopping mounds of green fruit, sculptors smoothing goddesses from the grey Hooghly mud, vendors of second-hand paperback crammer-books, glossy brown boys soaping themselves at hydrants, whining beggar girls with grubby hands and children on their hips, business-men with briefcases cramming down kufti from a paper wrap, obese jewelled women on mobiles directing their drivers, chai-drinkers cast-ing their clay cups to the ground, lean stray dogs padding with a pur-pose. Here, one day in 1910, Tagore stood at dawn on the veranda of the house in Sudder Street. Lawns and trees separated it from the jumble round about, the cries of mynahs and hooded crows mingling with the waking city. He had noticed, as Palmer did, that at dawn and dusk light became peculiarly beautiful and, as it were, inherent in trees and walls rather than the sky. That day, as the sun's first rays stole through the branches of the garden, 'the morning light in the face of the world revealed an inner radiance of joy'. Each human figure, too, sent out that radiance, so that two boys walking together, their arms nonchalantly round each other's shoulders, suddenly revealed to him 'the fathomless depths of the eternal spring of Joy'.

The monk Thomas Merton had much the same experience when he visited Louisville, Kentucky, one day in March 1958. He had left the rural simplicity of the Abbey of Gethsemani for this grimy industrial city on the Mississippi, bent on some errand that was, in retrospect, unimportant. Trappist vows bound him to silence. At the corner of Fourth Avenue and Walnut Street, in the heart of the shop-ping district (where a bronze plaque still marks the moment and the emotion) he was suddenly seized with overwhelming love and tender-ness for the crowd around him. The girls especially, as they walked in

the sunshine, were 'as good as and even more beautiful than the light itself'. He had indulged 'the illusion of a separate holy existence' from such people, a 'pseudo-angel' life, when there was no distinction or separation; when God had become incarnate in each one. But in such a setting, a bald, sandalled monk on a city sidewalk, he foundered in blushing silence. 'There is no way of telling people,' he wrote later, 'that they are all walking around shining like the sun.'

Blake thought there was. He had no hesitation in telling Mrs Blake that her moments of joy, as when he mentioned his Visions to her, made her 'a flame of many colours of precious jewels'. 'He whose face gives no light,' he had added in his 'Proverbs of Hell', 'shall never become a star.' As usual though, Traherne was least inhibited about it. His childhood playmates had been 'moving Jewels' in the street; later his own congregation, those heavy, hearty, apple-cheeked folk, were 'Glorious Hosts' to him, 'Spurs, Wings, Enflamers'. The sun beamed from their faces; he dreamed of robing them in red, crowning them with gold. In fact, there was no need after all to pluck down stars. 'My Lims and Members,' Traherne wrote,

> when rightly Prized, are Comparable to the fine Gold, but
> they exceed it … What Diamonds are equal to my Eys; what
> Labyrinths to mine Ears; what Gates of Ivory, or Rubie
> Leaves to the Double Portal of my Lips and Teeth? Is not
> Sight a Jewel? Is not Hearing a Treasure?

In short, he was 'an enlarged Seraphim', or an inward Cherubim, 'wholly celestial': more excellent, and more pampered by God's creation, than all of them.

246

Ravilious had read Traherne. His works were then, in a sense, new, rediscovered in a second-hand book barrow in the Farringdon Road in 1895 and republished in 1908. They struck a curious, other-worldly note in the nervy interwar years – a strange note too for Ravilious, whose more usual reading was Huxley, P.G. Wodehouse and H.G. Wells. But in the spring of 1935 he showed Traherne's 'Thanksgivings for the Body' to Helen at Furlongs, and later enclosed part of it in a letter to her. A colleague had told him the poem was 'something between Whitman and Blake'; Ravilious couldn't see much Blake in it, but loved it anyway. He left it unclear whether the body he was thinking of was Helen's – her lovely pink skin unsheathed from that 'hairy' coat, that spotted dress – or one of the luminous figures of his paintings, which barely touched the earth.

> O Lord!
> Thou hast given me a body,
> Wherein the glory of thy power shineth,
> Wonderfully composed above the beasts,
> Within distinguished into useful parts,
> Beautified without with many ornaments.
>> Limbs rarely poised
>>> And made for Heaven:
>> Arteries filled
>>> With celestial spirits …

He told her later, though, that he believed in the sort of 'transfiguring' relationship – described by Wells in *Mr Britling Sees it Through* – in which both he and she would become 'perfectly beautiful' to each

other and to themselves, just as Traherne described. Helen told him she liked the poem 'awfully'.

Those jewel-like human bodies might also have been clothed in light, in the beginning. Manichaeans believed that the first-created man had been armoured with it as helmet, breastplate and guard; in his struggle with the Prince of Darkness, mirroring light's own eternal struggle, he had to leave this dazzling carapace behind. The Christian Adam was usually less well clad: in Vaughan's words,

> Like the Sun shine
> All naked, innocent, and bright,
> And intimate with Heav'n, as light;

He too, though, was not always naked in Eden, but was sometimes made to discard radiant robes as he left the garden. Hopkins, preaching to the poor of Manchester on a theme of St Paul, told them they had all been given 'a white robe' and 'lightsome armour' in the beginning. Bunyan's Christian, struggling to regain that grace, acquired a 'Broidered Coat', given to him by 'three Shining Ones' on his way to the heavenly Jerusalem: resting in an arbour, he took a stunned 'review' of it, stroking the fabric that gleamed like them. It was perhaps not unlike Joseph's coat of many colours, which caused the wheat-sheaves to bow down before this teenage shepherd with the sun, the moon and the eleven stars.

Glory of this sort was the natural vesture of those who wandered the heavens, like Milton's Raphael, with six-tiered rainbows on their backs. But Newton had seen prismatic light round strands of his own hair, pulled from his head; and such light could float, too, about

men and women, or more often round their shadows on the ground. Benvenuto Cellini in 1539 was the first to record it, immediately after his great vision of the sun. The splendour was visible round his head at sunrise and for two hours afterwards, then again at sunset. The effect seemed permanent, though he showed it only to certain persons, those fit to know. It was clearer round his shadow; clearer still when dew was on the grass; and clearest of all in Paris, where the French king had received him kindly, and where the air was less hazy than in Italy.

Bad boy though he was, Cellini took this as a sign that God had exalted him. So did Thoreau, who was in any case inclined to think that way: who wished to make no noise on the earth, no footfall on the gravel road, but rather a panther's padding on grass. He often saw an aura playing round his shadow – thick trousers, straw hat, old music book for flower-pressing under his arm, jacket pocket bulging with journal, pencil, spyglass, compass, jack-knife, twine – as he strode along the railroad line near Concord, and each time 'would fain fancy myself one of the elect'. A visitor confirmed that no halo appeared round the shadows of Irishmen, those poor beggars and railroad navvies whose improvement, Thoreau thought, required 'a kind of moral bog-hoe'. They shone only round those of Americans. No wonder, then, that Whitman too reported so exultantly after a crossing in the Brooklyn ferry:

> Saw the reflection of the summer sky in the water,
> Had my eyes dazzled by the shimmering track of beams,
> Look'd at the fine centrifugal spokes of light round the shape
> of my head in the sunlit water…

Other rainbow lights moved faintly, a horseshoe shape on the dewy grass, in front of Jefferies as he stalked with his gun in the twilight-curtained woods. He was marked out (for what great purpose?) silently but with intent, as he marked out his game.

It could all be easily explained, Goethe wrote in his *Theory of Colours.* When the eye looked at shadow and then at brightness beside it, especially after sleep or rest, the boundary would break into rainbows, those 'sufferings' of light against the dark from which all colours came. This accounted for the outline iridescence of sunbeams as they pierced through leaves, and for the dazzling halo round a friend's head as he talked to him against a grey sky. His own eyes made these effects.

They also, he declared, made the spectrum opposites that hovered beside colours: the blue-green flames near the 'powerful red' of oriental poppies at dusk in his garden in mid-June 1799, flaring out as he walked up and down conversing; and, alongside the tight scarlet bodice of the tavern maid who brought his beer, her lovely sea-green shadow floating on the limewashed wall. (He kept a tinted sketch of this among his private papers, enabling him with one sidelong glance to summon her true colours again.) Scientists called this effect diffraction: colours evoked their complements, accounting too for Hopkins's hovering bluebells in the pale yellow sunshine of spring. Goethe explained it by saying that the eye sought completeness. So from sunshine it made a mess of blots, from buxom tavern beauty a creature drawn from mystery or from Elf-land, and from an ordinary man's shadow an aura fit for angels, or so it seemed.

All this would have made sense to Coleridge, who ordered *Zur Farbenlehre* as soon as he could ('I must buy the Book'), and may

have read it in the German. All Goethe's theories on light attracted him; he declared him the modern spokesman for 'the most ancient Pythagorean theory of Color', and heartily approved of the way he had offered 'Counter-experiments' to Newton's. On the other hand, he knew that Goethe had not succeeded in converting 'a single Mathematician' to his point of view; and he felt that the prismatic spectrum had not been properly explained by either of them. Where he undoubtedly agreed with Goethe was on the desire for completeness of both eye and soul: that interdependence of light and dark that might connect his own brooding shadow, for example, with the radiance of Sara Hutchinson on one particular evening at Gallow Farm in Yorkshire as she sat with her head on her hand before the fire, her lovely shoulder, arm and white neck caressed by the brightness of the flames.

And he longed for 'a glory'. A proper one, not just the half-hallucinatory luminosities and spectra brought on at bedtime by '2 pretty large Beakers of Punch' or a red herring eaten for supper. A real wonder, like those 'thousand silky Hairs of Amber & Green Light' shimmering from the sun at Ullswater, or that halo round the full moon at Gibraltar, with a few stars sparkling in it like a garland or a crown. In Germany, in German, he wrote notes about the strange glow-and-shadow effects witnessed on the Brocken in the Harz mountains, where Goethe had set his witches' revels in a maze of deceiving lights. Coleridge climbed it in May 1798 with a group of friends, never ceasing to declaim all the way on how to define the sublime. No Brocken-spectre showed up, however, only (on a second climb) a wild boar with a coronet of glow-worms round its rump.

Others elsewhere had more luck. From the *Manchester Transactions* Coleridge copied out the experience of John Haygarth, who saw in February 1780 his own glory cast on 'a very white shining cloud' trailing close to the ground in the Vale of Clwyd:

> I walked up to the cloud, and my shadow was projected into
> it; the head of my shadow was surrounded at some distance
> by a circle of various colours whose centre appeared to be ...
> near the situation of the eye, and whose circumference
> extended to the Shoulders ... It exhibited the most vivid
> colors red being outermost ... all the colors that the rainbow
> presents to our view – The beautiful colors of the hoarfrost
> or snow in sun shine –

Coleridge also noticed at Keswick that the stone wall of one of the Wesleys' Methodist chapels was inlaid with sun-reflecting 'little blown water-filled, or solid Glass Balls or Bubbles' in which each passer-by could see 'his own shadow with a heavenly glory, & all the rest dark & rayless – '. The sight might almost have turned him to Methodism, if anything could.

The closest he came to such an apotheosis was on his voyage in 1804 from Gibraltar to Malta. It was April 27, a Friday. They were in a dead calm, 'or nearly so':

> the Reflection of the Sun thro' the Sails & Ropes like a Vase
> or a circular Plume of flames in tortuous flakes of bright
> sulphur-blue; cherubic swords of Fire – now blowing all one
> way, now dividing, now blossoming in a complete crater-vase

(a lily flower!) – … My Shadow the Head in the center of the crater which now forms a Glory about my Head …

He tried to repress his excitement. 'Hints taken from real Facts by exaggeration,' he cautioned himself. Nonetheless, in the middle of the Mediterranean, S. T. Coleridge – seasick, constipated, tormented by rhubarb and bilge-water ('I have found myself in a Bason always, sometimes on one side, sometimes in the Bottom') – became, for a moment, glorious.

Usually humbler things seemed to symbolise him. His candle, besides focusing light for his experiments and his passionate, disordered dreaming, made a good proxy for himself. The tallow of his body was consumed in living (up to a point, though never enough for vanity to be satisfied); the flame was his own breath, his life, with the colours of the spectrum sometimes luminous about it. 'Halo round the Candle – Sigh visible,' he wrote in 1796; and in 1810, again tormenting himself with memories of Sara by the fire and his failure, at that precise moment, to press his suit with her: 'A Candle in its socket, with its alternate fits & dying flashes of lingering Light – O God! O God!' In the immediate aftermath of Wordsworth's humiliation of him over *Lyrical Ballads*, his imagination lay 'like a Cold Snuff on the circular rim of a Brass Candle-Stick, without even a stink of Tallow to remind you that it was once cloathed and mitred with flame'. The words of Böhme might have suited the situation, vis-à-vis Wordsworth as well as God: 'I am a very mean and little spark of His light; he may set me where he pleases, I cannot hinder him in that.'

Poet after poet made himself an everyday, usually struggling, version of light. Jefferies was almost alone in his proud, torch-like flame. Donne shone pathetically, a fading spill ('We are Tapers too, and at our owne cost die'). Dorothy described Wordsworth 'kindling' after he had walked continually up and down the orchard with her, like a dull match eventually striking on a box. Clare was a flickering rushlight of the farthing kind, thrown on the pile in his cottage corner, 'that have glimmered their day & are dead'; Hopkins was 'sputtering but unextinguished' as he signed off a letter to a friend. Whitman, himself more sun-like, also made 'diffusing, dropping, sideways-darting' sparks, like those that flew from a knife-grinder's wheel, of a crowd of jostling, fascinated urchins in Lower Manhattan.

Sometimes, too painful to dwell on, light had bathed them and then gone. Even the heaven-dazzle of Traherne's infancy had been blown out by 'Contrary Winds', leaving him in boyhood 'Lost as a dying Flame'. Job recalled with sighs his youthful preservation, when God placed light like a candle on his head; it did not last to manhood, but the benediction was long remembered. A wick when ignited first staggers and resists, then steadies, with a holy calm. Thus Dante at the mid-point of Paradise was first blinded by light, then veiled tenderly in it, 'to prepare the candle for the flame', as Beatrice told him.

— as when, in the incense-cold dark of a church in winter, the six high candles on the altar are lit by the tallest altar-boy, the match flaring in its sconce at the end of a thin pole; under that rippling, attacking flame the wick of one candle briefly catching, the next fading, while in cassock and ghostly surplice he flits to and fro, stretching

up half-unseen to the limit of the pole and of his arms; the first one
out, the next struggling, until the waxing spark of one or two encour-
ages the rest, and as he swirls down the altar steps he turns to see the
still, triumphant settling of every point of light –
 Six above him, the seventh his own.

Coleridge always found it more heartening to consider the flame alone. The longer he looked, the more it came to symbolise something deeper than bodily life and breath. Hence the notes he made on 'Monday Night, 11 o'clock, 17 Dec [1804]':

> … the exquisite oneness of the flame makes even its angles so different from the angles of tangible substances. Its exceeding oneness + its very subsistence in motion is the very *soul* of the loveliest curve/ it does not need its *body*, as it were.

That 'exceeding oneness' had to hint at soul as far as he was concerned; for only there, or in God, or in perfect whiteness (to go by Newton) were the many made One. On November 15 1806, at half-past eleven at night, he called the regular, inner, yellow-white flame of his candle its 'inner Soul', and noted that it forced the unsteady outer one to combine with it for a moment: '& the whole flame became, for a second of a second, one/ and of the form of the inner flame'. The experiment was confirmed when a little later the inner flame, 'beautifully amber-edged at times', drew the outer one too 'into conformity with its beauty'.

The child newly baptised, or his godparents, was given a flaring candle as a symbol of becoming light, holding it steady; and the

symbolism also occurred from day to day, as far as Hopkins was concerned. At Stonyhurst on a winter morning in 1872 he could not help noticing as young Tommy, screening the taper with his hand across the table in the dark refectory at breakfast, became a sculpted mask of leaves of gold, from the fine cleft of his nostrils to the down on his cheeks: an image Fra Angelico might have painted. The boy became light. And lovers – for Hopkins, necessarily, married lovers – also transmitted it. As he walked the lanes at night alone, each candlelit window seemed the token of 'Jessy or Jack' sewing or reading there, the two together, or one awaiting the other. He thought of 'to-fro tender trambeams' piercing the dark, beams fine as filaments of twisted silk, each representing twining fingers and eyes' eagerness, for he felt 'a kind of spooniness and delight', he confessed, about married love. When he sat inside, too, at evening, in his room at some college or another – a book on his knee, but his attention culpably distracted – an occasional lantern would move 'along the night',

> That interests our eyes. And who goes there?
> I think; where from and bound, I wonder, where,
> With, all down darkness wide, his wading light?
>
> Men go by me whom either beauty bright
> In mould or mind or what not else makes rare:
> They rain against our much-thick and marsh air
> Rich beams, till death or distance buys them quite.

In the Walden woods that light was Thoreau, tramping his way home or sitting, solitary and philosophical, in his tiny cabin where

the japanned lamp shone on three chairs, two forks, but only one spoon. He felt as far from the life he had left as if he had voyaged to the Pleiades, the Hyades, Aldebaran or 'Miss Cassiopeia's Chair'; and his window twinkled in remote distance and silence among the pines, with just as fine a ray as theirs. The villagers of Concord often remarked that he must get lonesome down there, and want to be nearer to folks. To this he had two answers. First, 'Why should I feel lonely? Is not our planet in the Milky Way?' And second, even more carefree, 'No more lonesome than the north star.'

Thoreau made a habit of pure living deliberately in order to shine. At the age of seven I was taught much the same: that after confession my soul would gleam like a polished mirror, bright enough for others to see. Confessions, as it happened, were held in the evenings, in a gloomy church called St Joseph's in New Malden, in south-west London. It was approached first across greenbelt fields round the Hogsmill, where Jefferies had roamed years before; then through a small, scrappy avenue of trees, past the forced-apart railings that were my shortcut to the swings, though I did not confess that; then through roads of 1930s pebbledash houses and wide, silent verges. My mother would take me. My tiny roster of sins confessed in the right nervous words, through the grille where the priest sat breathing as loudly as a steam train, I would emerge wildly shining, pure and good. I would skip home in the dark, though carefully, for new sins could waylay me craftily between the paving stones with small, snipping, muddy fingers, and one was Pride. On a night in December, in a thick pea-souper, we mis-felt our way out of the avenue of trees and ended up on the riverbank, slipping steeply on dark grass. I piped up:

'Didn't Jesus say I am the Way, the Truth and the Light?' (No – not quite.) And it seemed at that very moment that a street lamp, though still shrouded in mucous fog, was switched on above us, powered by seven-year-old saintliness alone.

Men and women passing through the world might sometimes leave light behind them. An Irish priest, Brother Slattery, explained to Hopkins that the 'candles' or wicks of fire that hovered round graves were generally known in his country to be departed souls, unable to leave. Souls of the stillborn and unbaptised were especially prone to wander and deceive. These may have accounted for Clare's 'will o whisps', unless the original Will or Jack was just an ordinary traveller benighted in the Fens, striving to beat back the blackness with his own beams. As it was, Clare always supposed the strange whisking flames, crackling like pea-straw, to be 'a person with a lanthorn' when he first saw them.

In ancient Greece Empedocles taught that the eye itself was made like a traveller's lantern, fashioned by Aphrodite out of earth, water, air and fire and fastened with rivets of love. (Ideally fitted, then, to make the love-light world that Böhme's God created.) It was then wrapped in soft protective coverings, 'as when a man who intends to make a journey prepares a light for himself on a wintry night, and fits linen screens against all the winds, but light, being more diffuse, leaps through' – as it would. Newton as a boy made a similar lantern of crumpled paper that folded flat in his pocket, to see with a soft-screened candle his winter way to school.

Empedocles meant, though, that in the case of human eyes the candle was already there. And others, too, believed it. In the seventh

century the Welsh bard Taliesin, beautifully conflating Logos and Light, proclaimed that he had been 'a word in a book … a light in a lantern … I have knowledge of stars/ That existed before the earth was made.' Traherne's body, too, was 'a Lantern only' to the Candle of Love set inside it. He had sensed it, so many times,

> Secur'd from rough and raging Storms by Night,
> Break through the Lanthorns sides, and freely ray
> Dispersing and Dilating ev'ry Way:
> Whose Steddy Beams too Subtile for the Wind,
> Are such, that we their Bounds can scarcely find.

On this theory inner and outer light worked together, and vision depended on the action between them. 'The eye is formed by light and for light,' wrote Goethe, 'so that the inner light may emerge to meet the outer light.' He went on (quoting an ancient writer, whose name he seemed to think unimportant): 'If the eye were not sunlike, how could it see light at all?' Or, in Blake's couplet,

> The Suns Light, when he unfolds it,
> Depends on the Organ that beholds it.

Even in the womb, therefore, the forming eye prepared itself for radiant exchanges and combinations. Traherne described an infant's eyebeams in the words he used for light itself: refined, subtle, piercing, quick and pure; faster than 'the sprightly Winds', far out-shooting 'the Reach of Grosser Air'. Only through such 'Spiritual Lamps', he wrote, could angels see earthly things and could light itself have purpose. 'The Sun in your Ey, is as much to you as the Sun in the Heavens,' he

told Susannah; '… It would shine on all Rivers, Trees and Beasts in vain to you, could you not think upon it':

> Had he not made an *Ey* to be the Sphere
> Of all Things, none of these would e're appear.

Besides, as he had assured her—perhaps encouraged by that 'naked bodily' experience that other hands primly expunged from his writings—'You are as Prone to lov, as the Sun is to shine.'

In this buoyant frame of mind he would trot, ever sprightly, to his church at Credenhill. He would weave through his beloved orchards, his 'silent Trees' and 'immortal wheat', to find the sun already submissive on the lintel and humble on the worn flagstones. For, modest churchman as he was, he was more than the sun. That was 'a poor little Dead Thing' compared with both his all-seeing eyes and his soul – sweetly kept as any apple in an apple loft, well away from soft brown rottenness. ('There's no Contagion here.') Within his breast he held, incandescent, his own portion of light: 'a far more perfect Sun, nearer unto GOD in Excellence and Nature'.

Herbert agreed. As a lutenist, he was well aware of the strings in his heart and how they vibrated when he prayed. Though he might be only 'a brittle crazie glasse', like all men and women, were not those inward heartstrings as bright and fine as the beams of the sun? Might they not tangle together, then, as he formed his morning praises, 'Till ev'n his beams sing, and my musick shine'?

There was no awe here, but a sense of confident equality with the sun. Blake felt it as keenly as anyone. 'I can reach the sun with my hand,' he would say, 'if I stretch it out.' In 'The Marriage of Heaven

and Hell' of 1790 he flung himself into it, through the 'fiery tracks' woven round it by vast white and black spiders, to emerge robed in white with the works of Swedenborg in his hand. It was from Swedenborg (before he dismissed him as old-hat) that he learned the contrast between the dead Sun of Nature, forged by Los when he fell from heaven, and the living sun of the spirit. The showdown, as Blake told his friend Thomas Butts, came between Felpham and Lavant in November 1802, a mild enough day, as he walked to meet his sister. Los appeared then, from a grey thistle in the lane in front of him, 'in all his power', blazing and glowering in the sun he had made; but Blake, equipped with 'the bows of my Mind & the Arrows of Thought … in their golden sheaves', fearlessly defied him. He owed nothing, he told him, to his sun:

> Thou measurest not the Time to me,
> Nor yet the Space that I do see:
> My Mind is not with thy light array'd,
> Thy terrors shall not make me afraid.

Instead his life was fed by 'Another Sun', the spiritual Los who had not fallen – though he had met him too, on Primrose Hill, when the blinding figure had snapped 'Do you take me for Apollo?' With him he had joined before, and meant to again, advancing in glory until 'nothing can withstand the fury of my course among the stars of God'. Already his fingers were sparking, ray-like, with the thought of the work he could do.

Outer and inner sun could often seem mirror-close. The rising of one might herald, even spur, the dawn of the other. As Vaughan

pointed out, this was the way things should be; and the right way round was that his readers should 'Rise to prevent the Sun':

> Walk with thy fellow-creatures. Note the *hush*
> And whispers amongst *them*. There's not a *Spring*,
> Or Leafe but hath his Morning-hymn. Each *Bush*
> And *Oak* doth know I AM. Canst thou not sing?

Palmer, though not naturally an early riser, knew that 'most great men' got up when the sun did; he regularly slept outside at Shoreham, or failed to sleep, to catch the gleams that were vital to his visions. Blake knew enough dawns to paint them continually, peopled by his angel-larks and by 'an Innumerable company of the Heavenly host crying "Holy Holy Holy is the Lord God Almighty"'. Clare, reporting for volunteer duty, remarked that dawn was 'a very late hour with ploughmen'. Blind Milton at dawn spoke his verses aloud, bringing them to birth as his night Muse left him. It was in those first rays that Chaucer and his daisy opened their eyes together. Turner would ask other artists if they ever saw the sunrise, implying that, by God, they should; in old age, wrapped in a blanket or a dressing gown, he would go up on his roof at Chelsea to watch the colours spread over sky and river. Faced with those dawn colours, Whitman felt his own vast soul breasting and embracing the world. Hence the 'song of me rising from bed and meeting the sun':

> Dazzling and tremendous how quick the sun-rise would
> kill me,
> If I could not now and always send sun-rise out of me.

Thoreau echoed him: 'Of what significance the light of day,' he asked, 'if it is not the reflection of an inward dawn?' At sunrise by Walden Pond, the fish stirring in the green lake, mist drifting from the firs, each morning a fresh spring for this 'perfect forest mirror', he felt himself able 'to carve and paint the very atmosphere and medium through which we look'.

Perhaps writers are prone to think this way. I did so one grey afternoon, walking up Newmarket Hill. The track was that taken by young John Dudeney to care for his flock, his long shepherd's coat loose around him, his nose in a Latin primer or a history book, though ever alert for small white-rumped wheatears breaking from the chalk. I was meant to be thinking too, but nothing was in my mind, except the steady thrum of boots on turf and the silly jingle of old tunes. The sky hung like a pall. I began to long for the sun to break through, just a little; and as I longed the sky opened, a crack among the clouds, and as I walked and willed it a slow sunset, rose-wreaths and embers, began to tinge, gather and spread. By the top of Brighton racecourse the sky was aflame from one side to the other, the sort of spectacle people run out of doors for; and as I reached the seafront I saw them, tiny gesturing figures with their cameras and phones, against the fire.

Preposterous though it seems, I was sure I had done this myself. As Thoreau said, there was something painterly in it: as if I was actually brushing colour into the sky, and with it (for it cannot be without it) light.

> *Of ashes once I wove a rose,*
> *From cloud teased out a glowing flower,*

And pinned them to the winter sky
Where, for one crimson-spreading hour
Their glory grew. My doing's this;
Celestial painting is my trade;
There's sometimes no effect of light
My busy thinking has not made.
And yet today that brush, the same
That flourished fire, disturbs in vain
The tall grey water, and a wraith
Curls down, like thought, to ash again

Coleridge felt this sun-power in his own fashion. 'Deeply depressed almost to despondence' by thoughts of Sara and home, pacing in his greatcoat on a flat Maltese rooftop in 1805, he watched the sun edge above the dusky horizon and felt 'as I always feel, as if it stepped in quick upon the Scene/ occasioning a startlet … (a breath of air on the surface of Tranquillity)'. Frequent 'startlets' and 'startlings' were the natural result of the opium he took; but his heart and the sun, too, seemed strangely connected. He sensed, as Traherne had done, 'the suddenness, the *all-at-once* of Love' leaping up with the dawn and seeming to make up 'fully half' of the world's visibility and beauty by its own power alone. In short, as he had asked himself before, 'Why is Love like the Sun?' And what was this 'self-fed fire' that sometimes seemed to burn up 'the Earthly of my nature' in boundless splendour? Another notebook held the clue. In the midst of his usual flood of reflections he had jotted down one clear phrase (though it was Sir Thomas Browne's, and not his own): 'Life is a pure flame and we live by an invisible Sun within us.'

He evidently liked that thought, corresponding as it did to his night-time musings on the candle on his table. The difficulty was that the candle flame, however pure, needed fuel and kindling to burn, and was in his own power, with his breath or the snuffer, to eliminate; whereas Browne's 'invisible Sun' seemed to have a power independent of himself. He longed to account for, but could not account for, the nature of the light that seemed to live in him.

Many before him had been fascinated by the phenomenon of inner light, and what caused it. Presuming it physical, but not being sure, Newton saw 'Fire ... like the Eye of a Peacock's Feather' spring into his eyes when he pressed them at the corners. Getting bolder, he probed behind his eye with a bodkin; white and coloured circles shot up then, which he was unable to explain. Milton in his blindness (a fate he attributed partly to his brave evocation of light, for 'May I express thee unblam'd?') was tormented by disturbing, abundant radiance, mixed with dark colours, that burst forth 'with violence and a sort of crash from within' as he tried to settle to sleep. The colours then condensed to impenetrable blackness, mixed with 'ashy light', as though the two were bound up together. Coleridge supposed the inner light might live in his brain marrow, 'as visible Light appears to do in sundry rotten mackerel & other *smashy* matters'. And there was no doubt that opium enhanced it, as he recorded later, having taken 'a considerable Quantity of λαυδανυμ': this time he saw 'a spectrum, of a Pheasant's Tail, that altered thro' various degradations into round wrinkly shapes, as of Horse Excrement, or ... still more like flat baked or dried Apples, such as they are brought in after Dinner'.

Contemporaries focused, more helpfully, on the light that played in imagination, memory or dreams. This appeared to be a species of daylight, sometimes dimmer, sometimes enhanced, which had certainly puzzled Newton, since it had no obvious physical source. Wordsworth's daffodils beside Ullswater appeared to Dorothy like a 'busy highway'; yet when William recalled them in the solitude of his study they were all the brighter for their inwardness, '[flashing] upon that inward eye', becoming stars. More provocatively, in his thirties Blake claimed to have recovered the light of childhood he had lost for twenty years, an experience that made him 'really drunk with joy ... whenever I take a pencil or graver into my hand'. This 'enthusiasm or rather madness', as he called it, was what he saw his visions by. It was not linked to his 'Corporeal or Vegetative Eye', he insisted; that was something he just looked *through*, like window glass, or Empedocles's lantern-screen. The medium he now saw *by* was surely close to the kinder, holier light Milton had prayed for against the 'ever-during dark' that surrounded him, that 'Universal blanc':

> So much the rather thou Celestial Light
> Shine inward, and the mind though all her powers
> Irradiate, there plant eyes, all mist from these
> Purge and disperse, that I may see and tell
> Of things invisible to mortal sight.

Coleridge was prepared, with Milton and Blake, to consider this light divine, but that was not quite the end of the matter. He was also preoccupied with an inner light that acted differently, unpredictably. Plotinus was his chief authority, in the fifth chapter of the *Enneads*,

and he had copied the passage into his notebook. It was not lawful, Plotinus wrote, to ask where this light came from, 'for it neither approached hither, nor again departs from hence to some other place, but it either appears to us, or does not appear'. And it was unwise to pursue it, though Hopkins, for one, tried:

Be shellèd, eyes, with double dark
And find the uncreated light.

Instead, it was necessary to abide in quiet until 'it suddenly shines upon us, as we prepare ourselves for the blessed Spectacle, like the eye waiting patiently for the rising Sun'.

This light, Plotinus explained, was not 'outside and alien', but an 'earlier' light within the eye. Intellect had nothing to do with it, nor visions of any kind. In fact, nothing was revealed by it; the light itself was revelation, the shock of knowing, remote from the outer world. 'Other objects are the lit, not the light,' he insisted. This type was so pure, so unmingled, 'that we are left wondering where it came from ... and where it has gone. We say, "It was here. Yet no, it was beyond!"' Like all light; and yet like none perceived in the normal way in the material realm.

Hermes Trismegistus reported that the inner light was less dazzling than the sun, that it 'did not make the eyes close': obviously, perhaps, since they played no part in seeing it. Like that divine light that had pierced first chaos and then the waters above the earth, it was 'rather sharp and penetrating, but not injurious and replete with all immortality'. It was nothing created, added the monk-theologian Symeon in the eleventh century, and therefore could not be found

among created things. His mind had searched for it everywhere, in the air, in the heavens, in the deepest abysses, but in the end it came when it wanted – left when it would – seeming to envelop his head in a luminous cloud, so that he cried out in fear. 'Then I realised suddenly that it was within me, and shone in the midst of my heart like a spherical Sun.'

Symeon often compared this light to the sun above him. Rays streamed from its disc; it dazzled and blazed. On the other hand it was inaccessible, ineffable, and never set; and it shone sometimes in his hands, as if he held it like a bird, as well as in his heart. This was light enshrined, *lux* rather than *lumen: lux perpetua.* 'I see You like the sun and like a star,' he wrote, 'I carry You in my belly like a pearl and see You like a lamp that is lit inside a vessel.' He was sure, despite all this, that it was bodiless, formless, non-composite and indivisible. In short, it could never be caught in the retina or by prisms, belonging as it did to some other world; and the puzzle remained impenetrable. 'With all your science,' cried Thoreau in 1854, 'can you tell me how it is, and whence it is, that light comes into the soul?'

Traherne, too, wondered. He knew there was a 'Hev'nly Ey' within him, a lantern-ray of love he sometimes had the ecstasy of seeing. But as a man intrigued by mechanisms, compasses and clocks, he longed to know how it came there and how it worked. He concluded that it was a mirror reflecting divine light: a mirror that was lidded like an eye, so that it could blink out God, refusing His guidance, as men blinked out the sun. That tiny point of ineffable brightness lay 'as deep within the Glass as it is high within the Heavens'. This, perhaps, was the 'hidden manna' and the white stone mentioned in Revelation, that

mysterious pebble of spiritual power. For Böhme, as for Symeon, it was a pearl, 'glimmering' in the consciousness just as the glimmering-through of light haunted Blake and Palmer; and the mystical meaning of the *Pearl* poem was the loss, as of a pearl dropped carelessly in grass, of the pure and illumined soul. Dante wrote that he and Beatrice in Paradise were received within 'the eternal pearl', *l'etterna margarita*, quite seamlessly, as though they entered their own light.

The within-ness of this light, its minuteness and its apparent compression, as in a case or box, was striking. Vaughan saw it as a tiny star within a tomb; Julian of Norwich was shown it in a secret chamber of the heart, 'God in a single point'. For Hopkins it was that 'vital candle in close heart's vault' that corresponded, though utterly still, to the small, hopeful candles set by lovers in windows: what St Paul called a love letter written not with ink but by the Spirit, and not on tablets of stone but 'in the fleshy tables of the heart'. *I will put my law in their inward parts, and write it in their hearts*, God had told Jeremiah. To glimpse it was rare, almost unhoped for. But at the moment of encounter this light did not pale, wriggle or escape, because it was divine love: a ray falling from the very beginning, defining the form and then, from each angle or facet, reflecting back. And not just reflecting, mused Coleridge (hoping ardently it might happen in his his own heart) 'like the polish'd mirror by rejection from itself, but by transmission thro' itself'.

In the physical world Newton had unearthed a similar principle. The 'least parts' of natural bodies – those fibres of feathers, gossamers of spiders, dust-grains of metals – being transparent, reflected and transmitted light. In opaque bodies the process was deeper and

un-apparent on the surface, but it happened nevertheless. 'Shadows are transparent ... full of REFLECTED LIGHT, though very deep,' wrote Palmer, remembering what he had learned at nineteen, lying in the grass; 'clear, beautiful and clean in colour.' The process seemed universal. As Newton said, 'The changing of Bodies into Light, and Light into Bodies, is very conformable to the Course of Nature, which seems delighted with Transmutations.'

He had drawn up a list of 'refractive power in respect of density': it began with a yellow pseudo-topaz, progressed through air, selenites, 'Glass vulgar', 'Crystal of the Rock', 'Island Crystal' (Icelandic feldspar, 'that strange Substance' in which, bafflingly, he had seen light polarised), borax, rainwater, linseed and turpentine, and ended with amber and diamond. Of all the substances he tried, diamond possessed the greatest power both to refract and reflect. Traherne took the thought on as a man of the cloth would, imagining Susannah's transfiguration among the 'Things of Heaven': 'As Light is in a Piece of Chrystal, so shall you be with every Part and Excellency of them.'

Hopkins, who had found crystalline star structures everywhere in Nature, endeavoured to describe this. For as stones, kingfishers, ash trees and oak trees selved in light, so too did human beings. 'Self | flashes off frame and face,' he wrote; the brow of the humblest shepherd blazed with 'forked lightning'; and all natural action flamed with divine beauty, in man and woman most of all. Ploughman, sailor, swimmer all expressed it, even in the swing of arms and the tramp of feet. Their essence was light. This was man's answering awareness of God's illumination, as the eye and the flower replied to the sun: 'the aspiration in answer to his inspiration'. For the human creature was

Nature's 'clearest-selvèd spark', marked out with a 'firedint' to shine 'sheer off, disseveral, a star'–and then

> Across my foundering deck shone
> A beacon, an eternal beam. | Flesh fade, and mortal trash
> Fall to the residuary worm; | world's wildfire, leave but ash:
> In a flash, at a trumpet crash,
> I am all at once what Christ is, since he was what I am, and
> This Jack, joke, poor potsherd, | patch, matchwood, immortal
> diamond,
> Is immortal diamond.

Human beings were already prisms: taking in light, transmitting it, refracting it into colours. Each man and woman painted creation in their own way, with their own eyes, and even simple people could do that creative work, he said, if they only knew. In the 'shook foil' of God's grandeur, that 'network of small many-cornered facets' made a blaze of reflected light. Hopkins himself offered not only his ordering vision but also the flare and flash of his poems, his strict, fierce stresses sparking out ('stress is the life of it,' he wrote of 'The Loss of the *Eurydice*'), or the 'bright and more lustrous emphasis' of his sprung rhythms. A good poem had to have inscape, a distinctive self, and ideally had to be 'explosive' – as God beat him out into chaff and grain, 'sheer and clear', which was also the stuff of his stars. When he made a poem work, to God's glory, not his own, the lines glowed, the rhyme and alliteration producing 'brilliancy, starriness, quain, margaretting'. By 'margaretting' he seemed to mean the lustre of a pearl.

This power was limitless. It contained the scope, freedom and speed of light: *one instant here, the next among the stars.* Thus Dante in Paradise felt his spirit spring towards light, like to like: 'and in the time that a crossbow bolt strikes, flies and is released from the catch, I saw myself arrived'. Vaughan's tiny star-lamp, the tomb lid lifted, would fill the globe; Dame Julian's secret chamber became, in an instant, palaces, spires and towers, 'all earth and all heaven'. 'No Churlish Proprieties, nor Bounds, nor Divisions,' wrote Traherne of his childhood, when his soul led him; no 'Hedges, Ditches, Limits, Bounds', therefore, though his young world was thickly circumscribed by them, his clothes torn by briars and green hawthorn as he scrambled for apples, nuts or birds' eggs. He jumped banks as nimbly as his brother jumped the moon, joyous as Adam in Paradise in his 'sweet and Curious Apprehensions of the World':

> No Confines did include
> What I possest, no Limits there I view'd;
> On evry side
> All endless was which then I spy'd.

Within him teemed his thoughts, 'brisk Divine and Living Things', tumbling inexhaustibly. Like the sun he darted his rays before him, occupying the hills 'with Light and Contemplation' before they were even climbed. He took in the trees; they grew within him, though taller far than he was. The hedgerow hazels in their straight stands might be white, unripe, hard to shake down; or ready to be cracked out of the thin double-clustered shell, their meat chewy and sweet. The Irish hermit poets spoke of a nutshell as *coich anama*, which also

meant 'soul shrine'. This did not imply confinement. On the contrary, a man held in that nutshell – as Shakespeare's imprisoned Richard II observed – could count himself 'a king of infinite space'. A ball the size of a hazelnut that might 'fall into nothing for littleness', placed in the nervous palm of Julian of Norwich, contained 'all that is made'. Traherne's 'busie, vast, enquiring Soul' within such a shell – one of dozens scattered in the lane, each one toothed by a squirrel – could find 'the whole globe of the earth', waiting. 'It doth entire in me appear/ As well as I in it.'

His words chimed with Blake, who declared that 'in your own bosom you bear ... all you behold'. And with Goethe, who had felt the moon he gazed on wandering in his own breast. He keenly believed in the 'universe within', especially when gazing at the Harz mountains across the Thüringer Wald, sipping wine from a gold cup he had brought with him in which the scene was reflected; or, in younger years, when he skated on the Main near Frankfurt, feeling his body soar in undetermined space. (The physical release, almost disembodiment, of skating also intrigued Coleridge and Wordsworth, who noted the enchanted tinkling that seemed to merge skaters, frost, woods and stars; Hopkins saw his windhover swoop 'as a skate's heel sweeps smooth on a bow-bend', king of air and earth.) 'If we had no light and colour in our own eyes,' Goethe told Eckermann, 'we should not perceive the outward phenomena; had I not the world already in my soul, I should have remained blind ... There is nothing without us that is not also within us.'

Whitman needed no telling. He already included the landscape within his giant, sprawling, marvellous self, his 'fluid and swallowing

soul'. He had watched in deliberate solitude (as I watched, though only a child, but the compass-pivot of the world on my slow, creaking swing), 'the copiousness, the removedness … of that stellar concave spreading overhead, softly absorb'd into me, rising so free, interminably high, stretching east, west, north, south … and I, though but a point in the centre below, embodying all.'

> And I said to my spirit *When we become the enfolders of those orbs, and the pleasure and knowledge of every thing in them, shall we be fill'd and satisfied then?*
>
> And my spirit said *No, we but level that lift to pass and continue beyond.*

He did not forget, either, the image of the creator-spider, whose weavings were thought – or light – spanning all he could see, or begin to imagine.

> And you O my soul where you stand,
> Surrounded, detached, in measureless oceans of space,
> Ceaselessly musing, venturing, throwing, seeking the
> spheres to connect them,
> Till the bridge you will need be form'd, till the ductile
> anchor hold,
> Till the gossamer thread you fling catch somewhere,
> O my soul.

For Thoreau, that thread was a lasso he carried 'coiled at his saddlebow'; it put the galaxies almost in his grasp. 'I cannot see the bottom of the sky,' he wrote, 'because I cannot see to the bottom of myself.' One

hair of his head, or the white crescent on his fingernail – one flicker of light – was 'the unit of measure for the distance of the fixed stars'.

Such thoughts did not come only from a land of immense horizons. Herbert, labouring in the tidy study beside his little church at Bemerton, knew that his eyes could 'dismount the highest starre'. Traherne declared that 'the rays of our light are darted from everlasting to everlasting'. Vaughan, too, gazing in his 'Angell-infancy' on a flower or gilded cloud,

> ... felt through all this fleshly dresse
> Bright *shootes* of everlastingnesse.

Coleridge continually comforted himself with the vastness of mind and soul, and their nimbleness. He imagined looking at his soul through a telescope: irregularities on the surface, to be sure, but what universes beyond! To be traversed in an instant! A few days after his 'glory' on the voyage to Malta, he seemed to contain a terrifying flash of lightning within the 'enlarged circumference' of his thoughts – indeed, grimly hailed the lightning as one of his Love-starts, love being light, which ('so help me God!') might eventually kill him. On one Lakeland walk his soul darted like a boy along a dry-stone wall, skipping the top stones daringly and fast, leaping then 'like a Kite' or a chamois goat to the far mountain slopes and peaks. ('Looking down upon the sky – stars – Lamps – Lambs.') Nothing constrained it. No knapsack of notebooks weighed it down. Time and distance had no meaning. He was behaving like light, in short – as any poet could, by opening out and illuminating what was hidden in things, the beauties, the connections. What did a poet add to a scene? he asked himself;

and answered, 'Lights and Relations.' Not least, it was through his own light-reflecting and conferring eye that the many became One: One in himself.

The stumbling beginnings of that light-work are vivid from my childhood. From the earliest book I read alone at school, *The Greedy Grocer*, I remember how the grocer's gold coins leapt out of the shadows of his shop; how the crystals of white sugar sparkled, even when he wickedly sifted them with sand, and the tin buckles glinted on his shoes. No pictures helped me; this was something I did myself, mixing light in. From another book I pulled out one strangely startling sentence: 'Aunt Jane peeled the silver foil from the chocolate and popped it into her mouth.' That crinkling, flashing foil was magic, somehow. It gleamed out of the page, alive: like the pin with which Pigling Bland's important licence papers were fastened in his jacket pocket.

I first tried the alchemy of writing to describe the way sunlight played in pom-poms of pink blossom on a flowering cherry in Chiltern Drive, where I walked to school. The moment was so important that I remember the desk I was sitting at, ridged and sloping, in the front right-hand row of the class; the dress I was wearing, one I vaguely disliked, blue and white check with a white collar; the messy sunken inkwell and the silver-capped fountain pen, with which I was still nervously clumsy; and, most strangely, the image of the tree as it lay in my mind, still as a photograph, waiting to break free. The words I found were nothing special, just the definitions of the parts: tree, petals, sky. But with them came the triumphant sense that my letters gradually made branches in which the pink blossom blew again, this time my own creation, and light flashed and leapt,

like a dancer. Van Gogh described this experience as 'being deep' in the yellow leaves, the corn or the grass.

Blake, hemmed in by sooty London, never doubted his power to make new worlds: 'The desire of Man being Infinite, the possession is Infinite and himself Infinite.' 'The possession' meant, of his visions – which, he insisted, all men could see 'if they chose'. When these appeared he would cry, to Mrs Blake or any nearby friend, 'Reach me my things!' – and would create, in pencil first, a new universe of forms. One thought, he wrote, filled immensity – as light filled it. When scientific talk at a friend's house turned to how long light took to reach the earth, and suchlike subjects, he suddenly cried: 'It is false. I walked the other evening to the end of the earth, and touched the sky with my finger.' Palmer, following close, imagined his world instantly expanding 'from the dock-leaf at our feet, far, far away to the isles of the ocean', and thence 'into the abyss of boundless light'. ('O! what heavenly grays does this suggest!')

The smallest thing might ignite both the desire and the wild trajectory: a cloud, a grain of wheat, a shell, a stone. Wordsworth suggested in his 'Intimations of Immortality' that one tree might do it, or 'a single field which I have look'd upon'; those small particular fields on which light paused, as he did, and passed on.

> Both of them speak of something that is gone:
> The Pansy at my feet
> Doth the same tale repeat:
> Whither is fled the visionary gleam?
> Where is it now, the glory and the dream?

For in the zigzag swallow-way of light, the infinite future might also turn out to be the infinite past.

When Blake first heard Wordsworth's ode in 1825 he reacted with violent emotion, going into raptures when the tree and the field were mentioned. 'You know what happened to crazy Blake,' wrote Hopkins to a friend in 1886 – Blake being, Hopkins added, 'himself a most poetically electrical subject both active and passive':

> when the reader came to 'The pansy at my feet' he fell into a hysterical excitement. Now commonsense forbid we should take on like these unstrung hysterical creatures: still it was a proof of the power of the shock.

Few understood better than Hopkins, though, why Blake had behaved that way. He might not 'take on' in that fashion himself, but the ode was still 'better than anything else I know of Wordsworth's ... so charged and steeped in beauty and yearning'. And truth, as far as he and Blake were concerned.

The pansy, in Blake's philosophy, contained heaven. Heaven lay in each wild flower; eternity in each well-spent hour. But he had begun that meditation from the minute to the infinite with a grain of sand. Sitting on the beach at Felpham – as he reported to Thomas Butts – he saw 'in particles bright/The Jewels of Light' shining in the morning sun. And not just 'Newton's Particles', as he mockingly called them; for to his amazement, all were 'Human-form'd'. Every mote of the yellow sands he gazed on, every stone and blade of grass, glittered, swarmed, and lived. Was everything, then, light? The tiny jewels became, as he considered them, 'One Man' tenderly enfolding him in limitless gold,

burning 'all my mire & my Clay' away. And such transmutations did not happen only in Sussex, in the light of the sea.

> There is a Grain of Sand in Lambeth that Satan cannot find
> Nor can his Watch Fiends find it;
> Tis translucent & has many Angles …
> Every angle is a lovely heaven …

Thirty miles to the west of Felpham, the chalk cliffs at Eastbourne come down to the sea. This is the less elegant part of town. Beyond the Holywell tea chalet the beach gets scrappy, with metal lock-up beach huts and high groynes between mounds of shingle. But the cliffs cascade to the beach in a muddle of elder, privet, honeysuckle, guelder rose, silverweed, foaming pink and white valerian and tall, ornamental mats of grass. Among all this lie huge straight-edged boulders of newly fallen chalk, from which signs warn you away. The pebbles on the beach, almost all pure white, are beautifully rounded into eggs and ovals and blinding in the sun. And Holywell itself is something of a miracle, because out of the chalk abutting the beach, just above sea level, flows a small but constant freshwater spring. It is almost as surprising, in this perennially dry and porous stone, as a sudden flight and shriek of swallows.

A faded wooden board inscribed in wobbly capitals advertises this as a holy well. Whether it is or not, no one knows for sure. The name is pronounced 'holly' round here, denoting simply the well by the holly tree. Locals take the water in bottles and say that, when it

settles, it tastes good enough. That it is curative is unlikely; doctors say the chalybeate spring has no healing properties. But it still sings loudly and sweetly in its pebble bed. The peculiarly smooth moulding of the chalk around it would have fascinated Ravilious, supple as the plump arms of the nymphs and goddesses he painted in his murals, or as the dreaming clouds above his hills.

For some the spring has become a place of pilgrimage and devotion. They leave bead necklaces and candles here, with random shells and heart-shaped pebbles arranged on shelves of rock. But most visitors pause only briefly, to fill their bottles and splash their faces. *Wash me, and I shall be whiter than snow.* They are more interested in the huge black granite rocks piled just beyond, towards the sea. On these you can scramble, perch, jump and lark around over pitched slopes and abysses, dangerously to and fro. These rocks, like those on the Brighton undercliff, are not from hereabouts. By a blue southern sea, under a southern light, their crystals of northern quartz and mica flash out like diamonds.

Up on these rocks a toddler in a striped T-shirt totters on an incline, unsure whether to go forward or back; a long-legged girl in ballet shoes tries to catch up on Facebook, no hands holding on to the granite slabs, her blonde hair teasing across her face; lads in jeans holler, topple and photograph each other, spilling cans of Carling, while their plastic football bounds away for miles; and an old couple picnic prudently at the base, with a thermos and a bag-for-life from Asda, carefully handing each other sugar, teaspoons and milk in a screw-top jar.

'Every angle is a lovely heaven,' Blake wrote. Each one made a prism to take in or send out light; and as Newton found, any veining

in the glass, or lack of polish, or 'inequalities in the Substance' made no difference to that principle. Light pierced through and flung out colour, diamond bright, from the least and transparent parts of everything created. And its wild, sharp, zigzag career, starting out from infinite space, was completed by the human eye and, some thought, the human heart.

Beyond the figures on the rocks a myriad stars, fresh-falling, flash from the waves and die and form again –

And a single yacht – there is always one – cleaves the sea like a blade.

COUNTY LIBRARY
PH. 01 4620073

NOTES

REFERENCES FOR QUOTATIONS

Since most of these works are available in many different editions, references are mostly given by original sections or dates of journal entries rather than by page numbers. Particular thanks are due to Christopher Whittick for sending me copies of Ravilious's letters, some of them unpublished, from the East Sussex Archive.

ABBREVIATIONS

AHP The Life and Letters of Samuel Palmer, Painter & Etcher. Written and edited by A.H. Palmer, 1892

CP The Prose of John Clare, ed. J.W. and Anne Tibble (Routledge & Kegan Paul, 1951)

DC The Divine Comedy

HH Notebooks & Papers of Gerard Manley Hopkins, ed. Humphrey House (OUP, 1937)

LLD Eric Ravilious: Landscape, Letters and Design. In 2 vols; ed. Anne Ullmann, Christopher Whittick and Simon Lawrence (Fleece Press, 2008)

N *Notebooks of Samuel Taylor Coleridge*, ed. Kathleen Coburn (Pantheon Press): Vol. 1 (1794–1804); Vol. 2 (1804–1808); Vol. 3 (1808–1819)
PL *Paradise Lost*
SPVL *Samuel Palmer, 1805–1881: Vision and Landscape*, ed. William Vaughan, Elizabeth E. Barker and Colin Harrison (Exhibition catalogue, 2005)
SS *Silex Scintillans*
WBW *William Blake's Writings*, ed. G.E. Bentley Jr. In 2 vols: *Volume II, Writings in Conventional Typography and in Manuscript* (OUP, 1978)

THE WHITE STONE

p. 2 Jefferies: *The Open Air* (Chatto & Windus, 1913): 'Sunny Brighton'
p. 4 Hudson: *Nature in Downland* (J.M. Dent, 1932), pp. 39–40; 15. Bunyan, *Pilgrim's Progress*, Section 8
p. 5 Bunyan: *A Book for Boys and Girls, or Country Rhimes for Children*. Psalm 51: 7
p. 6 Ravilious: to Helen Binyon (hereafter HB), 9 Aug. 1935 (*LLD* 166)
p. 8 Ravilious: to HB, 23 July 1942. White: *The Natural History of Selborne*, Letters X, XVII and VII. Ravilious: to HB, 30 Jan. 1936 (*LLD* 197)
p. 9 *Glimpses of Our Ancestors in Sussex* (online book): 'Communication of John Dudeney to Mr R.W. Blencowe'
p. 10 Revelation 2: 17
p. 11 Traherne: *Centuries of Meditations*, 2.67; 3.3; 4.60; 'The Demonstration III'.
p. 12 Jefferies: 'Hours of Spring'. Ravilious: to Diana Tuely (hereafter DT), 13 June 1938 (*LLD* 365)

p. 13 Jefferies: Cited in Samuel J. Looker and Crichton Porteous, *Richard Jefferies, Man of the Fields* (Baker. 1965), p. 211; *Story of my Heart* (Longman, Green & Co. 1883), Ch. 1. Clare: *Journal*, 15 Nov. 1824

p. 14 Clare: *Journal*, 7 Jan. 1825; Later fragment (*CP*, p. 252)

p. 15 Clare: 'The Journey from Essex' (*CP*, pp. 244–50); 'The Autobiography' (*CP*, p. 32)

p. 16 Jefferies: 'Hours of Spring'; 'The July Grass'. Böhme: *Confessions*, X. Jefferies: 'The July Grass'

p. 17 Ravilious: Tirzah Ravilious, *Autobiography* (*LLD* 92)

p. 18 Traherne: *Christian Ethicks*, 'Of Knowledge'; Whitman: 'Song of Myself', 453–54; 100–102; 90–94

p. 19 Whitman: 'Song of Myself', 490; Hopkins: letter to Bridges, 18 Oct. 1882

p. 20 Hopkins: 'Pied Beauty'. Jefferies: *The Open Air*, 'The Pine Wood'; 'Nature and Eternity'.

p. 21 Whitman: 'Song of Myself', 165–66, 394. Clare: 'The Fate of Genius'

p. 22 Thoreau: *Journal*, 30 May 1853; 10 Sept. 1860; *Walden, or Life in the Woods*, 'Economy'

p. 23 Thoreau: *Journal*, 12 March 1842. Böhme, *Christ's Incarnation*, XI

p. 24 Clare: 'To my Oaten Reed'. Herbert: 'Employment'. Blake: Letter to John Flaxman, 21 Sept. 1800; Letter (with Catherine Blake) to Nancy Flaxman, 14 Sept. 1800

p. 25 Clare: 'The Mores'

p. 26 Traherne: *Hexameron*; *Centuries*, 3.3; 'The World'. Hopkins: Early Diaries, 1864 (*HH*, p. 8). Milton: *PL* IV, 980–83. Clare: *Shepherd's Calendar*, 'March'. Hopkins: *Journal*, 23 July 1874

p. 27 Jefferies: 'Wheatfields'; *The Open Air*, 'Saint Guido'. Edward Thomas: *Richard Jefferies, His Life and Work* (1909), p. 215. Jefferies: *The Old House at Coate*. Palmer: *The Sketchbook of 1824*, ed. Martin Buttin (Thames & Hudson, 2005), pp. 175–76, 2, 52

p. 29 Palmer: *SPVL*, pp. 128, 142–43. Ravilious: to HB, 9 June 1935 (*LLD* 146)

p. 30 Ravilious to DT, 14 Jan. 1940; to Peggy Angus, 22 July 1939, 2 Aug. 1939. Dorothy Wordsworth: *Journal*, 24 Nov. 1801; Dante: *DC*, *Paradiso*, Cantos XXXIII 85–87 and XVIII 28–33

p. 31 Thoreau: *Journal*, 8 Feb. 1841; *Walden*, 'Where I Lived, and What I Lived for', and 'Solitude'. Clare: *Journal*, 1 Feb. 1825; 'The Progress of Ryhme', 282–84. Traherne: *Centuries*, 3.3

p. 32 Herbert: 'The Affliction (1)'; 'Employment (2)'. Job 30: 19–20

p. 33 Hopkins: *Journal*, 24 Aug. 1868. Clare: 'Fen Description: Autumn' (*CP*, p. 242)

p. 35 Jefferies: 'January in the Sussex Woods'

p. 36 Clare: 'The Autobiography' (*CP*, p.25). Hopkins: *Journal*, 1870 (*HH*, p. 133)

p. 37 Hopkins: 'Binsey Poplars'; *Journal*, 17 Oct. 1873. Jefferies: 'Wild Flowers'. Whitman: 'Song of the Open Road', 7

p. 38 Whitman: *Specimen Days*, 'Thoughts under an oak – A dream' (1878). Thoreau: *Walden*, 'Baker Farm'. Clare: *Journal*, Christmas Day 1824. Thoreau: *Journal*, 18 March 1858; 15 June 1840; 19 June 1843

p. 39 Rilke: 'Advent

p. 40 Hopkins: 'God's Grandeur'; letter to Bridges, 4 Jan. 1883; *Journal*, 17 Sept. 1872

p. 41 Hopkins: *Journal*, 13 July 1863; 'Barnfloor and Winepress'; *Journal*, 9 July 1868; 11 July 1866; 4 Sept. 1868; 19 July 1866; 9 July 1874

p. 42 Hopkins: *Journal*, 19 July 1872; Untitled, 'As Kingfishers catch fire'; 'Commentary on the Spiritual Exercises of S. Ignatius'; *Journal*, 12 Dec. 1972; 14 March 1871; 1 May 1871; 22 April 1871

p. 43 Hopkins: 'Epithalamion'; *Journal*, 16 June 1873; 'The Wreck of the Deutschland', st. 8. Milton: *PL* IX, 577–78

p. 44 Traherne: 'The Enquiry' V; 'The Odour'. Palmer: *AHP*, pp. 180, 175; *SPVL*, p. 214

p. 45 Jefferies: 'Nature and Books'; *The Old House at Coate*. Clare: *Autobiography* (*CP*, p. 12), 1

p. 46 Blake, *Notebook*, p. 7 (*WBW*, p. 927). William Stukeley: *Memoirs of Sir Isaac Newton's Life*, f. 15r (The Newton Project, online)

p. 47 Milton: *PL* IX, 705–07, 835

p. 48 Jefferies: *JE*, 'Nature and Books'. Blake: Letter to Butts, 23 Sept. 1800. (*WBW*, p. 1542). Traherne: *Centuries*, 3.3. Palmer: *AHP*, pp. 15–16; 1824 *Sketchbook*, pp. 2, 81–82

p. 49 Jefferies: 'Nature near London'

p. 50 Ravilious to HB, 12 May 1938 (*LLD* 357). Bunyan: *Pilgrim's Progress*, Section 1

AMONG THE BIRDS

p. 53 Thoreau: *Journal*, 21 Sept. 1840. Blake: *The Marriage of Heaven and Hell*, 'A Memorable Fancy'

p. 54 Jefferies: Cited in Looker & Porteous, op. cit., p. 210; 'Wild Flowers'; *The Nature Diaries and Note-Books of Richard Jefferies*, ed. Samuel J. Looker (1948), p. 244. Newton: *Opticks*, Book 2, Part III Prop. v; Bk 3,

Part I. Jefferies: 'Hours of Spring'; 'Out of Doors in February'. Clare: Later fragments (*CP*, p. 251)

p. 56 Hopkins: 'The Sea and the Skylark'; Letter to Bridges, 26 Nov. 1882 (asterisk indicates a footnote in the original); *Journal*, 22 April 1871. Blake: 'Auguries of Innocence'

p. 57 'Milton', Book the Second, *passim.*Palmer: *AHP*, p. 280

p. 58 Dante: *DC*, Paradiso XX, 73–75. Palmer: *AHP*, p. 168

p. 59 Coleridge: N 3314; 'Answer to a Child's Question'; Letter to Godwin, 1802; *Rime of the Ancient Mariner*, Part 1, 75–78; N 2345, 2494. St Columba's birds: see Brian Morton in *The Tablet*, 16 March 2013

p. 60 Coleridge: N 2054, 2556. Hopkins: *Journal*, 30 May 1873. Hudson: *Nature in Downland*, pp. 173–74.Clare: *List of Birds*: Swifts (*CP*, p. 278)

p. 61 Thoreau: *Walden*, 'The Beanfield'. Hopkins: 'The Windhover'

p. 62 Clare: *Nature Notes*, 'Hawks' (*CP*, pp. 196–97). Jefferies: 'Forest' Coleridge: N 3400. Messiaen: Preface to 'Quartet for the End of Time', and video interviews

p. 63 Hopkins: 'Spring'. Thoreau: *Journal*, 22 June 1854. Whitman: 'When Lilacs last in the dooryard bloom'd', 13. Hudson: *Nature in Downland*, pp. 240–41. Clare: 'The Eternity of Nature'

p. 64 Emerson on Thoreau: *The Atlantic*, Aug. 1862. Edward Thomas: 'The Unknown Bird'; 'Aspens'; 'Roads'

p. 67 Hopkins: 'Peace'. Dante: *DC*, Paradiso XVIII, 73–111

p. 68 Coleridge: N 582

p. 69 Jefferies: *The Open Air*, 'The Pine Wood'. Hopkins: 'Spring'

p. 70 Clare: *List of Northamptonshire Birds* (*CP*, pp. 261–91). R.S. Thomas: 'A Thicket in Lleyn' (poem); 'A Thicket in Lleyn' (prose), in *Britain: A World by Itself* (various authors, 1984). Coleridge: N 1851

p. 71 Messaien: video interviews. Collins: William Anderson, *Cecil Collins: The Quest for the Great Happiness* (Barrie & Jenkins, 1988), p. 58. Clare: *Journal*, 2 March 1825

p. 72 Ravilious: to HB, 24 July 1935 (*LLD* 163n); 27 Jan. 1935 (*LLD* 105). Irish poet: 'The Scribe in the Woods' from *The Finest Music: Early Irish Lyrics*, ed. Maurice Riordan, p. 4

p. 73 R.S. Thomas: 'A Thicket in Lleyn'. Blake (William and Catherine): Letter to Nancy Flaxman, 14 Sept. 1800 (*WBW*, p. 1538). Ravilious to DT, 18 Dec. 1938 (*LLD* 397). Clare: *Journal*, 9 Oct. and 16 Nov. 1824

p. 74 Traherne: *Select Meditations*, 3.65

p. 75 Vaughan: *SS* 1, 'Christ's Nativity' Williamson: 'Midsummer Night'; 'Star-Flights of Swifts' from *The Labouring Life* (1932); *The Lone Swallows* (1922), p. 120

p. 77 Coleridge: N 1635. Edward Thomas: 'Cock–crow'

p. 78 Coleridge: N 2086. Thoreau: *Journal*, 7 Feb. 1841

p. 79 Dante: *DC*, Paradiso XXIX, 12; Vaughan, *SS* 2, 'Cock-crowing'; Hopkins: *Journal*, 17 Nov. 1869. Einstein: *Autobiographical Notes*, ed. Paul Arthur Schlipp (Open Court, 1979)

p. 80 Clare: 'The Journey from Essex' (*CP*, pp. 247–48). Emerson: Anecdote from Charles Eliot Norton. Dante: *DC*, Paradiso CXII, 29–30

IN THE BEGINNING

p. 83 Palmer: *AHP*, p. 386. Traherne: *Centuries*, 1. 1

p. 84 Ravilious to HB, 30 Dec. 1936 (*LLD* 277). Grosseteste: *Hexameron* (*On the Six Days of Creation*), trans. C.F.J. Martin (OUP, 1999), Part Two, I–III

p. 85 Hermes Trismegistus: *The Divine Pymander*, 1.4. Ravilious to DT, 1 March 1939 (*LLD* 405). Milton: *PL* III, 6

p. 86 Hopkins: Meditation of 7 Nov. 1881. Böhme: *Three Principles*, XVI. Ravilious to DT, 3 Sept. 1938 (*LLD* 377). Traherne: *Centuries*, 4.80

p. 87 Whitman: 'Noiseless Patient Spider'. White: *Selborne*, Letter XXIII. Coleridge: N 2166

p. 88 Grosseteste: *Hexameron*, Part Two, X. Bacon: *Perspectiva* 1.7.1. Dante: *DC*, Paradiso XXIX, 13–18, 25–30. St Paul: Ephesians 5: 13

p. 89 Coleridge: N 1999, 2344

p. 90 Böhme, *The Signature of all Things*, XI. Traherne: *Centuries*, 2.78; 4.25; 'The Vision'. Hopkins: *Journal*, 24 Feb. 1873

p. 91 Hopkins: *Journal*, 1 Aug. 1868; Feb. 1870; Early Diaries (*HH*, p. 49); 12 Dec. 1872; 17 Sept. 1872. Traherne: *Centuries*, 3.3, 2.67; 'The Apostacy'

p. 92 Traherne: *Centuries*, 3.55. Clare: 'Autumn' (*CP*, p. 243). Jefferies: *The Open Air*, 'Wild Flowers'. Rich: Alfred W. Rich, *Water Colour Painting* (1918), p. 35. Hopkins: 'The Windhover'; 'Harry Ploughman'. Jefferies: *The Open Air*, 'Sunny Brighton'

p. 93 Blake: 'Descriptive Catalogue' (*WBW*, p. 861). Grosseteste: *Hexameron*, Part Two, X. 2,4. Traherne: *Centuries*, 3.35

p. 94 Blake: *Jerusalem*, 54. Goethe: Conversation with Eckermann, 1808. Bede and Jerome: Grosseteste, *Hexameron*, Part Two, IV. Milton: *PL* VII, 248–49

p. 95 Dante: *DC*, Paradiso XXXIII, 85–87. Grosseteste, *Hexameron*, Part Two, I. 1. Dante: *DC*, Paradiso XXX, 85–86; XXXIII, 108

p. 96 *Pearl*, sts 88–90. Galileo: A. Frove and M. Marenzana, *Thus Spoke Galileo* (OUP, 2006), p. 414. Hermes Trismegistus: *The Divine Pymander* 7

p. 97 Herbert: 'The Bag'. Bunyan: *Pilgrim's Progress*, Section 12. Langland: *Piers Plowman*, C Passus II, 149–155

p. 98 Hermes Trismegistus: *The Divine Pymander* 1.5. 'As dew…': 'I sing of a maiden Ravilious: to HB, 16 Dec. 1935 (*LLD* 191); to DT, 2 Jan. 1939 (*LLD* 399). Thoreau: *Journal*, 20 Jan. 1855; 30 Jan. 1841

p. 99 Hopkins: *Journal*, 13 March 1870; 26 Sept. 1873. Whitman, 'Song of the Open Road', 3. Turner: A.J. Finberg, *Life of J.M.W. Turner RA* (1937), p. 112. Thoreau: *Journal*, 15 March 1842

p. 100 Hopkins: 'The Wreck of the Deutschland' 4. Coleridge: 'The Watchman'; N 495

p. 101 Grosseteste: see James McEvoy, *The Philosophy of Robert Grosseteste* (OUP, 1982), pp. 158–60. Coleridge: N 2006. Thoreau: *Walden*, 'The Ponds'. White: *Journal*, 4 Nov. 1791. Palmer: *AHP*, p. 117. Blake: Letter to Thomas Butts, 11 Sept. 1801 (*WBW*, p. 1552). Jefferies: 'The Pageant of Summer'

p. 102 Palmer: *1824 Sketchbook*, p. 121. Ravilious: to HB, 3 June 1935 (*LLD* 142). Thoreau: *Journal*, 19 Oct. 1858

p. 103 Dante: *Vita Nuova* XXIII

p. 104 Dante: *DC*, Paradiso VIII, 53–54; X, 67–69; II, 139–46. Herbert: 'Mattens', 'The Pearl'. Hopkins: *Journal*, 22 July 1873. Goethe: *Faust*, Sc.1, 'Night'. Hopkins: *Journal*, 22 July 1873. Palmer: *AHP*, pp. 111, 173

p. 106 Blake: 'The Golden Net'. *Pearl*: 136, 9. Coleridge: N 1489. Hopkins: *Journal*, 24 May 1871

p. 107 Al-Kindi: *Works*, S 224; Hopkins: *Journal*, 1871 (*HH*, p. 204)

p. 108 Al-Kindi: *Works*, S 220. Dante: *DC*, Paradiso I, 66; IV, 139–40. Coleridge, N 4036; 'Lines Written at Shurton Bars'

p. 109 Donne: 'The Extasie'. Dante: *Vita Nuova* II

p. 110 Dante; *DC*, Inferno V, 28; Paradiso CXX, 11–15. Al-Kindi, *Works*, S 220–23. Newton: *Opticks*, Book Two Part IV, Obs. 5. Coleridge: N 1256; 'The Eolian Harp'

p. 111 Dante: *DC*, Paradiso XIV, 118–19. Donne: 'Break of Day'. *Pearl*: sts 7, 10. Blake: Letter to William Hayley, Jan. 1804 (*WBW*, p. 1589). Palmer: *AHP*, p. 195. Clare: 'Rural Evening'

p. 112 Newton: *Opticks*, Book 3 Part I, Qus 12–15

p. 113 Coleridge: N 1974

p. 114 Newton: *Opticks*, Book 3 Part I, Qus 29, 26; Book 2 Part III, Prop. viii; Book 3 Part I, Qu. 28; Book 2 Part III, Prop. x; Book 3 Part I, Qus 29, 30

p. 115 Newton: *Opticks*, Book 1 Part I, Exper. 15; Book 3 Part I, Qu. 18. Van Gogh: *Letters, passim*

p. 116 Galileo: Frove and Marenza, op. cit., p. 414n. Milton: *PL* III, 21–26; I, 288

p. 117 Goethe: Conversations with Eckermann, 1824, 1828. Newton: *Opticks*, Book 2 Part III, Prop. XII. Einstein: Letter to M. Besso, 1951

p. 118 Goethe: *Faust*, Part 1, 'Faust's Study'. Traherne: *Centuries*, 3.9–13; 3. 22; 'Constancie'

p. 119 Ravilious: to DT, 8 May 1939 (*LLD* 415). Clare: Natural History Letters (*CP*, pp. 167–68)

p. 120 Clare: *John Clare, The Journal, Essays and The Journey from Essex*, ed., Anne Tibble (Carcanet, 1980). Appendix 9

p. 121 Goethe: *Faust*, Part 1, 'Walpurgisnacht'; *Truth and Poetry* (experience of 1765). Baruch, III, 33. Milton: *PL X*, 450–52

p. 122 Traherne: *Centuries*, 3.33. Grosseteste: *Hexameron*, Part 2, Ch. VII. Hopkins: *Journal*, 1870 (*HH*, pp. 131–32). Book of Enoch, 6.7; 13.2–8

p. 123 Dante: *DC*, Paradiso I, 37–72. Newton: *Opticks*, Book 1 Part II, Prop. XI, Prob. VI

p. 124 Newton: Letter to Henry Oldenburg, 6 Feb. 1671/2. Palmer: *1824 Sketchbook*, p. 2; *AHP*, pp. 327, 113. Jefferies: 'Nutty Autumn'; 'Nature in the Louvre'. Thoreau, *Journal*, 27 Feb. 1841

p. 125 Coleridge: N 925, 2026. Hopkins: *Journal*, 8 July 1871; 'Spelt from Sibyl's Leaves; Hopkins: *Journal*, 11 May 1873; 18 May 1870; 'The May Magnificat'

p. 126 Coleridge: N 1603; Hopkins: 'The Blessed Virgin compared to the Air we Breathe'

p. 127 Goethe: *Theory of Colours*. 155 *et seq.*, 69, 590; Conversation with Eckermann, 1829. Palmer: *AHP*, p. 79; Edward Malins, *Samuel Palmer's Italian Honeymoon* (OUP, 1968), p. 118

p. 128 Newton: *Opticks*, Book 1 Part I, Definition II; Book 2 Part III, Prop. XII; Book 1 Part II, Prop. XI, Prob. VI

p. 129 Newton: Book 1 Part II, Exper. 15. Coleridge: N 2357, 3159. Turner: Finberg, *Life*, pp. 69, 163

p. 130 Turner: James Hamilton and others, *Turner and the Elements* (Exhibition catalogue, 2011), p. 63. Goethe: *Faust*, Part 2, Act I

FALLING EARTHWARDS

p. 133 Ravilious: to Tirzah, Sept. 1940; to HB, 5 Aug. 1935 (*LLD* 165)

p. 135 Coleridge: N 2044. Clare: 'The Ragwort'. Whitman: *Specimen Days*, 'Mulleins and Mulleins' (1877)

p. 136 Van Gogh: Letter to Theo, late Aug. 1888. Jefferies, *Letters & Papers*, p. 131; 'The Sun in the Brook'. Clare: *Journal*, 17 Nov. 1824. Donne: 'The Primrose'. Clare: 'The Autobiography' (*CP*, p. 24). Hopkins: *Journal*, 15 April 1871; 6 May 1871

p. 137 Clare: *Journal*, 23 April 1825. Jefferies: 'A Place of Enchantment'

p. 139 Chaucer: *The Legend of Good Women*, Prologue

p. 140 Coleridge: N 1476, 2565, 3233, 2778, 2511, 15

p. 141 Thoreau: Emerson in *Atlantic Monthly*, Aug. 1862. Jefferies: 'The Pageant of Summer'. St Bridget: Alexander Carmichael, *Carmina gadelica: Hymns and incantations...orally collected in the Highlands and islands of Scotland* (1928–71), vol. 1, pp. 167–68; Lady Gregory, *The Blessed Trinity of Ireland: Stories of St Brigit, St Columcille and St Patrick*, passim

p. 142 Palmer: Letter to John Linnell, 1828. Hudson: *Nature in Downland*, pp. 5–6

p. 143 Coleridge: N 799. Milk: *Carmina gadelica*; vol. I, p. 265. Hopkins: Letter to Baillie, 1 May 1888

p. 144 Traherne: *Centuries*, 3.3. Hopkins: Letter of 1 March 1870; *Journal*, 27 Sept. 1873. Thoreau: 'Night and Moonlight', *Atlantic Monthly*, 1863

p. 145 Hopkins: Extract from early diaries, *HH*, p. 32. Herbert: 'The Starre'. Vaughan: *SS* 1, 'Midnight Son-Dayes'

p. 146 Galileo: 'The Starry Messenger', para. 2. Jefferies: *Story of my Heart*, pp. 171–72. Hopkins: *Journal*, 22 July 1868

p. 147 Whitman:'Song of Myself', 33. Coleridge: N 330; 667. Torquemada: Pérez Galdós, *Torquemada en la hoguera*, Ch. VIII. Traherne: *Centuries*, 1. 29, 3.46

p. 148 Traherne: *Centuries*, 4.20. Book of Enoch, 19

p. 149 Hopkins: *Journal*, 27 Nov. 1872. Thoreau: *Journal*, 21 Jan. 1838

p. 150 Clare:'Winter'. Job 38: 22–23, 28–29. Herbert: 'Artillery';'The Banquet

p. 151 Thoreau: *Journal*, 5 Jan. 1856. White: *Selborne*, Letter LXII. Traherne: 'Thanksgiving for the Body';'My Spirit'

p. 152 Coleridge: N 2031, 2363. Newton: *Opticks*, Book 3 Part I, Qu. 29. Thoreau: *Journal*, 16 Oct. 1858. Jefferies: 'Summer in Somerset'. Wordsworth: *Prelude* (1850), Book 1, 450–52

p. 153 Whitman: *Specimen Days*, 'Night of March 18, 1879' and 'Hudson River Sights'; 'When I Heard the Learn'd Astronomer'; *Specimen Days*, 26 Aug. 1877, 'Distant Sounds', 'Hours for the Soul' and 'Another Winter Night' (1879)

p. 154 Van Gogh: Letters to Theo, April and mid-July 1888. Whitman: *Specimen Days*, 'The Weather – Does it Sympathise with these Times?'; 'When Lilacs Last in the Dooryard Bloom'd'; *Specimen Days*, Night of March 18, 1879. Clare:'The Sorrows of Love'. Coleridge: N 4055

p. 155 Palmer: Letter from Tintern, 19 Aug. 1835. Hopkins: *Journal*, 9 July 1868

p. 156 Hopkins:'The Starlight Night'

p. 157 Coleridge: N 3700. Blake: 'The Gates of Paradise', Engraving 9. Coleridge: N 219. Hopkins:'Moonrise'

p. 158 Coleridge:'Soliloquy of the Full Moon, She Being in a Mad Passion'; N 2610. Dorothy Wordsworth:'The Moon Rose large and dull'. Heraclitus: *Fragments*, 37. Coleridge: N 1042. Traherne:'On Leaping over the Moon'

p. 159 Thoreau: 'Night and Moonlight', *Atlantic Monthly*, Nov. 1863. Blake: 'Jerusalem', 66. Hopkins: Poem of September 1862. Coleridge: N 2052, 2060. Whitman: 'Out of the Cradle Endlessly Rocking'

p. 160 Galileo: 'The Starry Messenger'

p. 162 Thoreau: 'Night and Moonlight', op. cit. Whitman: *Specimen Days*, 'The White House by Moonlight'. Coleridge: N 2546. Palmer: *AHP*, p. 4. Milton: 'Arcades' 2. Song

p. 163 Palmer: *1824 Sketchbook*, p. 2; *AHP*, p. 40

p. 164 Traherne: 'On Leaping over the Moon'. Ravilious: Remark to Edward Bawden, cited in Helen Binyon, *Eric Ravilious, Memoir of an Artist* (1983)

p. 165 Clare: 'The Autobiography' (*CP*, pp. 13, 28). Traherne: *Centuries*, 3.14. Donne: 'The Sunne Rising'

p. 166 Kilvert: *Diary*, 11 July 1870

p. 167 'The maidens came': MS Harley 7578. Ravilious: to John O'Connor, 10 Aug. 1940, in *Ravilious at War: The Complete Work of September 1939–1942*, ed. Anne Ullman (Fleece Press, 2002) Kilvert: *Diary*, 14 Oct. 1870

p. 168 Jefferies: 'The Sun and the Brook'; *Story of my Heart*, pp. 18–19. Traherne: 'Shadows in the Water'

p. 169 Hopkins: *Journal*, 18 July 1873; 7 Aug. 1872. Ravilious: to DT, 20 Feb. 1939 (*LLD* 404); to Celia Dunbar Kilburn, 16 Nov. 1939; to HB, 10 Sept. 1939 (*LLD* 445). Dudeney: 'Glimpses of our Ancestors in Sussex' (online)

p. 170 Cellini, *Autobiography*, Ch. CXXII. Blake: *Milton*, Book the First

p. 171 Donne: 'The Sun Rising'. Herbert: 'Christmas', I and II. Traherne: *Centuries*, 3.18. Clare: Natural History Letters (*CP*, p. 173). Vaughan: *SS* I, 'Rules and Lessons'. Newton: *Opticks*, Book I Part II, Prop. IX, Prob. IV. Herschel: Cited in Hamilton and others, *Turner and the Elements*, p. 53

p. 172 Blake: Alexander Gilchrist, *Life of William Blake* (1863), Ch. 1; letter to Flaxman, Sept. 1800 (*WBW*, p. 1540); 'Europe: A Prophecy'. Kilvert: *Diary*, 12 July 1870

p. 173 Kilvert: *Diary*, 24 June ('Longest Day'), 1873. Vaughan: *SS* I, 'Religion'. Blake: Gilchrist, op. cit., Ch. XXXVI

p. 174 Traherne: *Centuries*, 3.27, 28. Dante: *DC*, Paradiso XXI, 34–39. Milton: *PL* XII, 629–32. Blake: Alan Cunningham, *The Cabinet Gallery of Pictures* (1833), I, 11–13; *The Marriage of Heaven and Hell*

p. 175 Blake: Letter to Butts, 10 Jan. 1802 (*WBW*, p. 1558). Palmer: *1824 Sketchbook*, p. 118; *AHP*, p. 201. Ravilious: to Douglas Percy Bliss, Sept. 1927 (*LLD* 24)

p. 176 Milton: 'Ode on the Morning of Christ's Nativity'. Milton: *PL* I, 45; IV, 556–57

p. 177 Blake: *Poetical Sketches*: 'Song'. García Márquez: 'A Very Old Man with Enormous Wings'

p. 178 Blake: Poems from MSS, *c* 1793. Book of Enoch 106, 1–6

p. 179 Genesis 32: 24–30. Dante: *Vita Nuova*, V Milton: *PL* V, 433

p. 180 Whitman: 'Song of Myself', 41. Clare: *Journal*, 24 May 1825. Kilvert: *Diary*, 31 Dec. 1877. Job 37: 11–16

p. 181 Milton: *PL* XI, 204–7. Dante: *Vita Nuova*, XIV. Coleridge: N 983. Masefield: *Grace Before Ploughing* (1917, reprinted 1966), Ch. II: 'The Angel'. Jefferies, 'Winds of Heaven'

p. 182 Collins: quoted in 'Fallen Angels' by Peter Fuller (*Images of God*, various authors, 1985). Whitman: *Specimen Days*, 'The Weather – Does it Sympathise with these Times?' Palmer: *AHP*, p. 113; letter to John Linnell, 1828. Donne: 'Air and Angels'. Milton: *PL* V, 745–47

p. 183 Dante: *DC*, Paradiso XV, 13–18. Coleridge: N 549

CATCH AS CATCH CAN

p. 185 Ravilious: to Douglas Percy Bliss, 15 Oct. 1927 (*LLD* 50) to DT, 20 Feb. 1939 (*LLD* 404)

p. 187 Ravilious: to DT, 20 Feb. 1939 (*LLD* 404). Einstein: *Autobiographical Notes*, pp. 52–53

p. 188 Heaney: 'Squarings', from *Seeing Things* (Faber, 1991). Newton: *Opticks*, Book 2 Part III, Prop. XI

p. 189 Newton: *Opticks*, Book 1 Part I, Prop. II, Theor. II, Expers 5, 6 and 10 (Illustration)

p. 190 Newton: Prop. IV, Prob. I, Exper. 11; Prop. VII, Theor. VI; Exper. 16; Book 3, Part I, Qu. 3; Book 2 Part III, Prop. XIII; Prop. XII; Book 3, Part I, Qu. 3

p. 191 Walton: *The Compleat Angler*, Ch. 13. Coleridge: *Ancient Mariner*, IV

p. 192 Newton: *Opticks*, Book 1 Part I, Prop. I, Theor. I. Clare: *Memories of Childhood*: 'Chusing Friends' and 'Leisure'

p. 193 Palmer: *AHP*, pp. 187, 282; *Sketchbook*, p. 74; *AHP*, p. 289; *SPVL*, p. 228

p. 194 Coleridge: N 54. Thoreau: *Journal*, 12 Dec. 1851. Jefferies: *Bevis, The Story of a Boy* (1882), pp. 265–66. Newton: *Opticks*, Book 3 Part I, Obs. V. Hopkins: *Journal*, 29 June 1872

p. 195 Coleridge: N 481; 1770. Van Gogh: Letter to Theo, Sept. 1882. Goethe: *Truth and Poetry*, Part 2, VI. Turner: Walter Thornbury, *The Life of J.M.W. Turner RA* (in two vols, 1862), Vol. 1, p. 125. Palmer: *AHP*, p. 97

p. 196 Ravilious: to Cyril Bertram, 2 and 9 Dec. 1928. Hopkins: *Journal*, 18 May 1870; 2 March 1871. Ravilious: Remark to Edward Bawden, cited in Alan Powers, *Eric Ravilious, Imagined Realities* (Exhibition catalogue, 2003), p. 38. Blake: *Descriptive Catalogue*, 1 and 6

p. 197 Palmer: *AHP*, pp. 79, 363, 89. Blake: 'The Marriage of Heaven and Hell', plate 14

p. 198 Notebook memorandum, 'To Wood cut on copper'

p. 199 William of Conches: *Dragmaticon*. Dante: *DC*, Paradiso II, 110–11; XXV, 79–81. Newton: *Opticks*, Book 3 Part I, Qu. 8. Hopkins: *Journal*, 4 April 1870. Coleridge: Letter to Godwin, 25 March 1801

p. 200 Monet: R. Kendall, *Monet by Himself* (Chartwell Books, 2000), p. 191. Ravilious: to Tirzah, 10 Dec. 1939 (*LLD* 459); to HB, 15 Feb. 1938 (333); to Tirzah, 3 March 1938 (336)

p. 201 Ravilious to HB, 1 March 1937 (291). Rich: *Water Colour Painting*, pp. 37, 43. Ravilious: to HB, 19 Dec. 1935 (97); to DT, 25 June 1939 (428). Rich: op. cit., p. 17

p. 202 Constable: John Gage, *Constable's Clouds* (Exhibition catalogue, 2000), pp. 59–68 *passim*

p. 203 Constable: Gage, *Constable's Clouds*, pp. 73, 103, 168. Hopkins: Letter to Baillie, 12 Feb. 1888

p. 204 Hopkins: *Journal*, Dec.–Jan. 1873–74. Ravilious: to HB, 9 May 1935 (*LLD* 127) and 12 April 1937 (295)

p. 205 Goethe: *Faust*, Prologue. Blake: Letter to George Cumberland, 12 April 1827 (*WBW*, p. 1667)

p. 206 Palmer: *AHP*, pp. 60, 100; *Sketchbook*, pp. 114, 11; *SPVL*, p. 89; *AHP*, p. 82. Blake: Marginalia to Sir Joshua Reynolds' *Discourses* (*WBW*, p. 1450)

p. 207 Palmer: *AHP*, pp. 82, 91, 111, 113, 292. Ravilious: to DT, 10 Sept. 1939 (*LLD* 446). Palmer: *AHP*, pp. 178, 55, 111

p. 208 Van Gogh: Letters to Theo, April 1885 and Sept. 1882

p. 209 Palmer: *AHP*, 166. Goethe: *Theory of Colours*, 13; *Truth and Poetry*, Part 8. Turner: Hamilton and others, *Turner and the Elements*, p. 76. Ravilious: to HB, 17 Sept. 1935 (*LLD* 170). Turner: Hamilton, op. cit., p. 62

p. 210 Palmer: *AHP*, pp. 144; 265–66; 172; letter to Alexander Gilchrist, *c.* April 1861

p. 211 Palmer: *AHP*, p. 112. Monet: Kendall, *Monet by Himself*, p. 196. Palmer: *AHP*, pp. 319, 243, 319. Turner: Thornbury, *Life*, p. 359

p. 212 Finberg, *Life*, p. 134. Ravilious on tempera: to Edward Bawden, cited in Binyon, *Memoir of an Artist*, p. 30; to HB, 25–26 Feb. 1936 (*LLD* 203)

p. 213 Ravilious to HB, 19 Aug. 1941. Coleridge: N 1577, 1489; 1495; *Biographia Literaria*, Book X; N 1782; 'To the Rev. George Coleridge'; N 4013

p. 214 Coleridge: N 1681; 3291; 2370

p. 215 Coleridge: N 1771; 1766

p. 216 Palmer: *AHP*, p. 80. Hopkins: *Journal*, 23 July 1874. R.S. Thomas: 'The Bright Field'

p. 217 Coleridge: N 2093; 1577

p. 218 Vaughan: 'Jacob's Pillar and Pillow'. Coleridge: N 3852

p. 219 Herbert: 'The Elixir'. Traherne: *Centuries*, 3.16; 'Poverty'; *Centuries*, 3.16

p. 220 Traherne: 'Hosanna'. Jefferies: 'Hours of Spring'. Ravilious: to HB, 25 July 1936 (*LLD* 251)

p. 222 Coleridge: N 2191. Ravilious: Eric Ravilious and J.M. Richards, *High Street, passim*

p. 223 Ravilious to HB, 27 Nov. 1935 (*LLD* 186); Blake: Marginalia to Sir Joshua Reynolds' *Discourses* (*WBW*, p. 1468)

p. 224 Palmer: *SPVL*, p. 37; *AHP*, p. 105; *SPVL*, pp. 76, 128; *AHP*, pp. 13, 133; letter to Alexander Gilchrist, 23 Aug. 1855

p. 225 Coleridge: N 1973, 1974. Thoreau: (*Journal*, 16 June 1840); 27 Feb. 1841; *Walden*, 'Baker Farm'

p. 226 Thoreau: *Journal*, 8 Jan. 1857. Blake: Letter to John Trusler, 23 Aug. 1799 (*WBW*, p. 1527). Palmer: *AHP*, pp. 113, 81, 291; *1824 Sketchbook*, p. 1

p. 227 Palmer: *1824 Sketchbook*, p. 18

IMMORTAL DIAMOND

p. 230 Hopkins: *Journal*, 2 March 1876. Ravilious: to HB, May 1940; to DT, May–June 1940

p. 234 Blake: 'Jerusalem'. Traherne: 'An Hymne upon St Bartholomew's Day'; 'Mattens'. Vaughan: *SS* 1, 'The Tempest'. Donne: 'A Valediction: Of my Name in the Window'. Newton: *Opticks*, Book 1 Part II, Prop. X, Prob. V. Hopkins: *Journal*, 30 Aug. 1867

p. 235 Hopkins: *Journal*, 21 April 1871. Jefferies: *Letters & Papers*, p. 218; 'On the Downs'. Hopkins: Extracts from early diaries, 1866 (*HH* p. 53); 'The May Magnificat'; 'The Wreck of *The Deutschland*'. 16; Unfinished fragment, 'The furl of fresh-leaved dogrose down …';

p. 236 Hopkins: *Journal*, 11 July 1868. Clare: 'The Autobiography' (*CP*, p. 12). Ravilious: to HB, 13 May 1936 (*LLD* 218). Hudson: *Nature in Downland*, pp. 150, 41–2

p. 237 Palmer: *AHP*, p. 82

p. 238 Palmer, *AHP*, p. 98; letter to Barlow, 1876; *AHP*, p. 10

p. 239 Palmer: *AHP* 15–16, 173, 103

p. 240 Blake: cited in Gilchrist, op. cit., p. 302. Palmer: *AHP*, p. 296. Dante: *DC*, Paradiso XV, 24. Kilvert: *Diary*, 27 April 1873, 24 June 1875, 12 April 1876

p. 241 Palmer: *1824 Sketchbook*, pp. 111–12. Hopkins: *Journal*, Dec. 1873 (*HH*, p. 187). Blake: 'I heard an Angel'. Jefferies: *JE*, 'One of the new Voters'. Van Gogh: Letter to Theo, Aug./Sept. 1888

p. 242 Van Gogh: Letter to Theo, 11 Aug. 1888. Clare: 'The Autobiography' (*CP*, p. 27)

p. 243 Clare: Fragment for 'An Essay on Landscape' (*CP*, pp. 214–15); 'Winter'; 'The Foddering Boy'. Traherne: 'On Christmas-day'. Ravilious: to DT, 18 Dec. 1938 (*LLD* 397); to DT, 28–29 Nov. 1939 (*LLD* 458); to HB, 11 June 1935 (*LLD* 148)

p. 245 Tagore: *Reminiscences* Ch. 34, 'Morning Songs'

p. 246 Merton: *Conjectures of a Guilty Bystander*. Blake: Letter to Hayley, 16 Sept. 1800 (*WBW*, pp. 1539–40); 'The Marriage of Heaven and Hell'. Traherne: *Centuries*, 3.3; 'A Contemplation'; *Centuries*, 1.66, 2.51

p. 247 Ravilious: to HB, 23 March 1935 (*LLD* 113) spelling as in his edition

p. 248 Ravilious: to HB, 15 Aug. 1935 (*LLD* 167); HB to ER, 25 March 1935 (114). Vaughan: *SS* 1, 'Ascension-hymn'; Bunyan: *Pilgrim's Progress*, Section 3. Genesis 37: 9. Newton: *Opticks*, Book 3 Part I, Obs. 1

p. 249 Cellini: *Autobiography*, Ch. CXXVIII. Thoreau: *Walden*, 'Baker Farm'. Whitman: 'Crossing Brooklyn Ferry'

p. 250 Goethe: *Theory of Colours*, 30, 100, 54, 28, 52. Coleridge: N 3606

p. 251 Coleridge: N 3708, 1108, 551, 410–18 *passim*

p. 252 Coleridge: N 258, 3466

p. 253 Coleridge: N 447, 2052, 2105, 174, 3708; letter to Godwin, 25 March 1801

p. 254 Jefferies: *Story of my Heart*, p. 107. Donne: 'The Canonisation'. Dorothy Wordsworth: *Journal*, 17 March 1802. Clare: 'The Autobiography' (*CP*, p. 85). Whitman: 'Sparkles from the Wheel'; Traherne: *Centuries*, 3.7. Job 29: 2–4. Dante: *DC*, Paradiso CXXX, 52–54

p. 255 Coleridge: N 2348, 2934

p. 256 Hopkins: *Journal*, 19 Dec. 1872; 'The Candle Indoors'; 'The Lantern out of Doors'

p. 257 Thoreau: *Walden*, 'Where I Lived …', 'Solitude'

p. 258 Hopkins: *Journal*, 1870 (*HH*, p. 132). Clare: 'Willow-wisps', (*CP*, pp. 167–68). Empedocles: *On Nature*, B 84

p. 259 Traherne: *Centuries*, 2.51; 'Nature'. Goethe: *Theory of Colours*, Introduction. Blake: 'The Gates of Paradise', frontispiece: 'What is Man?' Traherne: 'An Infant-Ey'

p. 260 Traherne: *Centuries*, 2.90, 2.65; 'The Improvment'; *Centuries*, 1.80, 2.60, 2.71; 'Silence'. Herbert: 'The Windows'; 'Christmas'. Blake: Cited in Gilchrist, op.cit., p. 325

p. 261 Blake: Letter to Butts, 1802; cited in Gilchrist, op.cit., p. 335

p. 262 Vaughan: *SS* 1 'Rules and Lessons'. Blake: 'A Vision of the Last Judgment'. Milton: *PL* VII, 29–30. Whitman: 'Song of Myself', 553–54

p. 263 Thoreau: 'Night and Moonlight', *The Atlantic*, Nov. 1863; *Walden*, 'Where I lived'

p. 264 Coleridge: N 2637, 4036, 3222, 4375

p. 265 Newton: *Opticks*, Book 1 Part II, Prop. VII, Th. V; Book 1 Part II, Prop. VII. Th. V; Trinity notebook (1666). Milton: *PL* III, 3; letter of 28 Sept. 1654. Coleridge: N 2372, 1681

p. 266 Dorothy Wordsworth: *Journal*, 15 April 1802. Blake: Letter to Hayley, Oct. 1804 (*WBW*, p. 1614). Milton: *PL* III, 51–55

p. 267 Coleridge: N 1678 (STC's paraphrase of *Enneads* 5.5 and 5.8). Hopkins: 'The Habit of Perfection'. Plotinus: *Enneads* 5.7. Hermes Trismegistus: *The Divine Pymander* X. 4

p. 268 Symeon: See Hilarion Alfeyev, *St Symeon the New Theologian and Orthodox Tradition* (OUP, 2000), pp. 226–39 *passim*. Thoreau: *Journal*, 16 July 1851. Traherne: 'On News'; *Centuries*, 3.26, 4.83

p. 269 Böhme: *Confessions*, X. Dante, *DC*, Paradiso II, 34–36. Hopkins: 'The Candle Indoors'. Coleridge: N 2435. Newton: *Opticks*, Book 2 Part III, Prop. II

p. 270 Palmer: *AHP*, p. 78. Newton: *Opticks*, Book 3 Part I, Qu. 30; Book 2 Part III, Prop. X. Traherne: *Centuries*, 2.76. Hopkins: 'To what serves Mortal Beauty?'

p. 271 Hopkins: 'That Nature is a Heraclitean Fire, and of the comfort of the Resurrection'; 'Carrion Comfort'; 'Poetry and Verse'

p. 272 Dante: *DC*, Paradiso II, 17, 23–25. Vaughan: 'They are all gone into the world of light'. Traherne: *Centuries*, 3.3; 'Wonder'; *Centuries*, 3.1; 'The City'; 'Thoughts. I'; *Centuries*, 5.8,9; 4.73

p. 273 Traherne 'Insatiableness' II; *Christian Ethicks*. Goethe: Conversation with Eckermann, 1824

p. 274 Whitman: 'Song of Myself', 33; *Specimen Days*, 'Hours for the Soul', 22 July 1878; 'Song of Myself', 46; 'Noiseless Patient Spider'. Thoreau: *Journal*, 31 Jan. 1841

p. 275 Thoreau: *Journal*, 23 June 1840; 10 Dec. 1837. Traherne: *Centuries*, 5.9. Vaughan: *SS* 1, 'The Retreate'. Coleridge: N 1797, 2639, 2866, 2347, 1031

p. 276 Coleridge: N 4016

p. 277 Van Gogh: Letter to Theo, June 1885. Blake: cited in Gilchrist, *Life of William Blake*, pp. 318, 324–25. Palmer: *AHP*, p. 79

p. 278 Hopkins: Letter to Richard Watson Dixon, Oct. 1886. Blake: 'Auguries of Innocence'; letter to Thomas Butts, 2 Oct. 1800 (*WBW*, p. 1546–47)

p. 279 Blake: 'The Crystal Cabinet'